S0-ACJ-940

INTRODUCTION TO COMPUTER GRAPHICS

Second Edition

HANS-JOACHIM BUNGARTZ

MICHAEL GRIEBEL

CHRISTOPH ZENGER

CHARLES RIVER MEDIA, INC.
Hingham, Massachusetts

006.6
B8821
2004

Originally published in the German language by Friedr. Vieweg & Sohn Verlag, D-65189 Wiesbaden, Germany, as "Hans-Joachim Bungartz / Michael Griebel / Christoph Zenger: Einführung in die Computergraphik. 2. Auflage (2nd edition)". © Friedr. Vieweg & Sohn Verlag/GWV Fachverlage GmbH, Wiesbaden, 2002

Copyright 2004 by CHARLES RIVER MEDIA, INC.
All rights reserved.

No part of this publication may be reproduced in any way, stored in a retrieval system of any type, or transmitted by any means or media, electronic or mechanical, including, but not limited to, photocopy, recording, or scanning, without *prior permission in writing* from the publisher.

Editor: David Pallai
Production: American Institute of Physics
Cover Design: The Printed Image

CHARLES RIVER MEDIA, INC.
10 Downer Avenue
Hingham, Massachusetts 02043
781-740-0400
781-740-8816 (FAX)
info@charlesriver.com
www.charlesriver.com

This book is printed on acid-free paper.

H. Bungartz, M. Griebel, C. Zenger. *Introduction to Computer Graphics, Second Edition.*
ISBN: 1-58450-332-7

All brand names and product names mentioned in this book are trademarks or service marks of their respective companies. Any omission or misuse (of any kind) of service marks or trademarks should not be regarded as intent to infringe on the property of others. The publisher recognizes and respects all marks used by companies, manufacturers, and developers as a means to distinguish their products.

Library of Congress Cataloging-in-Publication Data
Bungartz, H.-J. (Hans-Joachim)
 Introduction to computer graphics / Hans-Joachim Bungartz, Michael Griebel, Chrisp Zenger.-- 2nd ed.
 p. cm.
 ISBN 1-58450-332-7 (Paperback : alk. paper)
 1. Computer graphics. I. Griebel, Michael. II. Zenger, Christoph Wilhelm, 1940- III. Title.
T385.B8515 2004
006.6--dc22
 2003025387
Printed in the United States of America
04 7 6 5 4 3 2 First Edition

CHARLES RIVER MEDIA titles are available for site license or bulk purchase by institutions, user groups, corporations, etc. For additional information, please contact the Special Sales Department at 781-740-0400.

CONTENTS

CHAPTER 3 GRAPHICAL REPRESENTATION OF THREE-DIMENSIONAL OBJECTS 103

PREFACE

The creation and processing of graphical data have undergone a boom in the last twenty years, finding applications far beyond information science in widely ranging scientific disciplines, as well as in daily life. Thus, the ongoing development of ever more capable picture screen devices and corresponding special graphics hardware, as well as of user friendly graphics software, have led to an increasingly favorable price-capability ratio in this sector. Also it has led to the fact that, today, both work station computers for scientific use and personal computers in the office or home are thoroughly graphics capable, often with capabilities that not long before were restricted to large computers. For this reason, computer graphics has come in the meantime to be employed in many forms and over a wide range of applications:

- The possibilities of graphical data processing are used on an ever-increasing scale in teaching, from classical lectures via television to modern teaching and learning videos, such as interactive tutorials. Many formerly boring topics become easy and engaging with the aid of computer graphics. Just recall the visualizations of Julia-Fatou, Mandelbrot, and other fractal sets that were so popular in the 1980s. An entire branch of mathematics then became known and attractive as a result of the capabilities of computer graphics.
- Graphical data processing is by now indispensable in the office world (graphical user interfaces, presentation graphics, desktop publishing), advertising (prospectuses, TV ad spots), the media (cartoon animation, multimedia), and entertainment with its video and computer games.
- Computer graphics has also become important in many areas of art. Examples include lectures at the Kunsthochschule für Medien Köln (Media Art College, Cologne) founded in 1990 (The

Aesthetics of Computer Generated Pictures; Conception, Creation, and Realization of a 3D Computer Animation), as well as the Festival Ars Electronica presented since 1979 by the Austrian Radio (Österreichischer Rundfunk, ORF), with which the Prix Ars Electronica competition has been affiliated since 1987.

- Under the heading of virtual reality, graphical data processing has entered strongly into medicine and architecture. In addition, virtual reality applications play an increasing role in classical application areas such as flight simulators and flight control systems, for instance in the generation of synthetic vision.

- Graphical data processing has also become an essential aid in research and technology in general. Thus, for example, engineering construction plans are generated with computer support and in mechanical engineering, architecture, civil engineering, and electrical engineering almost the entire design process is often run on a computer (computer aided design). Meanwhile, the automated production and fabrication process is ever more controlled by product description (and graphical) data (from computer aided manufacturing to computer integrated manufacturing).

- In numerical simulation of processes as contemplated in the natural sciences and technology, visualization of computational results has become a decisive resource for obtaining results that can be interpreted by people and for illustrating complicated, time varying processes. For example, it is possible to make ever more precise numerical simulations on modern high power computers of the behavior of flows (computational fluid dynamics), chemical reactions (computational chemistry), physical changes on widely differing scales of observation ranging from astrophysics to quantum mechanics (computational physics), entire engineering fabrication processes as in semiconductor manufacture, and environmental problems (the spread of pollutants), as well as climate research and weather forecasting. Because of the vast flood of data, it is essential for the evaluation of the results of a simulation that the data be processed immediately, graphically displayed, and thereby made available for interpretation.

- Finally, the visualization of large data sets provided by measurement instruments is of decisive importance for the processing and evaluation of these data. These include the pictures and measurement data from space probes (Voyager, Galileo) and satellites (Meteosat, Landsat, Seasat, Geosat, ERS-1/2).

This book is not an all-encompassing treatment of computer graphics. It has grown out of the development of a three hour lecture series on graphical data processing given several times by the authors at the Technical University of Munich and at the Ludwig-Maximilian University of Munich for senior students in information technology and mathematics. Thus, the emphasis is on the presentation of knowledge about the elements of graphical data processing. In addition, the experience gained in the development and repeated execution of computer graphics laboratory work shows up in a number of places.

As opposed to many other books on this subject, which deal with various procedures for displaying objects on a screen or other output device, we shall also discuss the generation of objects in a computer (modeling of geometric bodies and the associated data structures) in some detail. This builds a bridge from pure computer graphics to geometric modeling, which seems especially important in many engineering applications (mechanical engineering, electrical engineering, civil engineering, or architecture).

Anyone who expects a detailed description of a program system for computer graphics from this book will be disappointed. Rather than specific programs or programming examples, we shall discuss the general principles and techniques which are of importance for today's modeling and graphical display systems. Graphics standards and program packages go out of date on almost a yearly time scale, while improved, more powerful systems and program environments are constantly being developed. We wanted to be free of this. It should also be pointed out that this book is just an introduction to computer graphics. Many aspects cannot be discussed at length as they might be in a comprehensive book on graphical data processing. Here we refer the interested reader to the standard references, such as the books by Foley, van Dam, Feiner, and Hughes [FDFH97] and Newman and Sproull [NeSp84]. On the other hand, the basic procedures and techniques are not only presented, but we attempt to make the individual steps and decisions understandable and traceable, so that the reader can easily transfer these concepts to applied problems.

In the first chapter, we discuss the elements of graphical data processing, such as coordinate systems and transformations, two-dimensional clipping, and efficient algorithms for representation of graphical primitives, as well as different color models. Chapter Two deals with the geometrical modeling of three-dimensional objects with different types of display for solid bodies, as well as with their topological structure and the

assignment of geometrical attributes. The realization of free form curves and free form surfaces is discussed in this connection. Finally, in Chapter Three we proceed to the central questions involved in the graphical display of three-dimensional objects and discuss parallel and central projection, visibility determinations, and illumination models, as well as shading, transparency, ray tracing, and radiosity procedures. Here, in particular, we consider the goal-oriented selection of the tool kit, as the real time applications which have recently come to the fore require fundamentally different techniques such as the creation of individual high quality, photorealistic images. In the fourth and last chapter we discuss, in a somewhat random ordering, a series of extended techniques, including texture mapping, stereography, fractals, grammar models, and particle systems, as well as a few selected modern domains of application of graphical data processing such as animation, visualization, and virtual reality and briefly present the basic concepts of these.

At this point we would like to heartily thank Stefan Zimmer for many helpful suggestions and fruitful discussions, as well as our students Ulrike Deisz, Anton Frank, Thomas Gerstner, Klaus Nothnagel, and Andreas Paul. Anton Frank, Thomas Gerstner, and Andreas Paul have forever enriched this book with many valuable tips on the practice of computer graphics, Anton Frank and Klaus Nothnagel have diligently provided the figures and color tables, and we thank Ulrike Deisz for her untiring efforts in the preparation of the manuscript. We thank Profs. R. Möhring, W. Oberschelp, and D. Pfeifer, the editors of the series Mathematische Grundlagen der Informatik (Mathematical Foundations of Information Technology), for valuable suggestions and for including our book in their series. Finally, we thank Vieweg Verlag, the publishers, for their friendly and cooperative collaboration.

We conclude with a general comment: pictures and visualization of data are almost always convincing—people believe what they see. Of course, computer graphics can only display the data which have been provided. This must always be kept in mind with the visualization of results from a numerical simulation. In the end, the techniques and procedures used to generate the data are of prime importance. Entirely false results and data can also yield impressive pictures [GlRa92].

Munich, January 1996

H.-J. Bungartz,
M. Griebel,
Chr. Zenger

PREFACE TO THE SECOND EDITION

The long overdue revision of our Introduction to Computer Graphics is finally ready after a good six years. With the correction of small and large inconsistencies and mistakes—we are obliged to thank our readers for catching them—and a hopefully successful shift to the new orthography, the text has been reworked, brought up to date, and expanded in some places. The goal of the book has not been changed, so we have retained the rough outline. The sections on the geometrical attributing of three-dimensional objects (free form curves and surfaces, etc.) have been completely recast, as have those on global illumination (ray tracing, radiosity, etc.), while the presentation of visualization has been somewhat expanded. In a third appendix we have finally collected a few problems from a laboratory manual Applications of Computer Graphics (Anwendungen der Computergraphik) conceived by the first author in 1999 for students majoring in information technology, mathematics, or engineering at the Technical University of Munich.

This second edition would also have been impossible without the substantial support of many people. As representatives of the readers who have commented, we would like to mention Dr. Johannes Zimmer and Dr. Hans-Georg Zimmer, whose suggestions and comments generated discussions and cleared away some misunderstandings. Dr. Stefan Zimmer, Ralf-Peter Mundani, and Andreas Kahler have made valuable contributes to the new edition. The preparation of the manuscript was in the most capable hands of Srihari Narasimhan. They all merit our sincere thanks. Finally, this time we again thank the publisher Verlag Vieweg and, especially, Mrs. Ulrike Schmickler-Hirzebruch for their part in a constructive collaboration.

Stuttgart, Bonn, and Munich, April 2002

H.-J. Bungartz,
M. Griebel,
Chr. Zenger

1

FUNDAMENTALS AND ELEMENTARY GRAPHICAL FUNCTIONS

Before dealing with the two central themes of this book, geometrical modeling and the graphical representation of three-dimensional objects, in Chapters 2 and 3, we would first like to provide an overview of the essential operational steps to go from an actual scene to a picture on an output device and, thereby, to justify this rough division into modeling and representational parts.

In this introductory chapter, we shall also discuss a few topics of basic importance: elementary objects as the basis for both modeling and representation; two-dimensional clipping as a first approach to the problems associated with visibility; the drawing of lines and circles on raster-oriented output devices as an example of rastering problems; and, various possibilities for gray-shading and color representation. As this brings up topics of great importance in various areas of graphical data processing, we have decided upon an extensive presentation, instead of a description of individual problem statements and solution methods. Rather, as with the Bresenham algorithm in Section 1.5, the individual steps leading from handy, but slow procedures to a highly efficient algorithm will be pointed out, or, in the case of color representation, several alternative methods will be provided, even if only a few are used in practice. In this way, the characteristics of the techniques, as well as their advantages and disadvantages, will be made clearer and the considerations employed here can be extended to applied problems.

1.1 BASIC PROCEDURE

As a rule, the starting point for the discussion is reality or a segment of it, the real scene, or, instead, the more or less concrete representation of a scene to be generated on the computer. In the following we shall always proceed, without loss of generality, from a real scene, of which, ultimately, an image is to be made available on an output device, i.e., on a printer, plotter, or screen. The sequence of work from the real scene to the picture on the output device is shown in Figure 1.1.

Accordingly, there are three major steps:

1. creation of a three-dimensional model of the real scene;
2. mapping of a model onto the two-dimensional virtual picture space, as well as the creation of a two-dimensional virtual picture;
3. output to the appropriate device.

The first step involves the geometric modeling of three-dimensional objects (see Chapter 2), while the other two steps involve the graphical representation of three-dimensional objects, the theme of Chapter 3.

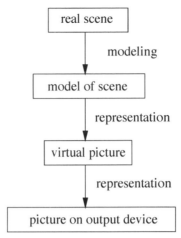

FIGURE 1.1 Elementary steps in graphical data processing.

Both the model of the scene and the virtual picture are constructed of elementary objects or graphical primitives, whose provisional forms will be suitably modified and ultimately combined. For the (three-dimensional) model of the scene, one uses three-dimensional elementary objects (e.g., cuboids, cylinders, etc.), while the (two-dimensional) picture will be created from "two-dimensional" elementary objects (e.g., lines, polygons, circles, etc.).

We shall now illustrate the three steps listed above using a simple example. Starting with the real scene or with a representation of a scene that is to be created artificially, a three-dimensional model of this scene will first be prepared (see Figure 1.2), perhaps out of building blocks appropriately represented in the computer, from which a two-dimensional image is to be generated.

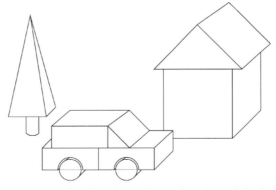

FIGURE 1.2 Example of a three-dimensional model of a scene.

Now a two-dimensional picture has to be created from this three-dimensional model. First the model is projected onto the plane of the picture. The representation of the picture proceeds in the following steps:

- Elementary objects are lines, circles, and semicircles:

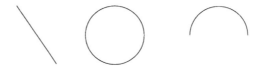

FIGURE 1.3 Examples of elementary objects.

- Composite objects include, e.g., rectangles or trees:

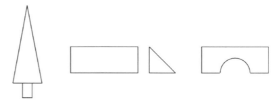

FIGURE 1.4 Examples of composite objects.

- In this way the three-dimensional model of the scene in Figure 1.2 can be represented in two dimensions:

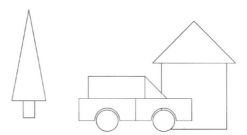

FIGURE 1.5 A two-dimenstional image of the model of the scene.

- A segment of this yields the virtual picture:

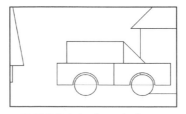

FIGURE 1.6 Virtual picture.

- The output is finally displayed in raster form on a screen or printer:

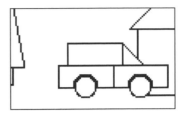

FIGURE 1.7 Picture on a raster-oriented output device.

Hierarchical representations are available for describing the model of the scene as well as the virtual picture, for example, by means of a tree structure, as shown in Figure 1.8.

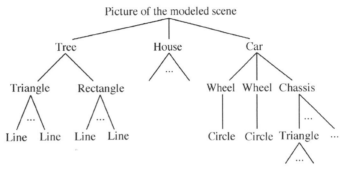

FIGURE 1.8 Hierarchical representation of the picture of the modeled scene as a tree.

A description of the entire path specified in Figure 1.1 will require coordinate systems and transformations between them. A representation of an elementary object or composite object in one coordinate system can be imaged onto the corresponding representation in another coordinate system using these transformations. The real scene will accordingly be specified in so-called world coordinates, the model of the scene in model coordinates, the virtual picture in virtual picture coordinates, and the picture on the output device in device-dependent device coordinates.[1] Furthermore, Figure 1.6 illustrates the importance of visibility problems and Figure 1.7 serves to clarify the difficulty of representing two-dimensional graphical primitives on raster-oriented output devices.

[1]As opposed to the notation introduced here, in the literature the concept of model coordinates often refers to the coordinate systems of the individual three-dimensional elementary objects. The composite model of the scene is then described in world coordinates.

1.2 ELEMENTARY OBJECTS

As we have seen in the preceding section, elementary objects play a decisive role, both in three-dimensional modeling and in two-dimensional representations. We shall become familiar with numerous possibilities for the definition and choice of elementary objects in Chapter 2. In order to examine elementary objects for graphical representation, we must first briefly consider the requirements of the relevant output devices. These include, on one hand, devices such as plotters, which can draw lines directly, and, on the other, devices such as laser or dot matrix printers and today's ubiquitous raster screens, which control and position individual picture points. Accordingly, two alternatives have acquired a special significance for the representation or the graphical problem: the vector-oriented approach, in which objects are assembled from lines specified by their beginning and end points, and the raster-oriented formulation, in which the picture is represented as a matrix of individual picture elements (pixels) and each pixel can be handled separately. The advantages of vector-oriented models lie in the ease of modeling and the efficiency with which they can be manipulated (zoom without loss of information, rotation and scaling of vector quantities). The raster-oriented approach, on the other hand, offers greater potential for easier and more efficient implementation.

As a rule, the description of elementary objects is vector-oriented. Here all the elementary objects reduce to lines and points, so they are fully characterized just by specifying certain points (their so-called principal points). Some examples for elementary objects include (cf. Figure 1.9) the following:

(a) Points,
(b) Lines (2 points: beginning and end),
(c) Polygons (n points),
(d) Broken lines (n points),
(e) Circles (2 points: center and a point on the circle),
(f) Ellipses (3 points: 2 foci and one point on the ellipse),
(g) Bézier curves (see Section 2.4),
(h) B-spline curves (see Section 2.4), and
(i) the symbol for a vector quantity.

The following are of particular importance for modeling three-dimensional bodies:

- polygonal grids[2] in 2D and 3D, as triangular strips or quadrilateral meshes, and
- curved surfaces: Bézier surfaces and B-spline surfaces (see Section 2.4)

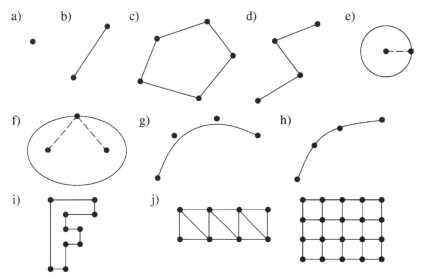

FIGURE 1.9 Elementary objects in the vector-oriented case.

The common principle for these elementary objects is that they can all be reduced to lines and points and that they can also be defined in terms of their principal points. The objects are described through the construct (type, vector coordinates, attributes). Examples of attributes include line width, type of line, color, etc. A model of the scene or an image is constructed out of multiple objects.

On the way to the display or representation on the computer, graphical primitives (gp) with their associated attributes (at) and entire pictures (image) can be specified by abstract data types [BaWö84]. We shall not go into details here, but a simple example might look like the following:

[2] Polygonal grids are sequences of triangles or quadrilaterals, as shown in Figure 1.9 (j). In the three-dimensional case they are also suitable for modeling spheres and other objects with curved surfaces.

```
type IMAGE ≡ (sort gp, sort at) image, empty, isempty, combine, view:
             sort image,
             funct image empty,
             funct(image) bool isempty,
             funct(gp,at) image view,
             funct(image,image) image combine,
             law: ∀ image   a: combine(a, emptyimage) = a,
             law: ∀ image   a,b,c: combine(combine(a,b),c) =
                                   combine(a,combine(b,c)),
                 ⋮
end of type
```

Elementary objects and their combinations are processed by means of
mapping between coordinate systems (translations, scalings, rotations), as
described in Section 1.3 below. Once the scene has been constructed, the
desired picture segment must be created using clipping techniques (see
Section 1.4). A representation on a raster output device is finally obtained
by converting the vectors into pixel sets (see Section 1.5). Efficient algo-
rithms that are embedded directly in the hardware are used in all these
steps. This leads to the possibility of real time applications.

1.3 COORDINATE SYSTEMS AND TRANSFORMATIONS

Real coordinate systems (world coordinates, model coordinates, virtual
picture coordinates), which can be more or less freely chosen but are
usually right-handed, rectangular systems, will be assigned (in general,
differently) to the world and to the virtual picture screen. On the other
hand, a raster-oriented output device, such as a raster picture screen, has
a device coordinate system that is generally left-handed, rectangular, and
employs integers (a pixel system). The origin often lies in the upper left
corner of the screen and the x and y axes point to the right and downward,
respectively. Typical screen resolutions are 768 x 576 pixels for the PAL
television standard or 1280 x 1024 or 1600 x 1200 pixels for graphics
work stations.

We now consider a transformation between two coordinate systems
$K = (B; b_1, b_2)$ and $K' = (B'; b_1', b_2')$ in the two-dimensional case. Both
are uniquely determined by the position of the corresponding origins
B and B' and the specification of a basis (b_1, b_2) or (b_1', b_2') in \mathbb{R}^2. As an
illustration, we would like to consider an example. Let

$$B := (0,0)_K^T = \left(\frac{3}{2}, \frac{3}{4}\right)_{K'}^T, \quad B' := (0,0)_{K'}^T,$$

$$b_1 := (1,0)_K^T = \left(\frac{1}{2}, \frac{1}{8}\right)_{K'}^T, \quad b_1' := (1,0)_{K'}^T,$$

$$b_2 := (0,1)_K^T = \left(\frac{1}{4}, 1\right)_{K'}^T, \quad b_2' := (0,1)_{K'}^T.$$

Given the point $P := (2,1)_K^T$ in the K coordinates, let us find its representation in the K' coordinates (see Figure 1.10). In linear algebra, a change of coordinates of this sort is described by an affine transformation. Then

$$v' = A \cdot v + d, \tag{1.1}$$

and in the example, we have

$$A = \begin{pmatrix} \dfrac{1}{2} & \dfrac{1}{4} \\ \dfrac{1}{8} & 1 \end{pmatrix}$$

and

$$d = \left(\frac{3}{2}, \frac{3}{4}\right)^T.$$

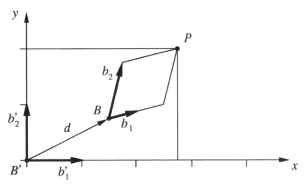

FIGURE 1.10 A coordinate transformation.

The columns of A are basis vectors b_1 and b_2 with respect to the K' system and d is the shift in the origin B' of K' to the origin B of K (in the K' system), while v represents an arbitrary point P in the K system and v' the same point in the K' system. In the example, for $v = (2,1)_K^T$ we obtain the vector $v' = (2.75, 2)_{K'}^T$.

The representation (1.1) for affine transformations often turns out to be inconvenient, as it requires explicit matrix multiplication and a vector sum. Thus, one proceeds to an extended notation in homogeneous coor-

dinates. Here a unit is added to all the vectors as an extra component. This has the advantage that in our example every point P or every basis has a unique representation $P = \beta_1 \cdot b_1 + \beta_2 \cdot b_2 + 1 \cdot B$ or $P = \beta_1' \cdot b_1' + \beta_2' \cdot b_2' + 1 \cdot B'$, which can also be represented uniquely by the triple vector $(\beta_1, \beta_2, 1)^T$ or $(\beta_1', \beta_2', 1)^T$, respectively. Then Equation (1.1) yields

$$\begin{pmatrix} v' \\ 1 \end{pmatrix} = \begin{pmatrix} A & d \\ 0 & 1 \end{pmatrix} \cdot \begin{pmatrix} v \\ 1 \end{pmatrix}. \tag{1.2}$$

In this way, affine transformations can be written simply as matrix products. Initially, this only offers a formal benefit, as we now have to consider affine spaces[3] instead of vector spaces. The exclusive appearance of matrix products, however, allows the introduction of efficient hardware based routines for performing these transformations. Note that a finite sequence of affine transformations again yields an affine transformation, e.g.,

$$v' = A_1 \cdot v + d_1,$$

$$v'' = A_2 \cdot v' + d_2$$

$$= A_2 \cdot A_1 \cdot v + (A_2 \cdot d_1 + d_2), \tag{1.3}$$

or in homogeneous coordinates,

$$\begin{pmatrix} v' \\ 1 \end{pmatrix} = \begin{pmatrix} A_1 & d_1 \\ 0 & 1 \end{pmatrix} \cdot \begin{pmatrix} v \\ 1 \end{pmatrix},$$

$$\begin{pmatrix} v'' \\ 1 \end{pmatrix} = \begin{pmatrix} A_2 & d_2 \\ 0 & 1 \end{pmatrix} \cdot \begin{pmatrix} v' \\ 1 \end{pmatrix}$$

$$= \begin{pmatrix} A_2 & d_2 \\ 0 & 1 \end{pmatrix} \cdot \begin{pmatrix} A_1 & d_1 \\ 0 & 1 \end{pmatrix} \cdot \begin{pmatrix} v \\ 1 \end{pmatrix}$$

$$= \begin{pmatrix} A_2 \cdot A_1 & A_2 \cdot d_1 + d_2 \\ 0 & 1 \end{pmatrix} \cdot \begin{pmatrix} v \\ 1 \end{pmatrix}. \tag{1.4}$$

In the following we shall consider a few standard transformations as examples of affine transformations in the two-dimensional case:

[3] An n-dimensional affine space \mathcal{A}_n is a pair (A, V_n) made up of a set A of points and an n-dimensional vector space V_n with an operation $*: A \times V_n \rightarrow A$. In this case: for all points $P_1, P_2 \in A$ there exists exactly one vector $x \in V_n$ with $P_1 * x = P_2$. Here the vector x is called the displacement vector from P_1 to P_2. In addition, we have $P * (x_1 + x_2) = (P * x_1) * x_2$ for all $P \in A$ and $x_1, x_2 \in V_n$.

- A displacement or translation (see Figure 1.11) is described by a simple vector addition. Here the matrix I is the identity matrix:

$$A = Id, \quad v' = v + d. \tag{1.5}$$

FIGURE 1.11 Translation.

- Shear (see Figure 1.12) describes the distortion of elastic bodies. As an example, shear in the x direction leaves the y coordinate of a point unchanged, but modifies its x coordinate in proportion to its y value, i.e.,

$$A = \begin{pmatrix} 1 & S_x \\ 0 & 1 \end{pmatrix}, \quad d = 0. \tag{1.6}$$

A shear in the y direction is defined analogously.

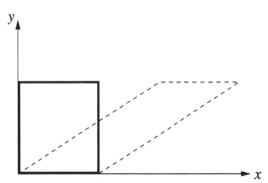

FIGURE 1.12 Shear in the x direction.

- A scaling relative to the origin involves multiplication by a diagonal matrix. Here the vector d is the zero vector,

$$A = \begin{pmatrix} a_{11} & 0 \\ 0 & a_{22} \end{pmatrix}, \quad d = 0. \tag{1.7}$$

As special cases, we consider

(i) $a_{11}=a_{22}>0$: centered zoom (undistorted magnification ($a_{11}>1$) or reduction ($a_{11}<1$), see Figure 1.13).

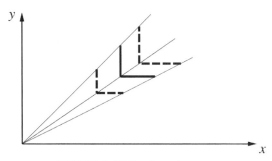

FIGURE 1.13 Centered zoom.

(ii) $a_{11}=a_{22}=-1$: Reflection about the origin (see Figure 1.14).

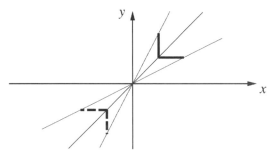

FIGURE 1.14 Reflection about the origin.

(iii) $a_{11}=1, a_{22}=-1$: Reflection about the x axis (see Figure 1.15).

FIGURE 1.15 Reflection about the x axis.

(iv) $a_{11}=-1, a_{22}=1$: Reflection about the y axis (see Figure 1.16).

FIGURE 1.16 Reflection about the *y* axis.

- For a rotation by an angle φ about the origin (see Figure 1.17) the matrix A and the vector d are given by

$$A = \begin{pmatrix} \cos\varphi & -\sin\varphi \\ \sin\varphi & \cos\varphi \end{pmatrix}, \quad d=0. \tag{1.8}$$

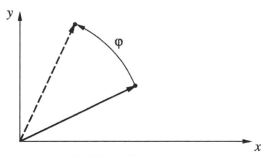

FIGURE 1.17 Rotation.

Here A is orthogonal, i.e.,

$$A^{-1}=A^{T}, \quad \det A = 1. \tag{1.9}$$

The generalization to the three-dimensional case is obvious for translations and scaling. A rotation in three-dimensional space can be described as a product of plane (two-dimensional) rotations in the *xy*, *yz*, and *yz* planes.

Complicated transformations (e.g., a rotation about an arbitrary point P or a scaling relative to an arbitrary point P) can now be constructed as sequences of simple affine transformations of this sort. Here all the transformations do not have to be carried out one after another, but the overall resulting transformation is calculated once at the start. In this way, complicated transformations of a large set of points can be performed rapidly and cheaply.

For reasons of consistency and maintenance of parallelism in affine transformations, only the principal points of the elementary objects will be transformed in the vector-oriented case, rather than the continuous lines. If one only applies translations, rotations, and distortion-free scalings with $|a_{11}| = |a_{22}|$ to these, then the object and the transformed object will always be similar because of the conformal property.

1.4 TWO-DIMENSIONAL CLIPPING

The illustrative transition to a virtual picture in Figure 1.6 requires the clipping of elementary objects if they do not show up completely in the desired picture segment. We shall be concerned with the clipping of lines in a rectangular window in this section. Of course, this only touches on the difficulties involved in clipping: surfaces (polygons) must also be clipped correctly (as with the Sutherland and Hodgman algorithm [SuHo74]; see [FDFH97], for example) and windows that are more complicated than a rectangle (e.g., arbitrary polygons) must also be processable. In the end, two-dimensional clipping is not adequate for correct reproduction of a segment of a picture for three-dimensional scenes. That requires three-dimensional clipping techniques, which we shall consider in more detail in Section 3.2.1 in connection with general questions of visualization.

Now let $P = (x_P, y_P)$ and $Q = (x_Q, y_Q)$ be two points in \mathbb{R}^2 and $[x_{\min}, x_{\max}] \times [y_{\min}, y_{\max}] \subset \mathbb{R}^2$ ($x_{\min} < x_{\max}, y_{\min} < y_{\max}$) be a rectangular window, relative to which the segment PQ is to be clipped (i.e., only the portion of this segment which lies within the rectangle is to be drawn). Four cases are then to be distinguished (see Figure 1.18):

1. P and Q lie within the rectangle;[4] the segment PQ is to be drawn entirely.
2. Just one of the points P and Q lies in the rectangle. Thus, a clipping point has to be calculated and the portion of the line segment PQ lying in the rectangle must be drawn.
3. Both points lie outside the rectangle and the segment PQ does not intersect the rectangle. In this case nothing is to be drawn.
4. Both points lie outside the rectangle and the segment PQ intersects the rectangle. Here two clipping points have to be calculated and the segment between the two clipping points is to be drawn. Note that the two clipping points can coincide at a corner.

[4] Here the term "in the rectangle" includes the boundary.

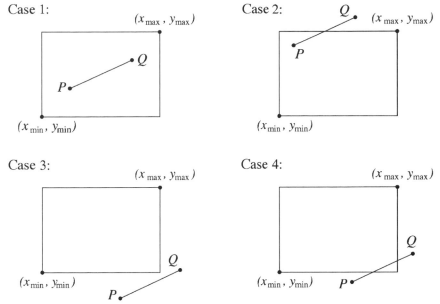

FIGURE 1.18 Four cases for clipping a line in a rectangle.

The obvious solution in the (trivial) first case is to draw the entire line and, otherwise, to search for points of intersection of the line containing P and Q with the straight lines $x = x_{min}$, $x = x_{max}$, $y = y_{min}$ and $y = y_{max}$ that lie on the edge of the rectangle and on the segment PQ. Finally, the line segment to be drawn is identified and can be output. This approach is evidently very time consuming because, especially in the third case, many clipping points have to be calculated that are irrelevant to our problem (as they do not lie on the rectangle or on PQ).

Here a remedy is supplied by the algorithm of Cohen and Sutherland (see, for instance, [FDFH97]) in which excess clipping point calculations are avoided through the use of series (inexpensive) tests. For this, nine regions are defined in \mathbb{R}^2 (see Figure 1.19). All the points are now ordered using a 4-bit code $P = (x_P, y_P)^T$, where $b_1^{(P)} b_2^{(P)} b_3^{(P)} b_4^{(P)}, b_i^{(P)} \in \{0,1\}$:

$$b_1^{(P)} = 1 : \Leftrightarrow x_P < x_{min},$$

$$b_2^{(P)} = 1 : \Leftrightarrow x_P > x_{max},$$

$$b_3^{(P)} = 1 : \Leftrightarrow y_P < y_{min},$$

$$b_4^{(P)} = 1 : \Leftrightarrow y_P > y_{max}. \tag{1.10}$$

The code is thus constant within each of the nine regions.

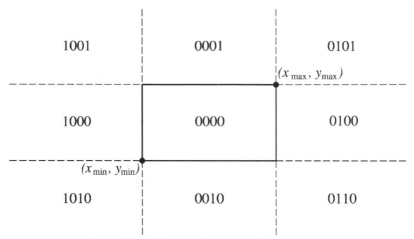

FIGURE 1.19 The 4-bit code as a function of position in the window.

It follows directly from the definition (1.10) that the segment PQ is to be drawn in its entirety if the sporadic logical OR of the code $b_1^{(P)}b_2^{(P)}b_3^{(P)}b_4^{(P)}$ for P with the code $b_1^{(Q)}b_2^{(Q)}b_3^{(Q)}b_4^{(Q)}$ for Q yields 0000. It follows further that PQ certainly lies outside the window if the sporadic logical AND for both codes does not yield 0000. In all other cases, the segment PQ lies partly within the window and partly outside it, so that clipping points must be calculated.

Suppose P lies outside the window $(b_1^{(P)}b_2^{(P)}b_3^{(P)}b_4^{(P)} \neq 0000)$. Then for every 1 in the code for P the line through P and Q must certainly be cut with one of the four lines defined by the window:

$$b_1^{(P)} = 1: \text{ cut by } x = x_{min},$$

$$b_2^{(P)} = 1: \text{ cut by } x = x_{max},$$

$$b_3^{(P)} = 1: \text{ cut by } y = y_{min},$$

$$b_4^{(P)} = 1: \text{ cut by } y = y_{max}. \tag{1.11}$$

Note that at most two 1's are possible in the code for P (see Equation (1.10) and Figure 1.20) If Q also lies outside the window $(b_1^{(Q)}b_2^{(Q)}b_3^{(Q)}b_4^{(Q)} \neq 0000)$, then the analog for Q has to be found. Altogether, we obtain the following algorithmic description for clipping a line segment PQ at the window $[x_{min}, x_{max}] \times [y_{min}, y_{max}]$:

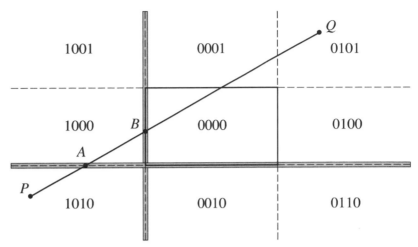

FIGURE 1.20 Calculating a clipping point using the Algorithm of Cohen and Sutherland. As $b_1^{(P)}b_2^{(P)}b_3^{(P)}b_4^{(P)} = 1010$, clipping points (associated with P) on PQ are to be calculated with $x = x_{min}$ and $y = y_{min}$. The segment from P to B is to be eliminated.

Algorithm of Cohen and Sutherland:

```
ready := FALSE;
while ¬ready:
begin
        calculate the codes b(P) and b(Q) for P and Q;
        if  b(P)∨b(Q) = 0000:
        begin
            draw the segment PQ;
            ready := TRUE;
        end
        if  b(P)∧b(Q) ≠ 0000:
        begin
            ready := TRUE;
        end
        if  ¬ready:
        begin
            choose an end point outside the rectangle (P);
            calculate the corresponding clipping point(s);
            choose a clipping point S if necessary,
            remove the segment PS and set P:=S;
        end
    end;
```

Other procedures for two-dimensional clipping can be found in Cyrus and Beck [CyBe78] and Liang and Barsky [LiBa84].

After the picture segment (the virtual picture) has been realized by clipping, the elementary objects must now be generated in device coordinates from their principal points and displayed on the output device. In the case of a screen or other raster-oriented device, this means that the vector-oriented elementary objects must be converted to pixel sets. We shall explain the techniques for doing this in the following section.

1.5 LINES AND CIRCLES ON THE SCREEN

On transforming from world or model coordinates, i.e., virtual picture coordinates, to device coordinates on a screen, the coordinates have to be rounded off, as the device coordinates must be integers. In all coordinate directions real intervals will be mapped onto integers in the course of rounding. Each pair (i,j) of integer device coordinates then draws a pixel of fixed size, which can be provided with a specified color or brightness. Obviously, a higher screen resolution (more and smaller pixels) will generally reduce the effect of rounding errors and, thereby, yield a better quality display.

Now various graphical primitives (lines, circles, etc.) have to be displayed on the screen, so a discrete pixel pattern has to be generated for each (continuous) elementary object that will provide the best possible approximation to the elementary object. Here two goals will be pursued: first, an optically satisfactory result (as good an approximation as possible by the pixel pattern) must be obtained and, second, the drawing must proceed rapidly and efficiently. Incremental techniques that rely solely on integer arithmetic and can be realized through hardware support are especially useful for this.

1.5.1 Lines

As noted above, the problem now is to create a pixel pattern that provides the best possible discrete approximation to a given line (see Figure 1.21). To do this the line is traced step by step, and the appropriately selected pixels are set in succession.

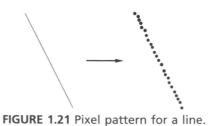

FIGURE 1.21 Pixel pattern for a line.

In choosing the pixels to be set, the previously-mentioned goal of an optically satisfying result leads to three requirements in the case of a line under consideration here: First, the resulting pixel pattern must come as close as possible to a straight line. Second, the beginning and end points of the line must be clearly defined. Third, obtaining a brightness that is as uniform as possible requires that the number of set pixels per unit length be as constant as possible. The third requirement is violated in the example of Figure 1.22.

In the following we proceed from several assumptions so as to simplify the explanation of the principle of the algorithm:

- The line goes from a starting point (x_0,y_0) to an end point (x_1,y_1) with $x_0 < x_1$. Both points lie right on a pixel.
- The width of the line amounts to one pixel.

FIGURE 1.22 Nonuniform intensity along a line.

- A pixel is either set or not set; that is, there is no distinction of intensity.
- The pixels are represented as non-overlapping circular disks surrounding the lattice point of an integer lattice (see Figure 1.23).
- The slope of the line is m, where $0 \leq m \leq 1$. This means that in every column of the pixel matrix there is exactly one pixel.

With $dx := x_1 - x_0$ and $dy := y_1 - y_0$ we then have a slope m and a y-intercept b of the line given by $m = dy/dx$ and $b = y_0 - mx_0$. In this way we get the customary equation for a line, $y(x) = mx + b$.

A) First Step:

```
procedure Line(x0,y0,x1,y1: integer);
var x: integer;
    m, b, y: real;
begin
    m := (y1 − y0)/(x1 − x0);
    b := y0 − m ∗ x0;

    for x = x0 to x1 do
    begin
        y := m ∗ x + b;
        WritePixel(x,round(y));
    end
end;
```

Here it should be noted that x is an integer, but y is, in general, real valued. The function round(y) should perform correct rounding and form the right open interval $[k-0.5, k+0.5[$ for all $k \in \mathbb{Z}$ from k onward. The procedure WritePixel(i,j) should finally set the corresponding pixel (i,j) on the screen.

This procedure is comparatively expensive, since one floating-point multiplication, one floating-point addition, and one round off operation have to be performed on each pixel.

B) Incremental Advance:

This involves a widespread principle of information technology (processing by fields, relative addressing, etc.). For the sake of clarity of the basic idea, we consider the transition from column $x_0 + i$ to column $x_0 + i + 1$:

$$y(x_0 + i + 1) = m \cdot (x_0 + i + 1) + b$$

$$= m \cdot (x_0 + i) + m + b$$

$$= y(x_0 + i) + m.$$

m must be added to the previous value of y in column $x_0 + i$. This yields the following procedure $(0 \leq m \leq 1, x_0 < x_1)$:

```
procedure IncrLine(x0,y0,x1,y1: integer);
var dx, dy, x: integer;
        m, y: real;
begin
        dx := x1 − x0;
        dy := y1 − y0;
        m := dy / dx;
        y := y0;

        for x := x0 to x1 do
        begin
            WritePixel(x,round(y));
            y := y + m;
        end
end;
```

This incremental algorithm offers an immediate improvement over the procedure described in A), in that there is no floating-point multiplication. Nevertheless, a floating-point addition and a round off operation are required at each pixel. There is also the fact that m, as a real number, cannot be represented exactly, so that errors may accumulate. A further improvement is then possible only by going to integer arithmetic.

C) Bresenham's Algorithm (Midpoint version [Bres65, Pitt67]):

The advantage of this procedure is that it avoids floating point arithmetic entirely. Only integer additions and shifts (multiplication with 2) are required, so that the algorithm is especially suited for hardware supported implementation.

The Bresenham algorithm is based on the principle that, proceeding from the current (i.e., the last set) pixel $P = (x_P, y_P)$, one chooses the one pixel from among the potential successors that lies closest to a continuous line. Under the assumptions that $0 \leq m \leq 1$ and $x_0 < x_1$, only the two pixels $E = (x_P + 1, y_P)$ and $NE = (x_P + 1, y_P + 1)$ come into question as successors (cf. Figure 1.23).

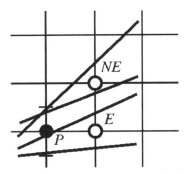

FIGURE 1.23 Possible successor pixels.

For choosing the successor pixel one now determines the midpoint $M_P = (x_P + 1, y_P + 1/2)$ between the two candidates E and NE. If M_P lies above the line to be drawn, then E is set, and if M_P lies below it, NE is the successor and is set. Should M_P lie exactly on the line, either E or NE can be set arbitrarily (cf. Figure 1.24).

The position of the point M_P relative to the line to be drawn still has to be determined. Proceeding from the equation for the line, $y = mx + b$, we then define the function $F(x, y)$ given by:

$$F(x, y) := dy \cdot x - dx \cdot y + b \cdot dx. \tag{1.12}$$

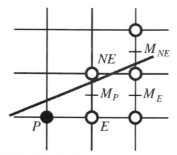

FIGURE 1.24 Continued pixel choice.

Because $m = dy/dx$, we can easily see that

$$y = mx + b \Leftrightarrow F(x,y) = 0. \tag{1.13}$$

Then, as a result of the sign of $F(x,y)$ we can determine the position of the point (x,y) relative to the line in question:

$$F(x,y) \begin{cases} =0 & : \quad (x,y)\text{lies on the line,} \\ >0 & : \quad (x,y)\text{lies below the line,} \\ <0 & : \quad (x,y)\text{lies above the line.} \end{cases} \tag{1.14}$$

With the integral decision variables D_P, where

$$D_P := 2 \cdot F(M_P)$$

$$= 2 \cdot F(x_P + 1, y_P + 1/2)$$

$$= dy \cdot (2\, x_P + 2) - dx \cdot (2\, y_P + 1) + 2\, b \cdot dx,$$

one obtains the following distinct cases:

Case 1: $D_P < 0$

(M_P lies above the line; E is the successor pixel to be set).

$$\Rightarrow \quad D_E = 2 \cdot F(M_E)$$

$$= 2 \cdot F(x_P + 2, y_P + 1/2)$$

$$= dy \cdot (2\, x_P + 4) - dx \cdot (2\, y_P + 1) + 2\, b \cdot dx$$

$$= D_P + \Delta_E$$

with $\Delta_E := 2\, dy.$

Case 2: $D_P \geqslant 0$

(M_P lies below or on the line; *NE* is the successor pixel to be set).

$$\Rightarrow \quad D_{NE} = 2 \cdot F(M_{NE})$$

$$= 2 \cdot F(x_P + 2, y_P + 3/2)$$

$$= dy \cdot (2 x_P + 4) - dx \cdot (2 y_P + 3) + 2 b \cdot dx$$

$$= D_P + \Delta_{NE}$$

with $\quad \Delta_{NE} := 2\,dy - 2\,dx.$

If M_P lies on the line, we choose (arbitrarily) *NE* as the successor pixel. As we begin at the starting pixel (x_0, y_0), D_{Start} is preset as follows:

$$D_{\text{Start}} := 2 \cdot F(x_0 + 1, y_0 + 1/2)$$

$$= dy \cdot (2 x_0 + 2) - dx \cdot (2 y_0 + 1) + 2 b \cdot dx$$

$$= 2 \cdot F(x_0, y_0) + 2\,dy - dx$$

$$= 2\,dy - dx.$$

We can also update the integral decision variable D_P, whose sign is decisive for choosing the pixel, in constant and integral increments $\Delta_E = 2\,dy$ or $\Delta_{NE} = 2\,dy - 2\,dx$. In sum, we obtain the following algorithmic description ($x_0 < x_1$):

```
procedure BresenhamLine(x0,y0,x1,y1: integer);
var dx, dy, deltaE, deltaNE, d, x, y: integer;
begin
        dx := x1 − x0;
        dy := y1 − y0;
        d := 2 * dy − dx;
   deltaE := 2 * dy;
  deltaNE := 2 * (dy − dx);
        x := x0;
        y := y0;
        WritePixel(x0,y0);

        while x < x1 do
        begin
           if d < 0 then
           begin
               d := d + deltaE;
               x := x + 1;
           end
           else
           begin
```

```
                        d := d + deltaNE;
                        x := x + 1;
                        y := y + 1;
                    end
                    WritePixel(x,y);
                end
        end;
```

Comments:

1. Under certain conditions, the asymmetry in the treatment of the case $D_P=0$ ($d=0$ in the program) can result in another pixel set on going from (x_0,y_0) to (x_1,y_1) than when the opposite sign is chosen; this should be avoided. This is to be taken into account when programming the $x_0>x_1$ variant. Sign reversal can also be a problem when the direction in which the line is drawn is changed, as can be seen in Figure 1.25.

FIGURE 1.25 Dependence of the shape of a line on the direction in which the line is drawn with changing line types.

2. If a boundary point (x_0,y_0) or (x_1,y_1) of the line to be drawn does not fall on a pixel, the start or end pixel can be established by rounding.

3. If a smallest allowable y component y_{min} (e.g., as a result of clipping; cf. Figure 1.4) occurs during drawing of a line, then it is necessary to avoid undesired side effects such that the choice of a new start pixel creates the appearance of a false slope and that all the pixels (x,y) are set with $y=y_{min}$ which were also to be set without the restriction $y=y_{min}$. For this purpose, one determines the intersection of the line $y=mx+b$ with $y=y_{min}-1/2$ and chooses the nearest pixel as a starting point (see Figure 1.26).

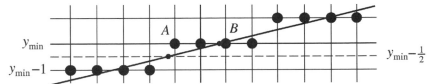

FIGURE 1.26 Pixel selection with restrictions: Without the limitation $y=y_{min}$ all the black pixels are to be set. Thus, the correct starting point with $y=y_{min}$ is A. The intersection with $y=y_{min}$, nevertheless, yields B as the starting pixel, while the intersection with $y=y_{min}-1/2$ gives, on the contrary, the desired A.

4. The preceding procedure has an undesired side effect: the brightness of the line is dependent on the slope. On a horizontal line ($m=0$), the set pixels are separated by 1, while for $m=1$ the distance is $\sqrt{2}$, which results in an impression of a different brightness. This effect can be compensated by adjusting the light- or color-intensity for the slope m (see Figure 1.27).

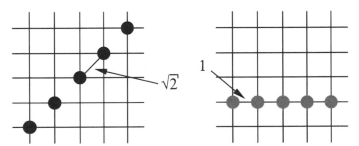

FIGURE 1.27 Slope dependent intensity as a means of obtaining uniform brightness.

5. Drawing polygonal chains or polygons requires more than a succession of individual lines. Thus, in many output devices one must avoid setting corner pixels twice. With polygons, it is often also necessary that no pixel should be set outside the polygon. When individual sides of polygons are drawn using the Bresenham algorithm, on the other hand, some pixels may be set outside the polygon.

6. Similar techniques can be used for such tasks as filling or cross-hatching polygons. The scan-line algorithms employed in those cases will be discussed in a general context in Section 3.2.5.

D) Structural Algorithms:

Since the Bresenham algorithm relies on the addition of increments to a decision variable at each set pixel, the computational cost remains linear. Thus, for a line consisting of n pixels, on the order of $O(n)$ integer operations are performed. So-called structural procedures, on the other

hand, only require a logarithmic cost. They employ the slope dependent regular structure of, say, the pixel patterns generated by the Bresenham algorithm. This class of procedures includes the algorithms of Brons [Bron74] and Pitteway and Green [PiGr82], the first of which we shall briefly introduce here as an especially efficient representative of the structural procedures. A more extensive discussion can be found elsewhere [Bron85, Stei86, Stei88, Scha93].

If the incremental advance in the Bresenham algorithm is regarded as a sequence of individual moves from one pixel to the next, then two types of movements can be distinguished: a diagonal step D (if the pixel NE is the successor pixel) and a horizontal step H (if the pixel E is the successor). Given the initial stipulations for the line $y = mx + b$, with $m = dy/dx = (y_1 - y_0)/(x_1 - x_0)$, that is to be drawn $(x_0, y_0, x_1, y_1 \in \mathbb{Z}, x_0 < x_1, 0 \leq m \leq 1)$, diagonal dy and horizontal $dx - dy$ steps do appear.

One possible way from the starting pixel (x_0, y_0) to the target point (x_1, y_1) is now to execute all the diagonal steps first and then all the horizontal steps, or vice versa (see Figure 1.28). For this we write $D^{dy}H^{dx-dy}$ or $H^{dx-dy}D^{dy}$, respectively. Since the pixel patterns or paths in Figure 1.28 are generally only poor approximations to the segment extending from (x_0, y_0) to (x_1, y_1), the starting sequence $D^{dy}H^{dx-dy}$ or $H^{dx-dy}D^{dy}$ must be suitably permutated. This is accomplished using the Brons algorithm.

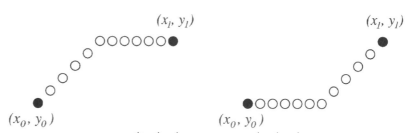

FIGURE 1.28 Sequences $D^{dy}H^{dx-dy}$ (left) and $H^{dx-dy}D^{dy}$ (right) as paths from (x_0, y_0) to (x_1, y_1).

Let arbitrary words from the strings D and H appear in the subsequent P and Q. Of a starting sequence P^pQ^q with relatively prime frequencies p and q and $1 < q < p$, an integer division with a remainder,

$$p = k \cdot q + r, \quad 0 < r < q,$$

now creates the permutated character string

$$(P^kQ)^{q-r}(P^{k+1}Q)^r,$$

for $q-r>r$, or

$$(P^{k+1}Q)^r(P^kQ)^{q-r},$$

for $r>q-r$. One proceeds recursively with this new decomposition into two partial sequences in frequency r or $q-r$ *until* $r=1$ or $q-r=1$. In this way, from the starting string $D^{dy}H^{dx-dy}$ $(dy>dx-dy)$ or $H^{dx-dy}D^{dy}$ $(dy<dx-dy)$ one obtains a sequence of permutated words of length dx with constant frequency of D and H. It can thereby be shown that the character string to the time of termination corresponds exactly to a cyclical shifting of the pixel pattern, which the Bresenham algorithm provides. Given the well known similarity of the Brons algorithm to the Euclidean algorithm for determining the greatest common divisor of two natural numbers, it is also clear that the computational effort for a line $y=mx+b$ with the above restrictions is only on the order of $O(\ln(n))$ with $n:=\max(dy,dx-dy)/\mathrm{ggT}(dx,dy)$, which represents a substantial increase in efficiency compared to $O(dx/\mathrm{ggT}(dx,dy))$ for the Bresenham algorithm.

As an illustration we consider the example of a line with a slope of 17/41, and with $dx=41$ and $dy=17$. We obtain the following character strings:

$$H^{24}D^{17} \qquad\qquad 24=1\cdot17+7$$
$$(HD)^{10}(H^2D)^7 \qquad\qquad 10=1\cdot7+3$$
$$(HDH^2D)^4((HD)^2H^2D)^3 \qquad\qquad 4=1\cdot3+1$$
$$(HDH^2D\,(HD)^2H^2D)^2((HDH^2D)^2((HD)^2H^2D))^1$$

1.5.2 Circles

Now we shall study procedures for drawing a circle on a screen. Here we consider circles whose center lies at the origin and whose radius R is a natural number:

$$x^2+y^2=R^2.$$

Without loss of generality, we shall discuss only the quarter circle in the first quadrant. The entire circle can be derived from reflections.

By analogy with our treatment of line drawing, we first consider an approximate solution.

A) First Step:

```
procedure Circle(r: integer);
var x: integer;
```

```
        y: real;
    begin
        for x = 0 to r do
        begin
            y := sqrt(r * r - x * x);
            WritePixel(x,round(y));
        end
    end;
```

The advantages of this intuitive procedure are evident. First, an integer subtraction, two integer multiplications, a floating point operation (square root), and a round off are required at each pixel. Among other things, this procedure leads to a nonuniform intensity, since x is raised by unity at each step instead of a fixed increment in φ (cf. Figure 1.29).

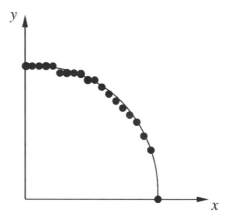

FIGURE 1.29 Nonuniform intensity for one pixel per column.

B) Bresenham Algorithm [Bres77]:

Before we turn to the incremental and integral Bresenham algorithm, we shall limit the arc to be drawn still further and consider only the region with $y \geq x$ in the first quadrant. The other half can again be obtained by reflection (see Figure 1.30). The procedure WriteCirclePixels(x,y) then sets $(x,y),(y,x)$, as well as the six corresponding pixels $(y,-x),(x,-y),(-x,-y),(-y,-x)$, $(-y,x)$ and $(-x,y)$ in the remaining three quadrants.

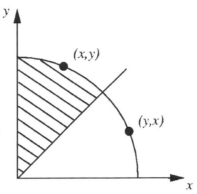

FIGURE 1.30 The circular segment considered in the Bresenham algorithm.

As before in the case of lines, at the current pixel $P = (x_P, y_P)$, the pixel which lies closer to the arc of the circle is chosen from the two potential successors $E = (x_P + 1, y_P)$ and $SE = (x_P + 1, y_P - 1)$ (see Figure 1.31). Here one again considers the position of the midpoint $M_P = (x_P + 1, y_P - 1/2)$ between the two candidates E and SE relative to the arc.

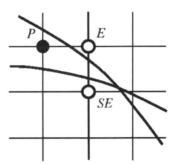

FIGURE 1.31 Possible successor pixels.

If M_P lies inside the circle to be drawn, then E is chosen, while if M_P lies outside, SE will be set as the successor. Should M_P lie exactly on the circle, then either E or SE can be chosen arbitrarily (see Figure 1.32).

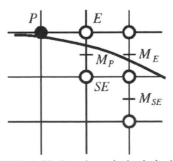

·**FIGURE 1.32** Continued pixel choice.

For determining the position of M_P relative to the circle we define, by analogy with Equation (1.12), a function $F(x,y)$:

$$F(x,y) := x^2 + y^2 - R^2. \tag{1.15}$$

Since $F(x,y)$ is obviously zero for all points on the circle, we can establish the position of the point (x,y) relative to the circle with the aid of the sign of F:

$$F(x,y) \begin{cases} =0 & : & (x,y) \text{ lies on the circle,} \\ >0 & : & (x,y) \text{ lies outside the circle,} \\ <0 & : & (x,y) \text{ lies inside the circle.} \end{cases} \tag{1.16}$$

With the initially nonintegral decision variable D_P, given by

$$D_P := F(M_P)$$

$$= F(x_P + 1, y_P - 1/2)$$

$$= (x_P + 1)^2 + (y_P - 1/2)^2 - R^2,$$

we can distinguish the following cases:

Case 1: $D_P < 0$

(M_P lies inside the circle, the successor pixel to be set is E.)

$$\Rightarrow \quad D_E = F(M_E)$$

$$= F(x_P + 2, y_P - 1/2)$$

$$= (x_P + 2)^2 + (y_P - 1/2)^2 - R^2$$

$$= D_P + \Delta_E$$

with $\Delta_E := 2 x_P + 3.$

Case 2: $D_P \geq 0$

(M_P lies outside or on the circle, the successor pixel to be set is SE.)

$$\Rightarrow \quad D_{SE} = F(M_{SE})$$

$$= F(x_P + 2, y_P - 3/2)$$

$$= (x_P + 2)^2 + (y_P - 3/2)^2 - R^2$$

$$= D_P + \Delta_{SE}$$

with $\Delta_{SE} := 2 x_P - 2 y_P + 5.$

If M_p lies on the circle, we choose (arbitrarily) *SE* as the successor pixel.

Here it should be noted that the integral increments Δ_E and Δ_{SE} for the decision variable D_p are now linear in x_p and y_p. Since the starting pixel is (0,*R*), we take

$$D_{Start} := F(1, R-1/2)$$

$$= 5/4 - R.$$

So that D_p will again be an integer quantity, as in the case of a line, we subtract 1/4 from D_{Start}. It is easily seen that the pixel choice does not change as a result. Because of the now integral starting value

$$D_{Start} := 1 - R$$

and the integral increments, D_p is always integral. In sum, we now obtain the following procedure:

```
procedure BresenhamCircle(r: integer);
var x, y, d: integer;
begin
      x := 0;
      y := r;
      d := 1 − r;
      WriteCirclePixels(x,y);

      while y > x do
      begin
            if d < 0 then
            begin
                  d := d + 2 * x + 3;
                  x := x + 1;
            end
            else
            begin
                  d := d + 2 * (x - y) + 5;
                  x := x + 1;
                  y := y - 1;
            end
            WriteCirclePixels(x,y);
      end
end;
```

As the increments Δ_E and Δ_{SE} are linear in x_p and y_p, one can calculate them incrementally in turn. Second order differences[5] can be used to obtain a further increase in efficiency, as one can operate without multiplications in this case. For this, we first recall the increments Δ_E and Δ_{NE} or Δ_E and Δ_{SE} in the case of a line or a circle, respectively:

- Straight line: $D_P \xrightarrow{\Delta_E, \Delta_{NE} \text{ constant}} D_E, D_{NE}$,

$$\Delta_E = 2\, dy, \ \Delta_{NE} = 2\, (dy - dx),$$

- Circle: $D_P \xrightarrow{\Delta_E, \Delta_{SE} \text{ linear}} D_E, D_{SE}$,

$$\Delta_E = 2\, x_P + 3, \ \Delta_{SE} = 2\, (x_P - y_P) + 5.$$

Now Δ_E and Δ_{SE} must, in turn, be brought up to date by constant increments; thus,

$$\Delta_{E,P} \xrightarrow{\text{constant increments}} \Delta_{E,E}, \Delta_{E,SE},$$

$$\Delta_{SE,P} \xrightarrow{\text{constant increments}} \Delta_{SE,E}, \Delta_{SE,SE}.$$

Depending on the sign of the integral decision variables D_p, two cases can again be distinguished:

Case 1: $D_P < 0$

(E is the successor pixel.)

$$\Rightarrow \quad \Delta_{E,E} = 2\, (x_P + 1) + 3$$
$$= \Delta_{E,P} + \mathbf{2},$$
$$\Delta_{SE,E} = 2\, (x_P + 1) - 2\, y_P + 5$$
$$= \Delta_{SE,P} + \mathbf{2}.$$

Case 2: $D_P \geqslant 0$

(SE is the successor pixel.)

$$\Rightarrow \quad \Delta_{E,SE} = 2\, (x_P + 1) + 3$$
$$= \Delta_{E,P} + \mathbf{2},$$
$$\Delta_{SE,SE} = 2\, (x_P + 1) - 2\, (y_P - 1) + 5$$
$$= \Delta_{SE,P} + \mathbf{4}.$$

[5] In the case of a straight line the function F was linear. Differences in neighboring values of this function (first order differences) thus yielded constant increments Δ_E and Δ_{NE}. For a circle, F is now quadratic, and the first order differences Δ_E and Δ_{SE} are linear. The differences of these (second order differences) yield only constant increments.

Since the starting pixel is $(0,R)$, we choose $\Delta_{E,\text{Start}}$ or $\Delta_{SE,\text{Start}}$ as the starting values for $\Delta_E = 2x_P + 3$ or $\Delta_{SE} = 2x_P - 2y_P + 5$, respectively:

$$\Delta_{E,\text{Start}} := 3,$$

$$\Delta_{SE,\text{Start}} := -2R + 5.$$

This leads to the following modified procedure:

```
procedure BresenhamCircle2(r: integer);
var x, y, d, deltaE, deltaSE: integer;
begin
      x := 0;
      y := r;
      d := 1 - r;
      deltaE := 3;
      deltaSE := −2 * r + 5;
      WriteCirclePixels(x,y);

      while y > x do
      begin
            if d < 0 then
            begin
                 d := d + deltaE;
                 deltaE := deltaE + 2;
                 deltaSE := deltaSE + 2;
                 x := x + 1;
            end
            else
            begin
                 d := d + deltaSE;
                 deltaE := deltaE + 2;
                 deltaSE := deltaSE + 4;
                 x := x + 1;
                 y := y − 1;
            end
            WriteCirclePixels(x,y);
      end
end;
```

Similarly, variants of the Bresenham algorithm can be set up for drawing ellipses, parabolas, hyperbolas [Pitt67], or cubic splines (which involve third order differences). It might be possible to gain some efficiency by calculating and storing the radially dependent pixel sequences

in advance and then, in specific cases for a given radius and center, to simply transform them for display on the screen (cf. the structural procedures in Section 1.5.1).

In this section we have discussed the Bresenham algorithm for circles in some detail, as well, to obtain deeper insight into the difficulties of rastering. In modern systems this technique no longer plays a major role for circles, etc., because lines and polygons are almost exclusively used as elementary objects for reasons of efficiency and hardware support. Thus, a circle is initially approximated by a sequence of polygons prior to the creation of a pixel set from the individual line segments.

1.5.3 Antialiasing

We have seen above, when representing elementary objects such as lines, circles, or, sometimes, polynomial splices on raster oriented output devices, pixel patterns (sets of set pixels) are created which must approximate the corresponding elementary objects as well as possible. Nevertheless, rastering can lead to so-called aliasing[6] effects. Thus, a line may show up as a stair-shaped zigzag pattern or beating of nearby curve segments (see Figure 1.33).

FIGURE 1.33 Aliasing effects in rastering.

One possible way of countering these aliasing effects (Antialiasing; see Color Plates 1–4) is, of course, to raise the resolution. But this method is very costly and does not deal with the basic problem at all. For this reason, attempts are usually made to use gray shading (see Section 1.6.1) to ensure smooth transitions and thereby minimize undesired effects. Currently, the two starting points for this task are unweighted area sampling and weighted area sampling. We shall study both methods using the drawing of a line as an example.

In the simple, unweighted case, one models the individual pixels as squares whose centers are the lattice points of the raster. The respective

[6] The concepts of aliasing and antialiasing originate from signal processing and sampling theory.

gray shades of a pixel are then specified by the fraction of its area crossed by a line with a width of one pixel (cf. Figure 1.34). In this way, significant improvements are already obtained in terms of optical effect.

FIGURE 1.34 Gray shading in unweighted area sampling.

In the weighted case, the location of the overlapping area in the pixel also plays a role: a region near the center of the pixel that is crossed counts more than an equally large crossed area at the edge of the pixel. For this, one models the individual pixels as overlapping circular disks whose centers are the lattice points of the raster. The radius is uniformly equal to the distance between two lattice points, or unity (see Figure 1.35).

FIGURE 1.35 Averaging the intensity I_P of a pixel P in Weighted Area Sampling.

For calculating the intensity I_P of a pixel P one now takes the integral of a weighting function w, for which

$$\int_{K_P} w(x,y)\, d(x,y) = 1 \tag{1.17}$$

over the portion $A_P \subseteq K_P$ of the circular disk K_P crossed by the line with area π:

$$I_P := \int_{A_P} w(x,y)\, d(x,y). \tag{1.18}$$

In the previous, unweighted case w is the constant $1/\pi$ and the fractional volume is equal to the relative fractional area,

$$\int_{A_P} \frac{1}{\pi} d(x,y) = \frac{\text{Area } (A_P)}{\pi}. \qquad (1.19)$$

In the general, weighted case w is, for example, a cone function (cf. Figure 1.36).

FIGURE 1.36 Weighting function for Weighted Area Sampling.

The algorithm of Gupta and Sproull [GuSp81], an antialiasing variant of the Bresenham algorithm of Section 1.51, is an efficient implementation of weighting. The width of the line to be drawn is again equal to unity. Here the cone function of Figure 1.36 serves as a weighting function $w(x,y)$. In this case, according to Equation (1.18) and based on the rotational symmetry of w, the intensity I_p of a pixel P depends only on the distance d from the pixel center to the central axis m of the line to be drawn. Here d can take values between 0 and 1.5 (see Figure 1.37). Instead of performing the cumbersome calculation of the integrals (1.18) in every case, the intensity values are calculated once as a function of d for 24 values of $d(d=i/16, i=0, \ldots, 23)$ and stored in a table. For the current pixel the distance d can again be calculated incrementally. Then, as the line is drawn, d will be suitably brought up to date and the corresponding intensity value read from the table.

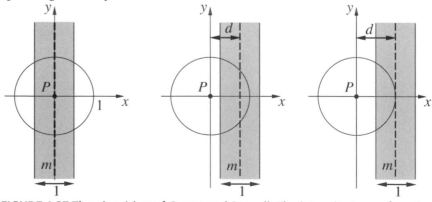

FIGURE 1.37 The algorithm of Gupta and Sproull. The intensity I_p as a function of the distance d, $0 \le d \le 1.5$: $d=0$ (left), $d=0.75$ (center), and $d=1.0$ (right).

1.6 GRAY SHADES AND COLOR REPRESENTATION

The ability to represent many different shades of gray or colors is of great significance for the creation of realistic, high quality pictures, especially in raster oriented output devices. The most important basic concepts for this topic will be presented in this section.

1.6.1 Representation of Gray Shades

In achromatic light, i.e., light without color information (e.g., black and white television), differentiation is possible only with regard to the light flux. This can be dealt with in two different ways: in one, the emitted light flux (intensity, luminance or luminosity) is measured and in the other, the light perceived by the human eye (brightness or lightness). That there is no directly proportional relationship between the measured intensity and the received brightness can be seen, for example, in the fact that a person perceives the transition from a 25 W light bulb to a 50 W light bulb as the same as that from a 50 W to a 100 W bulb. The sensitivity of the human eye is essentially related logarithmically to the energy.

This relationship must be kept in mind in a definition of gray shading. Let n be the number of desired gray shades, with $E_{min}>0$ being the smallest realizable intensity ($E_{min}=0$, i.e., complete darkness, cannot generally be attained.) and $E_{max}=1$ the maximum representable intensity. The n gray shades $E_0 < E_1 < \ldots < E_{n-1}$ will then be established as follows:

$$E_0 := E_{min},$$

$$E_i := \alpha^i \cdot E_0 \qquad (i=1,\ldots,n-1), \qquad (1.20)$$

$$\text{while} \quad E_{n-1} = E_{max}=1,$$

which immediately implies a factor α given by $\alpha = E_0^{-1/(n-1)}$ (see Figure 1.38).

FIGURE 1.38 Logarithmic gray shade function for $E_{min}=0.05$ and $n=6$.

The value of E_{min} depends on the output medium. For picture screens it lies between 0.005 and 0.025, for photographic prints or transparencies it is about 0.01 or 0.001, respectively, and for newsprint E_{min} is

quite high, at 0.1. As a person can generally only distinguish neighboring gray shades if $\alpha > 1.01$ [WySt82], the relationship $\alpha = E_{min}^{-1/(n-1)}$ yields an upper bound for the reasonable number of gray shades in different output devices of

$$n < 1 - \frac{\ln(E_{min})}{\ln(1.01)}. \tag{1.21}$$

Thus, the approximate number of gray shades that can be distinguished by humans on screens lies between 372 and 533, while the number for photographic prints is 464, that for transparencies is 695, and that for conventional newsprint is limited to 232.

Gray shading on raster screens is realized primarily by two techniques. Next, more bits have to be invested in each pixel with values according to which the pixel will be set on the screen. Thus, for example, in so-called frame buffers consisting of individual bit planes[7] one byte per pixel can represent 256 different intensity levels (see Figure 1.39 and Color Plates 5–7).

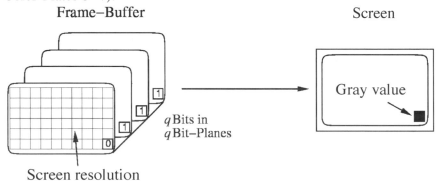

FIGURE 1.39 Realization of 2^q gray shades in q bit planes in a frame buffer.

Another approach is so-called halftoning or dithering. Here the area of a pixel is partially represented in black or white, corresponding to the desired intensity. In newspaper printing this is achieved by means of a variable radius of an individual circular area colored with ink. On a screen multiple (screen-) pixels will be used to represent one (picture-) pixel. As the eye takes an average from a large distance, one bit per device pixel (black and white display) can be used to realize different gray shades.[8] If, say, nine device pixels are used for a single picture pixel,

[7]A bit plane is a two-dimensional field of individual bits whose size corresponds to the resolution of the screen (e.g., 1280 x 1024).

[8]Dithering techniques are not restricted to black and white displays. They can also be combined with the gray scalerepresentation by bit planes to enhance the display quality.

then a so-called dither matrix can be used to represent ten gray shades (see Figure 1.40). Here the dither matrix is to be chosen so that no optical artifacts (i.e., line patterns; see Figure 1.41a) appear. Many output devices (e.g., laser printers) also require that only neighboring pixels be set. Then, steps (as in Figure 1.41b) are no longer allowed. For a discussion of the choice of dither matrices, see [Holl80], for example. The major disadvantage of dithering is that the picture resolution must be reduced if the screen resolution is not high enough to permit the use of multiple screen pixels for a single picture pixel. Here the principle of error diffusion in the algorithm of Floyd and Steinberg [FlSt75] can be of some help (see Color Plate 8).

FIGURE 1.40 A dither matrix and the associated gray shades. The corresponding set pixels are shown in white.

FIGURE 1.41 Gray scale representation of unsuitable pixel patterns. The corresponding set pixels are shown in white.

1.6.2 Color Representation

As opposed to the achromatic case, in which differentiation occurs only with respect to intensity, colored light is a superposition of electromagnetic waves of various frequencies and is generally characterized by a complicated spectrum, so it cannot be reduced just to a few parameters without loss of information. Looking back to the synthetic generation of colors, we can, however, see one possibility for describing it concisely and manageably. One can put up with a certain amount of loss; after all, human optical perception is also limited. By the beginning of the twentieth century the first color models were developed. These relied on a three-dimensional parameter space which is substantially valid today, with its three essential characteristics:

- hue,
- saturation or color purity, and
- (detected) intensity (brightness or lightness).

Wavelength, or, with light that is not purely monotonic, the dominant wavelength, is decisive for hue. The color purity or saturation parameter specifies the fraction of white or gray light: intense colors such as red or blue are highly saturated, while pastels are less so.[9] The remarks in Section 1.6.1 regarding intensity apply here, as well.

First we consider briefly the elements of the science of color. In nature, light appears as a mixture of electromagnetic waves with different wavelengths. Visible light ranges roughly from 400 nm (violet) to 700 nm (red).[10] The spectrum can be seen, for example, in rainbows or on passing white light through a prism. If the mixture is very homogeneous, as in the case of white light, then there is no dominant wavelength and the saturation is low. With monochromatic or nearly monochromatic light the dominant wavelength determines the perceived color and the saturation (color purity) is very high. Figure 1.42 shows typical spectral energy distributions in these two cases.

Different colors can also be mixed artificially. When the light from a red, a green, and a blue light source is combined, the corresponding spectral energy distributions will be combined and the light is mixed additively (see Color Plate 13).

In subtractive mixing (see Color Plate 14), which originates in painting, the colors behave differently. If one pours red, green, and blue together, the corresponding complementary color fractions will be masked out (cf. Figure 1.47) and the result is not white, but a dark brown.

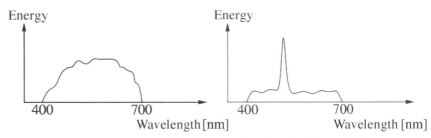

FIGURE 1.42 Spectral energy distributions for low (left) and high saturation (right).

[9] This is a crude and colloquial definition for the phenomenon of saturation in colorimetry. There one distinguishes more subtly, for example, between saturation and chroma as different measures of color purity.

[10] Different data are given in the literature for the range of visible light (300-400 nm for the lower bound and 700-800 for the upper). Here and in the following we adhere to the values from [FDFH97].

How does the human eye perceive color? This sensitivity is indeed color dependent. The current model recognizes three types of receptors in the retina (a further indication that a three-dimensional parameter space makes sense for describing colors) with peak sensitivities in different color regions. The sensitivity is lowest in the blue. The three classes of receptors are generally referred to as red, green, and blue, although the maximum sensitivity of the first actually lies in the yellow region (cf. Figure 1.43).

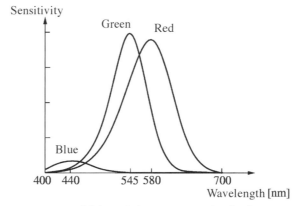

FIGURE 1.43 Sensitivity of the receptors in the human eye.

Another interesting question is how many colors can a human distinguish? At medium intensities and full saturation, roughly 128 different hues can be perceived. The selectivity of more than 10 nm at the edges of the spectrum is inferior to that in the center of the spectrum (less than 2 nm). At lower saturation, the number of distinguishable colors decreases continuously and for 0 saturation we observe only white or

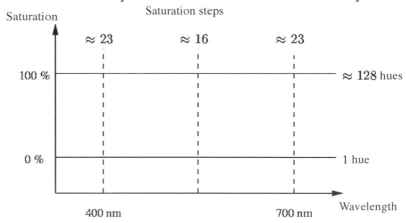

FIGURE 1.44 Distinguishable color and saturation shades at moderate intensities.

gray. On the other hand, for a given hue, between 16 (in the middle of the spectrum) and 23 (at the edge of the spectrum) distinct saturation steps can be discerned (cf. Figure 1.44). Thus, when the different intensity levels are finally taken into account, one obtains a rough estimate of about 350,000 distinct color perceptions by the human eye.

We now turn to the question of a concrete representation of colors, as on a screen. By additive mixing of the three elementary colors, red (R), green (G), and blue (B), in theory one can create every visible color F:

$$F = r \cdot R + g \cdot G + b \cdot B, \qquad r, g, b \in \mathbb{R}. \tag{1.22}$$

Only those colors for which the coefficients r, g, and b are nonnegative can be displayed on the monitor.[11] For this reason, in 1931 the Commission Internationale de l'Éclairage (CIE) defined three artificial elementary colors X, Y, and Z, such that for each visible color F,

$$F = x \cdot X + y \cdot Y + z \cdot Z, \qquad x, y, z \geqslant 0. \tag{1.23}$$

This leads to the so-called CIE cone of visible colors (see Figure 1.45 and Color Plate 12). There the coefficients x, y, and z are normalized to

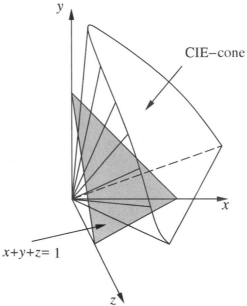

FIGURE 1.45 CIE cone with and without normalization to $x + y + z = 1$.

[11]In nature, however, colors with negative r, g, or b do exist in the RGB representation. This means that these colors cannot be created by additive mixing of the primary colors red, green, and blue. However, in the case $r < 0$ and $g, b = 0$, say, a color can be created by adding a corresponding red fraction r to the specified color through additive mixing of green and blue.

$x+y+z=1$, so they only carry information on hue and saturation, but not on intensity. The projection of the intersection of the CIE cone with the plane $x+y+z=1$ on the xy plane yields the representation of the color information shown in Figure 1.46. (The gray colored region in the interior indicates the color range that can be displayed on a typical color monitor in accordance with Equation (1.22) with $r,g,b \geqslant 0$).

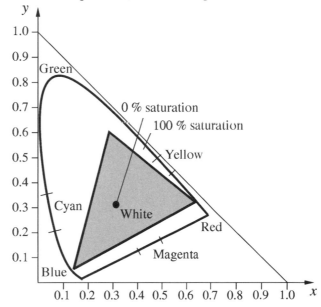

FIGURE 1.46 Projection of the intersection of the CIE cone with the plane $x+y+z=1$ on the *xy* plane. The region that can be displayed on a typical color monitor is indicated in gray.

The CIE model with its artificial (X,Y,Z) system is inconvenient for work with raster-oriented output devices such as display screens. Thus, other color models have been introduced, despite the above-mentioned disadvantage with respect to their power. Here we shall consider seven of these models: the already-mentioned RGB model, plus the CMY, CMYK, YIQ, HSV, HLS, and CNS models.

The RGB Model

Here the primary colors red, green, and blue are mixed additively. The colors are stored in the form of numerical triplets $(R,G,B)^T$ with values between 0 and 1, which specify the intensities of the red, green and blue fractions. Gray tones with $0(\alpha,\alpha,\alpha)^T$ with $\alpha \in [0,1]$: $\alpha=0$ corresponds to black and $\alpha=1$, to white. Screens operate in principle with the RGB model. Figure 1.47 and Color Plates 9 and 10 show the RGB primary colors red, green, and blue and their respective complementary colors (oppositely positioned on the cubes), cyan, magenta, and yellow.

The CYM Model

Here cyan, magenta, and yellow serve as primary colors. These are mixed subtractively. The corresponding complementary colors are also

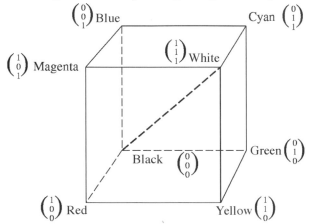

FIGURE 1.47 The RGB elementary colors and their complementary colors.

masked out. The conversion from additive to subtractive primary color mixing and vice versa is carried out using the following formula:

$$\underbrace{\begin{pmatrix} C \\ M \\ Y \end{pmatrix}}_{\substack{\text{Representation in the} \\ \text{CMY model}}} = \begin{pmatrix} 1 \\ 1 \\ 1 \end{pmatrix} - \underbrace{\begin{pmatrix} R \\ G \\ B \end{pmatrix}}_{\substack{\text{Representation in the} \\ \text{RGB model}}}$$

Pure red is described by $(1,0,0)^T$ in the RGB model and in the CMY model the vector $(0,1,1)^T$ yields pure red. Green and blue are masked out as complementary colors of magenta and yellow. Such color printers as the ink jet printer operate with the CMY model.

The CMYK Model

This model is an extension of the CMY model and uses black (K) as a fourth color. It is primarily used in four color printing [SCB88]. Proceeding from a CMY representation, the values of C, M, Y, and K will be newly defined pixel-by-pixel as follows:

$$K := \min\{C, M, Y\},$$

$$C := C - K,$$

$$M := M - K,$$

$$Y := Y - K. \tag{1.25}$$

Note that here (at least) one of the three values C, M, and Y will go to zero so ultimately the procedure involves operating, as before, with (at most) three quantities. This process (1.25), in which the black (K) occupies the same share as cyan, magenta, and yellow, is referred to as undercolor removal. In this way, first, a "darker" black is possible as it is otherwise obtained by subtractive mixing and, next, the overall required amount of ink for printing is reduced, so that costs are lowered and faster drying results.

The YIQ Model

This model is used in the American NTSC television standard [Prit77]. It is downward compatible with black and white television, since the Y signal (the Y primary color of the CIE system) describes the intensity and, thereby, can be output to black and white screens. The color information is coded in the I and Q signals. The transformation from RGB to YIQ display is by the linear mapping

$$\begin{pmatrix} Y \\ I \\ Q \end{pmatrix} = \begin{pmatrix} 0.299 & 0.587 & 0.114 \\ 0.596 & -0.275 & -0.321 \\ 0.212 & -0.528 & 0.311 \end{pmatrix} \cdot \begin{pmatrix} R \\ G \\ B \end{pmatrix}. \tag{1.26}$$

The YIQ model has yet another advantage. It makes it possible to represent the brightness information in Y with higher resolution and to transfer color information in I and Q, which takes into account the fact that human visual capacity is significantly more sensitive to brightness than to color variation.

The HSV Model

Here the colors are described by the three parameters hue, saturation, and value (brightness/intensity) [Smit78]. The HSV color space is a pyramid with a regular hexagon as its base plane and unit height. The vertex corresponds to the color black and a cross section parallel to the base at a distance α from the vertex ($0 < \alpha \leq 1$) emerges, since from the partial cube $[0,\alpha]^3$ of the RGB cube (Figure 1.47) the three surfaces which do not contain the black corner $(0,0,0)^T$ are projected onto the plane through the point $(\alpha, \alpha, \alpha)^T$ orthogonally to the diagonals between the black and white corners (see Figure 1.48 and Color Plate 11). Obviously the intensity will be given by the height and the hue by the angle. The saturation takes its maximum value of 1 at the outer edges of each hexagonal surface (horizontal intersection through the HSV pyramid) and, therefore, on the side surfaces of the HSV pyramid. It is constant on lines parallel to the outer edges. The saturation can be characterized approximately by the relative distance to the central axis.

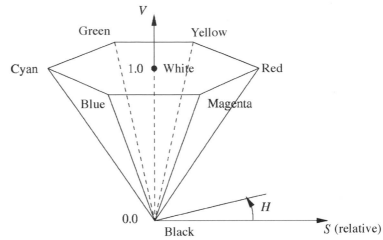

FIGURE 1.48 The HSV model (with approximate characterization of the saturation via the relative distance from the central axis: the saturation takes its maximum value of 1 on the side surfaces of the pyramid).

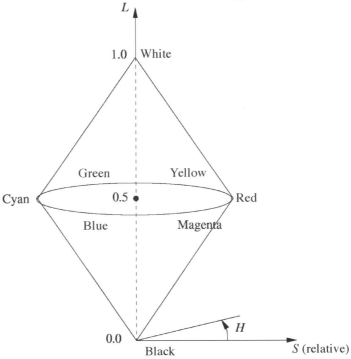

FIGURE 1.49 The HLS model (representation of saturation through the relative distance from the central axis: on the lateral surface of the double cone S takes on its maximum value 1).

The HLS Model

The HLS model developed by Tektronix is very similar to the HSV model. As with the latter, the pertinent color space is obtained by a nonlinear transformation of the RGB color space, and the three param-

eters hue, lightness (brightness/intensity), and saturation are used. The HLS color space is, however, most often represented as a double cone with a black ($L=0.0$) and a white vertex ($L=1.0$), at which no differentiation with respect to the parameters H and S is possible (see Figure 1.49). Whereas the parameters H and L essentially correspond to their HSV counterparts H and V (representation via the vertical coordinates or the angle), the HSV and HLS models differ in the saturation concept that is employed. Indeed, here, also, the saturation takes its minimum 0 on the central axis and its maximum 1 on the outer surface. A color with a white fraction (min(R,G,B)>0) is, however, not always fully saturated in the HSV model. In the HLS model, on the other hand, the lateral area of the upper cone contains colors with $S=1$ and min(R,G,B)>0. We would like to end the discussion at this point with this comment.

The last two models, HSV and HLS, are user oriented, as they are the most natural for people. The color display can be changed intuitively, simply, and quickly by modifying the parameters. For this reason, these models are used in color editors. The first four models, RGB, CMY, CMYK, and YIQ, on the other hand, are oriented to special requirements of output devices and are poorly suited for interactive work. The so-called CNS model (Color Naming System [BBK82]) is a further step in the direction of user friendliness beyond the HSV and HLS models.

The CNS Model

Here hue, saturation, and brightness are also used as basic parameters and the user can, however, describe the desired color in English. This can be done using five intensity values (very dark, dark, medium, light, very light), four saturation values (grayish, moderate, strong, vivid), and seven color shades (purple, red, orange, brown, yellow, green, blue), which can each be subdivided into four (for example, between yellow and green: yellowish-green, green-yellow, and greenish-yellow). With the CNS model colors can be very accurately selected by the user; only 560 different combinations are available, however.

Once a color model has been decided upon, the corresponding color information must be stored suitably. In practice, a color display with arbitrary precision is neither possible nor necessary, since people only can distinguish a limited number of colors, while the available speed and memory of the computer are decisive. A display with 8 bits for each primary color, as might be installed, for example, in a 24-bit graphics system, permits the simultaneous display of about 16.78 million colors. For a screen resolution of 1280 x 1024 pixels, this results in a memory requirement of almost 4 MB per picture. In view of the already

mentioned circumstance that people can distinguish only about 350,000 colors and given the fact that more than 16 million colors cannot possibly be displayed simultaneously on the 1.3 million pixels in the picture, this memory demand seems excessive. Furthermore, such direct color coding is inflexible, since individual colors cannot be changed rapidly or without modification of the picture data. For this reason, the following procedure is often chosen: instead of $3r$ bits ($r=8$ in the above example), only q bits ($q<3r$) will be assigned to each pixel in the frame buffer and the number of bit planes will also be reduced. In that way, 2^q different entries can be addressed in the so-called color plates. The full 24-bit coding remains there for each of the 2^q colors and can be used for the color selection on the screen (see Figure 1.50).

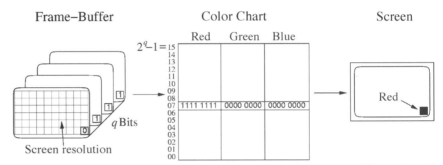

FIGURE 1.50 Color representation on a screen with frame buffer and color plate.

Consequently, only 2^q instead of 2^{3r} colors can be displayed simultaneously. The spectrum of the colors that can ultimately be displayed, nevertheless, remains the same. The required memory falls from $3r$ times the number of pixels to q times the number of pixels. In this way, a compromise has been made between the required computing power or computing time and the memory requirements.

The procedure described above also turns out to be extremely flexible. Thus, a color change can be realized simply through a change in the corresponding entry in the color plate. Should the number of potentially representable colors be raised (along with the parameter r), this will only require some changes in the color plate (the number of entries must be appropriate).

There are, of course, often problems with the color plate in practice. Thus, for example, a single change in the color plate modifies all the pixels of the pertinent color on the screen. This can lead to undesired side effects, especially, in window systems with different applications in different windows. Otherwise, and also for the sake of a realistic display, 24-bit graphics systems are preferred in practice, despite the higher cost.

2

GEOMETRICAL MODELING OF THREE-DIMENSIONAL OBJECTS

Geometrical modeling [BaRi74, BEH79, Mort85, Fari87, Mänt88, AbMü91, Hage91] (CAGD: Computer Aided Geometric Design) is an aspect of computer aided design (CAD) that deals with the theory, techniques, and systems for computer supported description and representation of three-dimensional objects. It permits (at least in principle) or creates the foundations for

- calculating the geometric properties of bodies (volume, surface area, etc.);
- graphical representation of bodies;
- extensive graphical applications (reflection, shading, etc.); and
- calculating the physical and geometrical content of the bodies after further attribution of physical properties or material parameters (masses, etc.) to the bodies. Examples include the engineering applications mentioned in the Preface, such as calculations of elasticity, strength, or resonances by means of finite element programs.

The path from a given object to its representation on the screen is made up of several operational steps (cf. Figure 2.1). As the last step will be discussed in Chapter 3, here we shall be concerned with the modeling of geometrical bodies and their representation in a computer. Three questions arise in this regard:

- What, in fact, is a body?
- How is it to be represented (mathematically)?
- How is it to be realized (on a computer)?

Here we shall limit ourselves to rigid bodies [Requ77, Requ80b], which, in particular, are translationally and rotationally invariant and, therefore, represent real three-dimensional structures and exhibit neither isolated points nor isolated or dangling edges or surfaces (cf. Figure 2.2). We have a long way to go for a mathematical description of rigid bodies. For detailed discussions of geometrical modeling, we refer to the reviews mentioned in the Introduction, as well as to [Requ77, ReTi78, Requ80a, Grie84, Requ88, Mänt89, HoRo95].

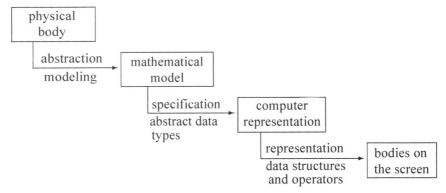

FIGURE 2.1 From a physical body to a picture on the screen.

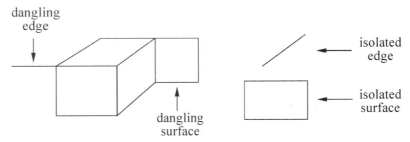

FIGURE 2.2 Dangling and isolated one- and two-dimensional structures.

2.1 MATHEMATICAL MODELS FOR RIGID BODIES

First we introduce the required concepts from topology. Let $X \subseteq \Omega$ be a set of points in the region $\Omega \subseteq \mathbb{R}^3$.

- x is a boundary point of X precisely when every neighborhood of x contains points from X and from $\Omega \setminus X$. In addition, $x \notin X$ is also possible.
- $x \in X$ is an interior point of X precisely when there is a neighborhood U of x with $U \subseteq X$.
- The boundary of X is defined as $\delta X := \{x \in \Omega : x$ is a boundary point of $X\}$.
- The interior of X is defined as $\overset{\circ}{X} := X \setminus \delta X$.
- X is referred to as open precisely when $\overset{\circ}{X} = X$.
- The closure of X is defined as $\bar{X} := X \cup \delta X$.
- X is referred to as closed precisely when $\bar{X} = X$.
- The regularization of X is taken to mean the set $\mathrm{reg}(X) := \overline{\overset{\circ}{X}}$.
- X is referred to as regular precisely when $\mathrm{reg}(X) = X$.

Figure 2.3 illustrates the above definitions through an example. Here it is clear that one can get rid of isolated points or dangling edges and surfaces using the regularization of a set X.

$$X \qquad \delta X \qquad \overset{\circ}{X} \qquad \overline{X} \qquad \mathrm{reg}(X)$$

FIGURE 2.3 An example of a boundary, interior, closure, and regularization.

The operations with sets include the well known set operations union (\cup), intersection (\cap), and difference (\backslash). In order to avoid isolated points and isolated or dangling edges and surfaces, we proceed to the so-called regularized set operations op* [Requ77], where op $\in \{\cup, \cap, \backslash\}$:

$$X_1 \ \mathrm{op}^* \ X_2 := \mathrm{reg}(X_1 \ \mathrm{op} \ X_2).$$

One can then regard rigid bodies as simple, bounded, regular sets. However, the following difficulties now arise:

1. A finite description of such sets is not unconditionally ensured. This is, however, necessary for representation in a computer.

2. The surface of the body must unambiguously define what is inside and what is outside. This, however, is not guaranteed. For this reason, one proceeds a step further and considers semianalytic sets:

- X is semianalytic precisely when X is formed by a finite combination of sets $F_i := \{x \in \mathbb{R}^3 : f_i(x) \geqslant 0, f_i \text{ analytic}^1\}$ with the aid of the regularized set operations \cup^*, \cap^* or \backslash^*.

In the following we also take rigid bodies to be bounded, regular, and semianalytic subsets of \mathbb{R}^3. Note that this definition also includes, say, the two bodies in Figure 2.4.

[1] A function $f : \mathbb{R}^3 \to \mathrm{BR}$ is analytic if for every $x_0 \in \mathbb{R}^3$ there is a neighborhood $U(x_0)$ in which f can be expanded in a convergent power series. An analytic function f is, in particular, differentiable to arbitrary order in all its variables.

Edges with nonmanifold surroundings

FIGURE 2.4 Limiting cases of rigid bodies.

2.2 REPRESENTATIONS OF A BODY

A representational scheme S refers to a relation $S \subseteq M \times R$ where M is the mathematical model space for the rigid body and R is the corresponding representational space (syntactically correct symbol structures (terms) by a finite alphabet [Requ80a]), for example, the set of all objects that can be represented by building blocks. The abstract concept of a rigid body will accordingly be brought to life by the representational scheme.

In choosing a suitable representational scheme, in general different goals will be pursued [Requ80a, Requ80b]:

- S must be a (partial) mapping, i.e.,

$$(m, r_1), \; (m, r_2) \in S \quad \Rightarrow \quad r_1 = r_2. \tag{2.1}$$

No body can be described by two different representations.

- S must be as powerful as possible, so as to permit many representations. In the ideal case,

$$\forall m \in M \quad \exists r \in R \quad \text{with } (m, r) \in S. \tag{2.2}$$

- The image must be unique: no representative should describe two bodies.

$$(m_1, r), \; (m_2, r) \in S \quad \Rightarrow \quad m_1 = m_2. \tag{2.3}$$

- All R must form the set of values of S as an image. Every representative $r \in R$, therefore, must describe a body $m \in M$:

$$\forall r \in R \quad \exists m \in M \quad \text{with } (m, r) \in S. \tag{2.4}$$

- S must be exact, i.e., permit representation without approximation.

- The description of the representatives must be as compact as possible.
- The introduction of efficient algorithms for different applications (computations, manipulations, graphical representations) must be possible and be supported.

In the following we introduce some of the most widespread representational schemes. These are subdivided into direct representations, which describe the volume itself, and indirect representations, in which the description is in terms of edges and surfaces.

2.2.1 Direct Representational Schemes: Volume Modeling

A) Standard Cell Enumeration Scheme:

Here the space is divided into a lattice of equally sized three-dimensional cells (voxels), which are usually cubes with edges of length h. A body is then represented by a set of cells (see Figure 2.5 and Color Plate 17), where each cell is represented by the coordinates of its center. Whether the center of the cell lies in the body is of prime importance. For a specified size of the standard cells, the representative for a given body is thus specified uniquely. This leads to a bit matrix or a list of cells as a data structure. The attainable accuracy is, therefore, dependent on the chosen cell mesh size h. The finer the mesh size is, the better approximation of a given body will be. As the mesh size h approaches zero, the entire mathematical model space M will be exhausted; that is, this description scheme is theoretically very powerful. Of course, it is also rather expensive in terms of memory requirements. In particular, for small h it leads to a large bit matrix, a disadvantage that can be overcome in part by using run length coding[2] and similar methods for compressed (long term) storage of thinly occupied bit matrices.

[2] Run length coding stores bit vectors (and, thereby, in particular, the rows of a bit matrix) as series of pairs (value, length) or (position, length). In the first case, the corresponding number of zeros and ones following each other is stored; in the second, only the lengths and the position of the unit sequences are retained.

FIGURE 2.5 Modeling a body with standard cells.

B) Cell Decomposition Scheme:

Here the body is built up of certain (possibly parametrized) elementary objects. The elementary objects are assembled into complicated structures through repeated "sticking operations" (combinations), as during play with building blocks (see Color Plates 15 and 16). Besides squared or flat bordered elementary objects, elementary objects with curved edges or surfaces can also be used. A large variety of choices for the elementary objects is equivalent to a generalization of A). Note, however, that here S is not, in general, an image: under certain conditions multiple representations of a given body can exist (see Figure 2.6).

Solid body Primitives Representatives

FIGURE 2.6 Multiple representations with a cell decomposition scheme.

C) Octal Tree Scheme (Octrees):

The hierarchical and recursive octal tree scheme (see, for example, [Same84]) is as powerful as the enumeration scheme, but avoids the enormous memory requirements of the latter. Its two-dimensional analog is the quad tree scheme.

First, a sufficiently large cube that encompasses the body is chosen. This cube is subdivided recursively into cubic segments with half the edge lengths until either a given cube lies entirely inside or outside the body to be represented or a prespecified accuracy h for the finest scale edge length has been attained. The test of whether a given cube lies

within (in) or outside (off) the body to be described or intersects its boundary (on) is decisive and operationally efficient. Figure 2.7 illustrates this procedure for a two-dimensional example. A tree structure with four-fold or eight-fold branching (quadtree, octree) is used as a data structure in the two and three-dimensional cases (cf. Figure 2.8).

FIGURE 2.7 Modeling an object with a curved boundary using quadtrees.

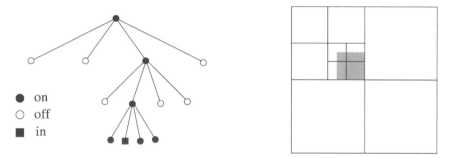

FIGURE 2.8 Tree structure for a quadtree of depth 3.

After termination all leaves with "in," "off," or "on" are labeled. A precision $h = O(2-t)$ can be attained with a tree of depth t. For example, a resolution of 1 mm for a volume of 1 m^3 would require a tree of depth $t = 10$.

For long term memory the tree can be linearized using standard depth-first or breadth-first techniques. Here the coordinates of the origin of the initial cube and the highest precision h are also stored.

With regard to the required working memory, the hierarchical approach via octal trees is about an order of magnitude more efficient than the simple standard cell enumeration scheme. In the case of "good" boundaries for the surfaces or bodies[3] as in Figure 2.7, a resolution of order $O(h)$ will require only $O(h^{-1})$ vertices instead of $O(h^{-2})$ cells in the two-dimensional case, and only $O(h^{-2})$ vertices instead of $O(h^{-3})$ cells in the three-dimensional case. The required working memory size is, therefore, determined by the boundary (2D) or outer surface (3D) of the body to be represented. Compression techniques can be used for long term storage in either case.

The octal tree scheme assigns a unique representative to each body. Furthermore, it is cheaper than the standard cell enumeration and can be employed efficiently in graphics as well as in many computational algorithms, for example, for calculating volumes or centers of gravity.

D) CSG Scheme (Constructive Solid Geometry):

This scheme is strongly inspired by structure and is, therefore, easily controlled interactively. Here a body is represented as the result of successive regularized set operations \cap^*, \cup^* and \setminus^* on specified primitives (see Color Plates 18–23). The construction process is described by a binary tree with primitives at the leaves and operators in the inner nodes (see Figure 2.9: This is the analog of the Kantorovich-Tree formalism of information theory). Half spaces are permitted as primitives, so that rigid bodies in accordance with Section 2.2.1 are not necessary in the course of a construction process. Boundedness and closure must then be ensured separately. In general, the required calculations (profile, etc.) must be guaranteed to be fast and efficient.

[3] For rapidly oscillating boundaries or fractal structures, which will be discussed in Section 4.4.1, these considerations do not necessarily apply.

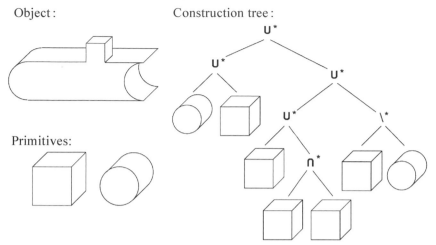

FIGURE 2.9 A construction tree in the CSG scheme.

One possible extension is to permit affine transformations (rotations, translations, etc; cf. Section 1.3) after each regular set operation.

The construction principle in a CSG scheme can also be described by a grammar. Its vocabulary the corresponds precisely to the representation space:

$$
\begin{aligned}
<\text{object}> \quad ::= \quad &<\text{primitive}>|<\text{object}><\text{transformation}>\\
&|<\text{object}><\text{operation}><\text{object}>\\
<\text{transformation}> \quad ::= \quad &\text{translation} \mid \text{rotation} \mid \text{scaling}\\
<\text{operation}> \quad ::= \quad &\cup^* \mid \cap^* \mid \backslash^*\\
<\text{primitive}> \quad ::= \quad &\text{cube}|\text{cylinder}|\text{sphere}|\text{half space}| \ldots
\end{aligned}
$$

Because of commutativity and associativity, in general, multiple construction trees yield a construction process with the same result. Uniqueness can be achieved through a transition to disjunctive normal forms[4] by means of the operators \cap^*, \cup^*, and $-^*$ (complement) and by introducing rules that further limit the construction process.

[4] Every formula made up of the operators \cap^*, \cup^*, and \backslash^*, along with the operands A_1, \ldots, A_n can be brought into its (uniquely determined) so-called disjunctive normal form of the form $\cup^{*k}_{j=1}(B_1 \cap^* B_2 \cap^* \ldots \cap^* B_n)$ with $B_i \in \{A_i, \overline{A_i}\}, i = 1, \ldots, n$. Details can be found in the standard literature on mathematical logic or boolean algebra.

E) Special-Case Primitives:

For special applications in which the same (in certain cases, compli-cated) objects are encountered, it may make sense to abandon entirely the (regular) set operations as elementary functions and instead treat the encountered objects as (parametrizable) primitives. This makes modeling substantially simpler. For example, only a few parameters are necessary to describe cogwheels of a particular class, while much greater effort would be required to assemble them from "real" primitives (rectangles, etc.).

F) Displacement Geometry Scheme:

Here a body is described by moving a specified two-dimensional object (a surface) along a displacement line or, in general, along a displacement curve and the inscribed region is treated as a volume. The pair (F, L), where F is the surface to be moved and L is the displacement curve, serves as a description. In this way, for example, solids (surfaces) of translation (see Figure 2.10) and solids of revolution (see Figure 2.11). are produced. This procedure is used in machine tool control, as well as in most CAD programs.

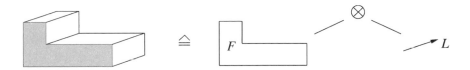

FIGURE 2.10 Displacement geometry scheme: a displacement along a line generates a solid (surface) of translation.

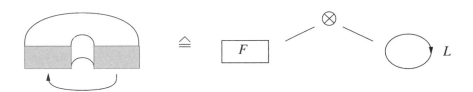

FIGURE 2.11 Displacement geometry scheme: a rotation about an axis gener-ates a solid of revolution.

G) Interpolation Scheme:

In this scheme the starting point is two surfaces F_1 and F_2 in three-dimensional space. The resulting solid K is then defined as the set of

points which lie on a line (see Figure 2.12) or on a generalized curve between two arbitrary points P_1 on F_1 and P_2 on F_2:

$$K := \{x \in \mathbb{R}^3 : \exists P_1 \in F_1, P_2 \in F_2, t \in [0,1] : x = tP_1 + (1-t)P_2\}. \qquad (2.5)$$

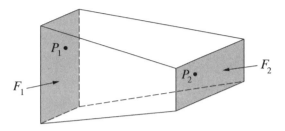

FIGURE 2.12 Representation of three-dimensional bodies by area interpolation.

Schemes such as the last two described above are often also referred to as $2\frac{1}{2}D$ models, since the volume models are derived from two-dimensional structures (construction drawings).

2.2.2 Indirect Representation: Edge and (Outer) Surface Modeling

In indirect representation schemes, the volume is not modeled directly. Rather, the basis of the model is edges in wire model schemes or outer surfaces in (outer) surface models.

A) Wire Model Scheme:

Here a solid body is defined through its (possibly curved) edges (hence the name wire model or wire frame; see Color Plates 1–4, 24, and 26–29). This line-oriented procedure has come into widespread use as it leads to very efficient realizations. Accordingly, many commercial 3D systems in the engineering world are based on the wire model scheme, especially in connection with the representation of surfaces.

Certainly, this scheme is subject to ambiguity. There are examples in which many elements of the mathematical modeling space M will be imaged onto the same representatives from R (cf. Figure 2.13). In such cases, the question arises of which one is the body to be described. Consequently, the unambiguous elimination of hidden lines is likewise as difficult, as say, the calculation of points, lines, or surfaces of interaction with other bodies. This means, however, that, alone, this scheme is only of limited suitability for CAGD and its applications.

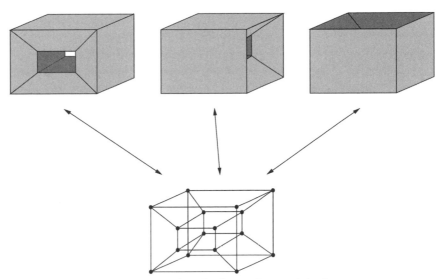

FIGURE 2.13 Ambiguity in a wire model scheme.

B) Surface Representation:

Like the wire model scheme, this representation scheme originates from vector oriented graphics. Here the representation of a body is the indirect result of a description of its surface. The latter is subdivided into a finite set of partial surfaces (bounded by the edges). For this, in turn, a representational form must be found. In the simple planar case, the partial surfaces are described in terms of the edges and points (in the special case of triangular surfaces, three points are necessary) which form their boundaries. This also involves a multilayered and hierarchical procedure, for representations for the partial surfaces, edges, and points must be found as a part of the overall representation. An example of the resolution of the surface of a body into partial surfaces can be seen in Figure 2.14.

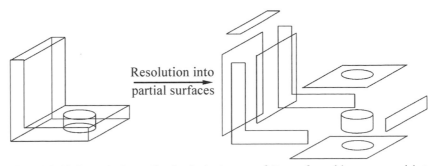

FIGURE 2.14 Description of a body in terms of its surface (decomposed into partial surfaces).

The advantages compared to, say, the CSG procedure are:

- Surfaces, edges, and points are specified explicitly; that is, the procedure supports the drawing of lines and the creation of pictures.
- Local modifications of the surfaces are easily carried out.
- It is easier to integrate the technique of free form curves or free form surfaces (B-splines and B-spline surfaces, Bézier curves and surfaces, NURBS; see Section 2.4 or [Fari90, Fari94]) than, for example, in the CSG model [ReVo82].
- The representation is unique (i.e., S is an image) if the partial surface representation is unique, but it is not, in general, one-to-one.
- One attains very great display power in combination with the free form surfaces, but the power is similar to that in the wire model without free form surfaces.

The disadvantages of this procedure are:

- Extensive and complicated data structures are necessary.
- Not every collection of surfaces fits to a solid body; fixed validity conditions have to be met.
- Certain classes of bodies are difficult to represent. For example, objects that are hollow or are not connected can be described, but they cannot be distinguished easily from one another, as it is difficult to establish whether a boundary is an "inner" boundary (hollow bodies) or a more distant "outer" boundary (objects that are not connected) (cf. Figure 2.15) [BEH79, Mänt81].

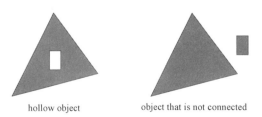

<div align="center">

hollow object object that is not connected

</div>

FIGURE 2.15 Illustrating the difficulty of distinguishing objects that are hollow and objects that are not connected without additional geometrical information.

In order to be able to decide whether a given surface representation can be used to represent a rigid body in the sense of Section 2.1, we require some validity conditions. For this we shall study three possible properties of surfaces or outer surfaces:[5] closure, orientability, and the existence of points at which the outer surface intersects itself. This leads to the following three sufficient conditions:

I) The outer surface of a body must be closed. This excludes breaks in the edges or actual holes in the partial surfaces, but not holes through a body as in a torus. Closure is thereby ensured, for example, in the two-dimensional case of boundary representation by edges and points, if every edge has exactly two boundary points and belongs to the boundary of precisely two surfaces. Closure has the additional effect that the boundary of every surface has exactly as many edges as corner points and that an equal number of surfaces and edges belongs to each point.

II) The outer surface of a body must be orientable. (An orientable surface has two distinct sides.) A Möbius strip, for example, is not orientable (cf. Figure 2.16).

FIGURE 2.16 A Möbius strip.

Closure is not a sufficient condition for orientability of a surface. Certain surfaces, such as the Klein bottle (cf. Figure 2.17) are closed, but not orientable. The question of the orientability of a closed surface can be answered using the following procedure of Möbius. For this purpose, one considers the orientation of the edges.

[5]Although a surface is an outer surface, as such, only through the property that it, say, bounds a solid body, we refer to every surface represented in this scheme as an outer surface or face, based on the concept of outer surface representation.

FIGURE 2.17 Front (left) and cross sectional (right) views of a Klein bottle.

Test for Orientability:

Let $\{e_1, \ldots, e_n\}$ be the set of all edges of the outer surface.

1. Orient the bordering edges on each part of the surface counter-clockwise.

2. The following holds for all edges $e_i \in \{e_1, \ldots, e_n\}$: if the orientations of the edges of the two parts of the surface bordering e_i are opposite, then the edge e_i is eliminated from the set $\{e_1, \ldots, e_n\}$ (cf. Figure 2.18).

FIGURE 2.18 Edge orientation in the Möbius procedure: the edge in the center is eliminated.

3. If the set of edges is empty in the end, then the given surface is orientable, otherwise not.

Closure and orientability, however, are not always sufficient for the unique specification of a body by a given outer surface. Thus, we consider yet a third property of outer surfaces:

III) The outer surface of a body cannot intersect itself. If the outer surface is again described with the aid of surfaces, edges, and points, this means that:

- Every individual partial surface cannot intersect itself.
- Partial surfaces cannot intersect one another two-by-two at their inner boundary, but only at the border. Thereby, an edge can never intersect a surface in the interior. In addition, a corner point can never lie on the inside of a surface.
- An edge cannot intersect itself. Hence, a (edge) point can never lie in the interior of an edge.
- Edges cannot intersect one another two-by-two in their interior.

With this third condition we can now provide a sufficient criterion: a surface that is closed and orientable and does not intersect itself forms the boundary of a rigid body in the sense of Section 2.1 and thereby divides space into two disjunctive regions, one of which is finite (just the interior of the body). It can be shown that this also holds for surfaces which satisfy conditions I) and II): surfaces that are closed and do not intersect themselves are orientable.[6]

If the outer surface consists of two or more partial surfaces that are closed, but not attached to one another, it is no longer connected. The outer surface of a hollow body, for example, has the property that it consists of an outer and an inner partial surface. Here, again, the difficulty of visualizing hollow and unconnected bodies in the outer surface representation without additional geometric information becomes apparent (cf. Figure 2.15).

2.2.3 Hybrid Schemes

Depending on the application, the different representation schemes have various advantages and disadvantages. Thus, multiple schemes are often used in modeling systems and individual objects are transformed when necessary from one type of representation to another. One possible hybrid scheme is illustrated in Figure 2.19.

[6] With the aid of the classification condition for closed surfaces and the fact that the projective plane does not allow itself to be embedded in \mathbb{R}^3, it can be shown that every closed plane which can be embedded in \mathbb{R}^3 is also orientable.

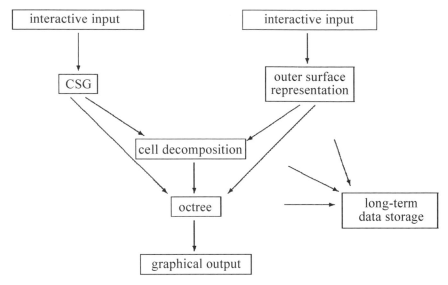

FIGURE 2.19 An example of a hybrid scheme.

Naturally, because of the different powers of the schemes, both validity and consistency problems will arise in a hybrid scheme. In addition, when data are converted to a less powerful scheme, there is a loss of information. Furthermore, the change from one type of representation to another is not equally good or simple for all of the schemes.

It is, therefore, important for long-term data storage, as well as for the exchange of geometrical data between various modeling systems,[7] that a data exchange format be found which is as neutral as possible (the demand for standards). It is this, however, which creates the most problems in practice.

2.3 TOPOLOGICAL STRUCTURE OF BODIES IN THE OUTER SURFACE REPRESENTATION

The outer surface representation of a body contains topological information[8] (neighborhood relationships among points, edges, and surfaces) and

[7]One example of a modeling system is the CATIA (Computer Aided Three-dimensional Interactive Applications, Dassault Systems, 1982) CAD-system which is used especially in the manufacture of automobiles.

[8]The (combinatoric) topology concept being used here is not to be confused with the classical concept of Section 2.1. Topology now describes the relational net of points, edges, and surfaces, as opposed to geometry, which deals with their position and extent or form in space. Thus, for example, a tetrahedron and cube are not topologically equivalent—although in the classical sense (existence of a homeomorphism) they would be.

geometrical information (form of surface segments, position of points, straight or curved connection of neighboring points) [Baum74, BEH79]. Topology is, therefore, more fundamental as geometry, since two bodies with the same topological information, i.e., the same relational net of points, edges, and surfaces, bear different geometrical information, and, therefore, can have different forms (see Figure 2.20).

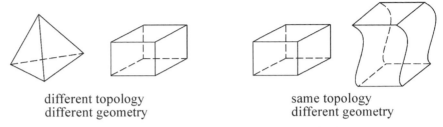

different topology
different geometry

same topology
different geometry

FIGURE 2.20 Topology and geometry of bodies.

We shall limit ourselves to polyhedra for the description of the topological structure of bodies. Geometrically complicated shapes with the same topology can then be realized by appropriate geometrical attribution (see Section 2.4).

2.3.1 *vef* Graphs

The topological structure is now described with the aid of so-called vef graphs $G := (V, E, F; R)$. Here $V := \{v_1, \ldots, v_{n_V}\}$ denotes the set of (corner) points or vertices, $E := \{e_1, \ldots, e_{n_E}\}$, the set of edges, and $F := \{f_1, \ldots, f_{n_F}\}$ the set of faces (facets). Vertices in G are the elements from V, E, or F. The edges in the graphs are established through an appropriate adjacency relation R. Some possible relations include the following:

$vv \subseteq V \times V$: points are neighboring (have edges in common);
$ve \subseteq V \times E$: point borders edges;
$vf \subseteq V \times F$: point is a corner point of a surface;

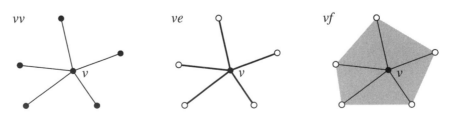

FIGURE 2.21 Illustrating the relations *vv*, *ve*, and *vf*.

$ev \quad \subseteq \; E{\times}V \; : \;$ edge has a point as a corner point;

$ee \quad \subseteq \; E{\times}E \; : \;$ edges are neighboring (have a corner point in common);

$ee' \; \subseteq \; E{\times}E \; : \;$ edges are neighboring and border the same surface (ee' is a special case (partial set) of the relation ee and is, as a rule, used in place of ee on practical grounds.);

$ef \quad \subseteq \; E{\times}F \; : \;$ edge borders surface;

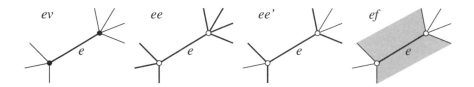

FIGURE 2.22 Illustrating the relations ev, ee, ee', and ef.

$fv \quad \subseteq \; F{\times}V \; : \;$ surface adjoins point;

$fe \quad \subseteq \; F{\times}E \; : \;$ surface adjoins edge;

$ff \quad \subseteq \; F{\times}F \; : \;$ surfaces are neighboring (have edges in common).

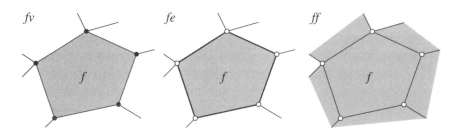

FIGURE 2.23 Illustrating the relations fv, fe, and ff.

In the following we write $v_i v_j$ as a short form of $(v_i, v_j) \in vv$, etc.

As a first concrete example we examine the topology of tetrahedra (see Figure 2.24). Here $n_V{=}4$, $n_E{=}6$, and $n_F{=}4$. The corresponding vef graphs for the two relations vv and ef are shown in Figures 2.25 and 2.26. In addition, as an example for ff we also have:

$$f_i f_j \Leftrightarrow i \neq j. \tag{2.6}$$

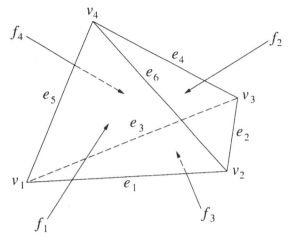

FIGURE 2.24 The topology of tetrahedra.

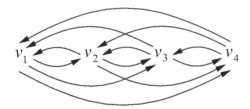

FIGURE 2.25 The *vef* graph for the *vv* relation.

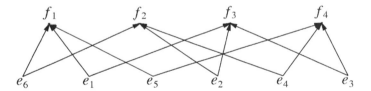

FIGURE 2.26 The *vef* graph for the *ef* relation.

For *ee* we have

$$e_4 e_i, e_1 e_i \quad \text{for } i \notin \{1,4\},$$

$$e_5 e_i, e_2 e_i \quad \text{for } i \notin \{2,5\},$$

$$e_6 e_i, e_3 e_i \quad \text{for } i \notin \{3,6\}. \tag{2.7}$$

The memory requirement for the individual relations, i.e., the number of pairs to be stored in memory, is of great importance and should, therefore, be considered in more detail. At first glance, this seems

complicated. Thus, for example, for the relation ff the number of surfaces adjacent to a given surface depends on the shape of the surface (triangle, quadrilateral), which makes stating the depth in ff as a function of n_F more difficult. Specifying the depth of vv as a function of n_V also presents difficulties, since here the number of neighboring vertices of a vertex depends on the number of adjoining surfaces (see Figure 2.27). On the other hand, specifying the memory depth (complexity) as a function of the number n_E of edges turns out to be simpler. The following table lists the memory depth of the different relations as a function of n_E:

Relation	vv	ve	vf	ev	ee'	ef	fv	fe	ff
Depth	$2n_E$	$2n_E$	$2n_E$	$2n_E$	$4n_E$	$2n_E$	$2n_E$	$2n_E$	$2n_E$

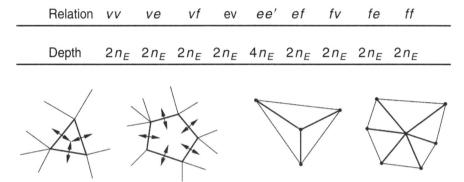

FIGURE 2.27 Memory depth of the relations ff and vv. Specification with respect to n_F or n_V is not, in general, possible, since the number of surfaces bordering a surface (left) and the number of points adjacent to a point (right) depend on the specific example.

As proof of the individual complexities given above, we briefly consider the different relations and, in each case, examine the number of pairs which appear per edge in each relation:

- vv: each edge e leads to exactly two pairs $v_i v_j, v_j v_i$.
- ve: each edge e is bounded by exactly two vertices v_i, v_j.
- ev: each edge $>e$ has exactly two vertices v_i, v_j.

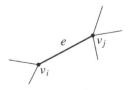

FIGURE 2.28 Illustrating the memory depth for the relations vv, ve, and ev.

- ef: each edge e borders exactly two surfaces f_i, f_j.
- fe: each edge e serves exactly two surfaces f_i, f_j as a border.
- ff: each edge e leads to exactly two pairs $f_i f_j, f_j f_i$.

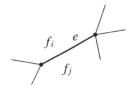

FIGURE 2.29 Illustrating the memory depth of the relations *ef*, *fe*, and *ff*.

- vf: Here

$$v_i f_l \quad \Leftrightarrow \quad \exists_2 \; e_1, e_2: \; v_i e_1 \; \wedge \; v_i e_2 \; \wedge \; e_1 f_l \; \wedge \; e_2 f_l. \tag{2.8}$$

Since each edge e is bounded by two points v_i, v_j and itself borders two surfaces f_k, f_l, each $e \in E$, therefore, leads to four pairs $v_i f_k$, $v_j f_k$, $v_i f_l$ and $v_j f_l$ (see Figure 2.30). Because of Equation (2.8), each pair shows up exactly twice.

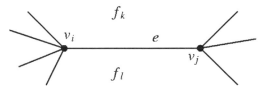

FIGURE 2.30 Illustrating the memory depth of the relations *vf* and *fv*.

- fv: An analogous argument to that for vf yields a depth of $2n_E$.
- ee': Each edge borders two surfaces f_1, f_2; each surface e has, respectively, two neighboring edges e_{1a} and e_{1b} or e_{2a} and e_{2b}, respectively (cf. Figure 2.31).

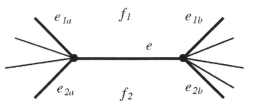

FIGURE 2.31 Illustrating the memory depth of the relation *ee'*.

It is, naturally, unnecessary to store all the previously mentioned relations explicitly, since a high order of redundancy would result [Mänt81]. Certain relations can be expressed in terms of others:

$$vf \equiv ve \times ef,$$

$$fv \equiv fe \times ev,$$

$$vv \equiv ve \times ev \ \setminus \ \{v_i v_i, i = 1, \ldots, n_V\},$$

$$ff \equiv fe \times ef \ \setminus \ \{f_i f_i, i = 1, \ldots, n_F\},$$

$$ee' \equiv ev \times ve \ \cap \ ef \times fe \ \setminus \ \{e_i e_i, i = 1, \ldots, n_E\}.$$

In addition, $ve \times ef$ denotes the set of all pairs $v_i f_j$ for which one edge $e \in E$ exists with $v_i e$ and $e f_j$; thus, $(v_i, e) \in ve$ and $(e, f_j) \in ef$.[9]

The assembled relations vf, fv, vv, ff, and ee', which are connected through e can, thus, be calculated from ve, ev, fe, and ef. For connections through v or f, this is not generally true. For example, $fv \times ve$, as opposed to fe, also brings surfaces and edges that do not border on the latter into a relationship (see Figure 2.32).

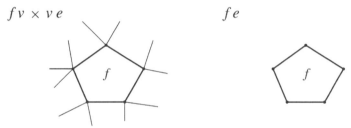

FIGURE 2.32 Different depth of the relations $fv \times ve$ (left) and fe (right): all the indicated edges are related to the surface f in each case.

The central question in the search for an efficient data structure and an associated reduction in memory is the following: which relations are to be stored and which relations can be rapidly and conveniently calculated from the stored data.[10] A tradeoff between memory and computational time is the problem here. We can get some initial ideas about this problem from the previous discussion. The edges are of decisive importance. We consider four possible procedures:

Variant 1:

Here only the relations ev and ef will be stored; this leads to a memory depth of $4n_E$. Evidently, this is the minimum memory require-

[9] The operation $ve \times vf$ is just the join-operation of relational data banks.

[10] We shall not enter into the problem of suitable storage in memory for graphs or relations. Here there are many possibilities, e.g., using pointers and lattices or using relational data banks.

ment in order to be able to calculate all the other relations. In this sense, the procedure is optimal. Of course, a very large amount of time is required to compute the relations that are not stored. For example, to determine all the surfaces bordering a given vertex v_i, on the order of $O(n_E)$ accesses to the data structure will be required. For polyhedra with a large number of edges n_E, calculating the relations will be particularly costly in terms of time.

With respect to implementation, on the other hand, Variant 1 seems very convenient. Operations such as adding or solving elements are simple to realize and static data structures are sufficient, since two vertices in ev and two surfaces in ef are to be entered for every edge e.

Variant 2:

In order to deal more conveniently with the time depth (complexity), one now stores the relations ve and fe, as well as the relations ev and ef. The memory depth thereby increases from $4n_E$ to $8n_E$, which is still quite satisfactory compared to storing all the relations introduced above ($20n_E$). It is easy to show, for example, that the required number of accesses to the data structure for determining all the surfaces bordering on a vertex v_i now no longer depends on n_E, but is only (linearly) dependent on local quantities, e.g., the number of edges leaving a corner point v. Since this number and the number of edges per surface are not, in general, constant, a dynamic data structure is now necessary. This is a disadvantage in terms of implementation.

In the two variants discussed so far, in the vef graphs edges (arrows) run only between elements of E and V, E and F, or V and F (after calculation) and back. However, there are no arrows between elements of V, elements of E, or elements of F. Graphs of this type are also referred to as tripartite graphs.

Variant 3: Winged-Edge Data Structure [Baum72, Baum75]

Here the relations ev and ef, as well as ee', will be stored. In addition, a list of vertices (for each vertex a reference to one of the edges bordering on it) and a list of surfaces (for each surface a reference to one of the edges bordering it) will be required. Thus, the memory depth comes to $8n_E + n_V + n_F$. The time expenditure for calculating the unstored relations and, therefore, for example, the required number of accesses to the data structure in order to obtain all the surfaces bordering a given vertex v_i depends, as in Variant 2, only on local quantities and not on n_E. As in Variant 1, we return to static data structures, so this variant is well suited for implementation.

As an illustration, we turn again to the example of the topology of tetrahedra in Figure 2.24. Figure 2.33 lists the corresponding relations and their lists.

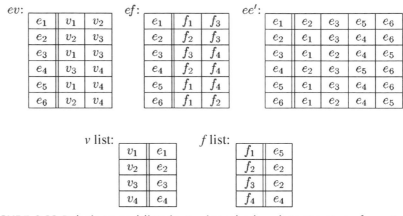

ev:

e_1	v_1	v_2
e_2	v_2	v_3
e_3	v_1	v_3
e_4	v_3	v_4
e_5	v_1	v_4
e_6	v_2	v_4

ef:

e_1	f_1	f_3
e_2	f_2	f_3
e_3	f_3	f_4
e_4	f_2	f_4
e_5	f_1	f_4
e_6	f_1	f_2

ee':

e_1	e_2	e_3	e_5	e_6
e_2	e_1	e_3	e_4	e_6
e_3	e_1	e_2	e_4	e_5
e_4	e_2	e_3	e_5	e_6
e_5	e_1	e_3	e_4	e_6
e_6	e_1	e_2	e_4	e_5

v list:

v_1	e_1
v_2	e_2
v_3	e_3
v_4	e_4

f list:

f_1	e_5
f_2	e_2
f_3	e_2
f_4	e_4

FIGURE 2.33 Relations and lists in a winged-edge data structure for a tetrahedron.

Variant 4: Half-Winged-Edge Data Structure [Star89]

Besides ev and ef, the new relation ee'' is stored instead of ee'. Of the four edges e_1, e_2, e_3 and e_4, which are stored for each edge e in ee', the two same edges border each as e. In each case, the same edge with respect to the corresponding surface following in a clockwise sense on e will be chosen and stored from each of these two pairs of edges. In the example of Figure 2.34, e_2 and e_3 will be stored with e.

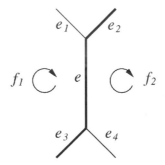

FIGURE 2.34 The relation ee'' in a half-winged-edge data structure. The edges e_2 and e_3 will be stored with edge e.

The vertex and surface lists will be taken unchanged from the winged-edge data structure. Thus, the memory depth is $6n_E + n_V + n_F$. The time spent in calculating the unstored relations and, therefore, the

required number of accesses to the data structure to obtain all the surfaces bordering a given vertex v_i, will certainly be somewhat greater than for the winged-edge data structure but will be independent, as before, of n_E. Here, again, it is possible to work exclusively with static data structures.

2.3.2 Euler Operators

Thus far we have been concerned with the representation of the topological structure of a body and have introduced *vef* graphs for this purpose and investigated them with a view to their efficient realization. It is, however, clear that not every arbitrary *vef* graph actually describes the topological structure of a body. Thus, the question arises of which criteria must be met by a *vef* graph for it to correspond to a rigid body. Beyond that, we must search for rules for the construction of graphs in order to ensure that the corresponding criteria are not violated.

Euler's Formula (1752) is a necessary criterion for the case of convex polyhedra. Every *vef* graph of a convex polyhedron obeys the equation

$$n_V - n_E + n_F = 2. \tag{2.9}$$

The Euler formula was generalized for bodies with holes or hollow spaces by H. Poincaré (1893) as follows:

$$n_V - n_E + n_F = 2 \cdot (n_S - n_H) + n_R. \tag{2.10}$$

Here n_S denotes the number of connected components of the outer surface, n_H the number of holes through the body (as in a torus), and n_R the number of holes in the individual surfaces. We shall consider a few examples to illustrate the magnitudes n_H and n_R.

Figure 2.35 shows a torus and a possible description of its topological structure. Here $n_V = 4$, $n_E = 8$, $n_F = 4$, $n_S = 1$, $n_H = 1$ and $n_R = 0$, so that $4 - 8 + 4 = 2 \cdot (1 - 1) + 0$. Another possible description of the topology of the torus is shown in Figure 2.36 (left). As opposed to Figure 2.35, now there are also holes in surfaces: the surface segments which border the torus above and below are annuli. We have $n_V = 8$, $n_E = 12$, $n_F = 6$, $n_S = 1$, $n_H = 1$ and $n_R = 2$. This shows that the topological structure of a body can be described in different ways.

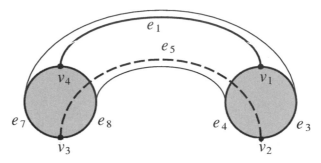

FIGURE 2.35 Illustrating the description of the topological structure of a torus (cross section).

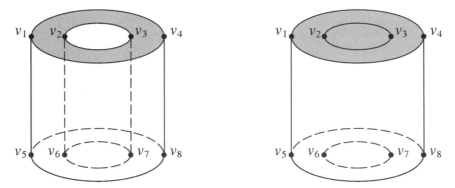

FIGURE 2.36 Illustrating the description of the topological structure of a torus and of a cylinder.

Figure 2.36 (right) shows that holes in surfaces are not (necessarily) connected to holes in a body. Here the basic object is a massive cylinder with annular surfaces on its top and bottom. Here $n_V = 8$, $n_E = 10$, $n_F = 6$, $n_S = 1$, $n_H = 0$ and $n_R = 2$.

Here it is again clear that topological information is not sufficient for a complete description of solids. It cannot be determined whether two unconnected outer surfaces together represent, for example, a hollow sphere or two separate spheres (see Figure 2.37). This can only be settled with additional geometrical information.

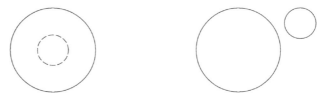

FIGURE 2.37 Hollow sphere or two separate spheres?

We shall now introduce construction operators for *vef* graphs which ensure that the results of construction operations always satisfy the Euler (-Poincaré) Formula. For this we consider the six-dimensional lattice space with the elements $(n_V, n_E, n_F, n_S, n_H, n_R) \in \mathbb{N}^6$. The Euler (-Poincaré) Formula is then the equation of a five-dimensional hyperplane in this space:

$$n_V - n_E + n_F - 2 \cdot (n_S - n_H) - n_R = 0. \tag{2.11}$$

This hyperplane is also referred to as the Euler plane. All valid representations of bodies correspond necessarily to points in the Euler plane. (The opposite does not hold!) The vectors lying in the Euler plane are known as Euler operators [Baum74, BHS78, Mänt88]. We now seek a basis of the Euler plane (i.e, five linearly independent Euler operators which cover the Euler plane) which is easily implemented and has a (unique) semantic meaning. The user then works only with this basis of Euler operations. With this cover, he will be denied direct access to the *vef* graphs via their effects, so hard to visualize and control, on the topology of the body (see Figure 2.38).

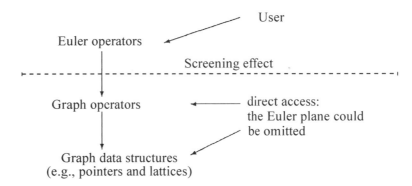

FIGURE 2.38 Screening of the vef graphs through Euler operators.

In the following we give an example of a basis of five linearly independent Euler operators. As an illustration the operation of the respective operators will be demonstrated with the aid of a rubber ball model. In order to reveal the purely topological character of the Euler operators, we suppose that points, edges, and surfaces are outlined on a ductile rubber ball. The rubber ball, itself, is represented as a dashed circle in the following figures.

1. *mvsf* (f, v): make vertex shell face (see Figure 2.39).

 This operator forms an initial body which consists of a shell (connecting component), a surface f, and a point v:

 $$\mapsto (1, 0, 1, 1, 0, 0). \tag{2.12}$$

FIGURE 2.39 The operator *mvsf* in the rubber ball model.

2. a) *mev* (v_1, v_2, e): make edge and vertex (see Figure 2.40).

This operator inserts a new edge e, which joins an already existing point v_1 with a new point v_2:

$$(V, E, F, S, H, R) \mapsto (V+1, E+1, F, S, H, R). \qquad (2.13)$$

FIGURE 2.40 The operator *mev* in the rubber ball model.

b) *semv* $(v_1, v_2, v_3, e_1, e_2)$: split edge make vertex (see Figure 2.41).

This operator divides an existing edge e_1 between the points v_1 and v_2 with a new point v_3 and thereby creates the new edge e_2 from v_2 to v_3:

$$(V, E, F, S, H, R) \mapsto (V+1, E+1, F, S, H, R). \qquad (2.14)$$

Note that Equation (2.14) describes the same transformation as Equation (2.13). Nevertheless, the two Euler operations *mev* and *semv* are based on different semantics.

FIGURE 2.41 The operator *semv* in the rubber ball model.

3. $mef(v_1,v_2,f_1,f_2,e)$: make edge and face (see Figure 2.42).

 This operator divides an existing surface f_1 with a new edge e between two existing points v_1 and v_2 and thereby creates a new surface f_2. The two points can also end up as identical:

$$(V,E,F,S,H,R) \mapsto (V,E+1,F+1,S,H,R). \qquad (2.15)$$

FIGURE 2.42 The operator *mef* in the rubber ball model.

4. $kemr(e)$: kill edge make ring (see Figure 2.43).

 This operator divides the border of a surface into two components by removing an edge e. $kemr$ is only applicable in situations such as that shown in Figure 2.43:

$$(V,E,F,S,H,R) \mapsto (V,E-1,F,S,H,R+1). \qquad (2.16)$$

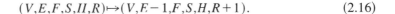

or

FIGURE 2.43 The operator *kemr* in the rubber ball model.

5. $kfmrh(f_1,f_2)$: kill face make ring and hole (see Figure 2.44).

This operator joins two surfaces so that the border of surface f_1 becomes another component (a ring) in the border of the other surface f_2. This leads to the formation of a torus hole:

$$(V,E,F,S,H,R)\mapsto(V,E,F-1,S,H+1,R+1).\qquad(2.17)$$

FIGURE 2.44 The operator $kfmrh$ in the rubber ball model.

This operator is, unfortunately, not easily represented by means of the rubber ball model. At best it looks like Figure 2.44, where a thin rectangle initially drawn on the back side of the rubber ball is brought through the interior to the front to make a torus hole.

Some other Euler operations include kev (kill edge and vertex), $mekr$ (make edge kill ring), $mfkrh$ (make face kill ring and hole), kef (kill edge and face), and $kvsf$ (kill vertex shell face; a termination operator that annihilates the initial body).

The construction of a pyramid is shown here as an example (see Figures 2.45 and 2.46).

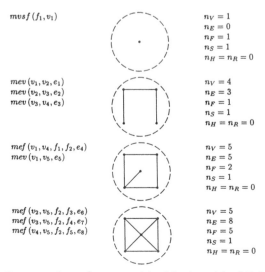

FIGURE 2.45 Construction of a pyramid with the aid of Euler operators.

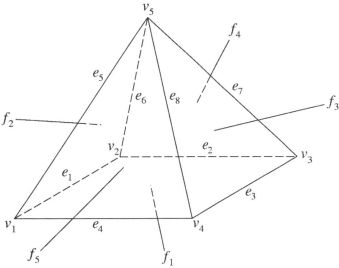

FIGURE 2.46 Labelling of the points, edges, and surfaces of the pyramid.

The *vef* graph of every "reasonable" rigid body can ultimately be described by Euler operators from a basis for the Euler plane. As the example of a pyramid shows, intermediate steps in this process can also lead to nonsensical objects. Thus, it is clear that the unique semantics required at the outset have not yet been established (see Figure 2.47). This can only be achieved with the aid of additional information through parameter lists.

FIGURE 2.47 Illustrating syntactic ambiguity without additional information for the example of the Euler operator *mev*.

2.4 GEOMETRIC ATTRIBUTION OF THE TOPOLOGICAL SURFACE REPRESENTATION

2.4.1 Description for Segments of Curves and Surfaces

The preceding section gave a description of the topological structure of a body using *vef* graphs, and the Euler operators were introduced as a construction mechanism for this. Now comes the attribution of

geometrical information for the system, in particular, for the previously purely topologically defined points, edges, and surfaces.

- The simplest case is the geometrical attribution of the topological points $v_i \in V$ to the geometric points $\mathbf{P}_i := (x_i, y_i, z_i) \in \mathbb{R}^3$. Then, in the case of polyhedra the edge geometry is automatically defined by the line between the points (linear interpolation):

$$\mathbf{g}(t) := \mathbf{P}_1 + t \cdot (\mathbf{P}_2 - \mathbf{P}_1), \quad t \in [0,1]. \tag{2.18}$$

- The surface geometry for triangular planar surface segments is, moreover, defined by the geometry of the three vertices:

$$\mathbf{F}(t_1, t_2, t_3) := t_1 \mathbf{P}_1 + t_2 \mathbf{P}_2 + t_3 \mathbf{P}_3, \tag{2.19}$$

where $t_i \in [0,1]$ and $\Sigma t_i = 1$. For a given (topological) triangulation in the vef graphs (i.e., for every surface f_i there are exactly three edges e_j with $(f_i, e_j) \in fe$), the specification of the geometry of the points is sufficient for a geometrical attribution. The rest is then implicitly determined by linear interpolation.

- Bilinear interpolation is possible for quadrilateral surface segments (see Figure 2.48):

$$\mathbf{F}(t_1, t_2) := (1 - t_1)(1 - t_2) \cdot \mathbf{P}_1 +$$

$$t_1(1 - t_2) \cdot \mathbf{P}_2 + (1 - t_1)t_2 \cdot \mathbf{P}_3 + t_1 t_2 \cdot \mathbf{P}_4, \tag{2.20}$$

where $t_1, t_2 \in [0,1]$. Note that the surface segment (patch) that results from bilinear interpolation is no longer linear and, therefore, planar, but is bilinear and, in general, curved.

FIGURE 2.48 Bilinear interpolation for quadrilateral surface segments.

- *n*-edged surfaces can be reduced through (repeated) subdivision into triangular and quadrilateral surfaces.

In general, however, the limited capabilities of the polygonal modeling will not be satisfactory: the patch geometry is too simple and the resulting breaks at the boundaries of the patches are often obtrusive. Modeling systems for the efficient generation of curved lines and surfaces are essential, especially for CAD. Typically, many pioneering developments with so-called free form curves and free form surfaces, such as Bézier curves, Bézier surfaces, Coons patches, or transfinite interpolation have occurred in the automobile industry: Bézier curves were developed independently by P. de Casteljau at Citroën and P. Bézier at Renault.[11] S. Coons was trained at Ford and the originator of transfinite interpolation, W. Gordon, worked for General Motors.

Because of their outstanding significance, at the end of this chapter on geometrical modeling we shall discuss various starting points for creating free form curves and free form surfaces (see, for example [Dahm89] or the detailed discussion in [Fari90] or [Fari 94]). Here it should always be kept in mind that very different statements of the problem may be involved: in an interpolation problem specified points are to be suitably joined, while, on the other hand, in an approximation problem a specified curve or surface is to be approximated as closely as possible whereby it should yield no points common to the original and the approximation. Interpolation and approximation are reconstruction problems, while the design of curves or surfaces is often desired in CAGD (without a concrete prototype). Thus, in terms of ideas, we shall begin first with the reconstruction problem.

2.4.2 Free Form Curves

Let $n+1$ points in space, $\mathbf{x}_i(t_i) \in \mathbb{R}^d$ (d=1, 2 or 3) or, briefly, \mathbf{x}_i, i=0, ... n, be specified, either as discrete samples of an analytically defined parametrized curve or as a batch of data points. If these points are simply connected by lines, then we treat them as a piecewise linear case. The next possibility, interpolating the points in space \mathbf{x}_i, i=0, ... ,n to fit an *n*-th degree polynomial, is never seriously used in computer graphics because of the poor convergence properties of polynomial interpolation with increasing degree *n* of the polynomial that are so well known from numerical analysis. Thus, the interpolation problem is, in general, poorly conditioned for large values of *n* and small (local) changes in the initial

[11]de Casteljau's work was somewhat earlier, but was never published because of secrecy.

values $\mathbf{x}_i, i = 0, \ldots, n$ can result in large (global) changes in the curve. In addition, strong oscillations often show up (see Figure 2.49) which, as a rule, are undesired in computer graphics or CAD applications. Two aspects are of great importance here:

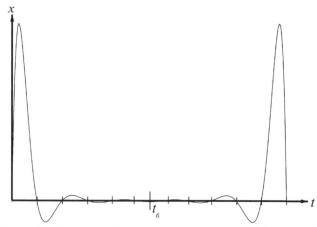

FIGURE 2.49 Oscillations in polynomial interpolation: although all the initial values $x_i, 0 \leqslant i \leqslant 12$, except x_6 are zero, this initial value $x_6 = -1$ causes strong oscillations at the edge of the interval $[t_0, t_{12}]$ under consideration.

Controllability: the user of a CAD system makes intuitive changes in a curve by setting various parameters. With an interpolated curve, for example, a change in the initial settings t_i or initial points \mathbf{x}_i causes a shift in the interpolated curve. Here it is important that manipulating this parameter (degree of freedom) should have a predictable and controllable effect on the shape of the curve. Only under this condition can a design be created interactively on the screen in a rapid and precise fashion.

Localization Principle: a local change in the input data (for example, in an initial value \mathbf{x}_i) can only have a small global effect, if any at all. In the ideal case the curve changes only in a small region near the initial point (t_i, \mathbf{x}_i). This is also especially important for interactive work. In the design of an automobile chassis, for example, a local modification of the fenders must not influence the shape of the doors!

In order to approach the two goals of controllability and localization as closely as possible, a series of starting points have been developed for free form curve modeling. The three most important concepts, Bézier curves [Bezi70, Bezi74], B-splines (see the relevant literature on numerical mathematics or, especially, [deBo78, BBB87, Dier95]) and NURBS [Forr80, PiTi87], will be briefly discussed below. Details are provided in the standard work by Farin mentioned above.

2.4.2.1 Bézier Curves

To define Bézier curves we first use the concept of Bernstein polynomials. The Bernstein polynomials of degree n are defined as follows:

$$B_i^n(t) := \binom{n}{i} \cdot (1-t)^{n-i} \cdot t^i$$

with $t \in [0,1]$, $i = 0, \ldots, n$. (2.21)

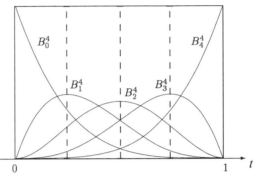

FIGURE 2.50 An example of a Bernstein polynomial of degree 4.

It can easily be shown that $B_i^n(t) \in [0,1]$ for all $n \in \mathbb{N}$ with $0 \leqslant i \leqslant n$ and $t \in [0,1]$. In addition, $B_i^n(t)$ has an i-fold zero at $t=0$, as well as an $(n-i)$-fold zero at $t=1$. The Bernstein polynomials also obey

$$\sum_{i=0}^{n} B_i^n(t) = 1 \qquad \forall t \in [0,1],$$ (2.22)

since

$$\sum_{i=0}^{n} B_i^n(t) = \sum_{i=0}^{n} \binom{n}{i}(1-t)^{n-i}t^i = ((1-t)+t)^n = 1.$$ (2.23)

The curve

$$\mathbf{x}(t) := \sum_{i=0}^{n} \mathbf{b}_i \cdot B_i^n(t) \quad \text{with } t \in [0,1] \text{ and } \mathbf{b}_i \in \mathbb{R}^d$$ (2.24)

is referred to as a Bézier curve of order n and the points $\mathbf{b}_0, \ldots, \mathbf{b}_n$ are Bézier points (control points) and with their convex shells they cover the control polyhedron ($d=3$) or the control polygon ($d=2$) of the curve. The important properties of $\mathbf{x}(t)$ include the following:

1. $x(0)=b_0$ and $x(1)=b_n$. This means that the Bézier curve interpolates b_0 and b_n. Note, however, that the other control points do not generally lie on the Bézier curve.

2. $\dot{x}(0)$ and, therefore, the tangent to x at $t=0$ is $n \cdot (b_1 - b_0)$ and that at $t=1$ is $n \cdot (b_n - b_{n-1})$.

3. Because of Equations (2.22) and (2.24), the values of $x(t)$ are a convex combination[12] of the control points (with a coefficient $B_i^n(t)$ for the control point b_i) of $x(t)$. Thus, Bézier curves are invariant under affine transformations.

4. Because of Equation (2.22) the Bézier curve develops entirely within the control polyhedron or polygon.

5. Bézier curves are symmetric in the control points. (The orderings b_0, \ldots, b_n and b_n, \ldots, b_0 yield the same curve.)

6. For two nonnegative numbers α and β with $\alpha + \beta = 1$ and two sets b_j or c_j of control points $(0 \leqslant j \leqslant n)$ the following holds: the curves to the control points $\alpha b_j + \beta c_j$ coincide with the correspondingly weighted average of the two individual curves.

7. If all the Bézier points lie on a straight line, then the Bézier curve will fit a segment. Parabolic arcs can be created exactly and circular arcs are at least well approximable.

8. Bézier curves are shape preserving: a nonnegative (monotonic, convex) data set leads to a nonnegative (monotonic, convex) curve:

$$\text{all} \quad b_i \geqslant 0 \Rightarrow x(t) \geqslant 0,$$

$$\text{all} \quad b_{i+1} - b_i \geqslant 0 \Rightarrow \dot{x}(t) \geqslant 0, \tag{2.25}$$

$$\text{all} \quad b_{i+1} - 2b_i + b_{i-1} \geqslant 0 \Rightarrow \ddot{x}(t) \geqslant 0,$$

where the relation "\geqslant" is to be taken component by component.

The efficient evaluation of $x(t)$ for a parameter value t and, thereby, the determination of a point on the curve is of great importance. There are various techniques for doing this:

[12]A convex combination is a representation of a point P in the convex shell of $n+1$ points P_0, \ldots, P_n, as $P = \sum_{i=0}^n \omega_i P_i$ with $\sum_{i=0}^n \omega_i = 1$ and $\omega_i \geqslant 0$.

- recursion according to

$$B_i^{r+1}(t) := (1-t) \cdot B_i^r(t) + t \cdot B_{i-1}^r(t),$$

$$B_i^0(t) := \begin{cases} 1 & : \quad i=0, \\ 0 & : \quad \text{otherwise,} \end{cases} \qquad (2.26)$$

- or by continued linear interpolation, using the de Casteljau alogorithm, of the original initial approximation to the Bézier curve:

$$i=0, \ldots, n:$$

$$\mathbf{b}_i^0 := \mathbf{b}_i;$$

$$k=1, \ldots, n:$$

$$i=k, \ldots, n:$$

$$\mathbf{b}_i^k := (1-t) \cdot \mathbf{b}_{i-1}^{k-1} + t \cdot \mathbf{b}_i^{k-1};$$

This ultimately yields $\mathbf{x}(t) = \mathbf{b}_n^n$. Here it should be noted that the parameter t is not restricted to $[0,1]$, but can be an arbitrary real number. As an illustration, Figure 2.51 shows the Neville-type scheme[13] upon which the de Casteljau algorithm is based.

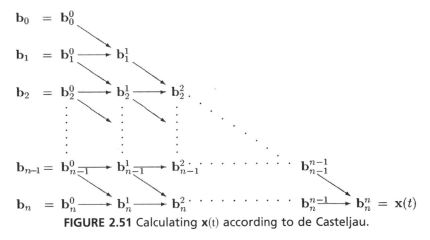

FIGURE 2.51 Calculating $\mathbf{x}(t)$ according to de Casteljau.

Figure 2.52 shows a scheme for geometrical construction of $\mathbf{b}_3^3 = \mathbf{x}(t)$ for the case $n=3$ that helps elucidate the significance of the \mathbf{b}_i^k in the de Casteljau algorithm.

[13] The Aitken and Neville scheme of numerical analysis provides for efficient recursive polynomial interpolations (see, for example [Stoe94]).

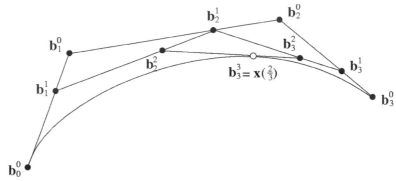

FIGURE 2.52 Geometrical construction according to de Casteljau for $n=3$ and $t=2/3$.

In both cases the calculation requires $O(n^2)$ steps overall, as $n + (n-1) + \ldots + 1 = n(n+1)/2$ computational steps are required, during which the Bernstein polynomial is to be evaluated according to Equation (2.26) and the sum to $\mathbf{x}(t)$ is to be taken per Equation (2.24).

With a set of k assembled Bézier curve segments the effort of the calculation is only dependent on the local polynomial degree n and not on k. Furthermore, in the technique of joining Bézier curves, local changes remain local, which is advantageous. We shall consider the question of a smooth transition with joined Bézier curves in Section 2.4.4.

One troublesome aspect is that for certain positions of the control points, the Bézier curves may have points of contact or, in general, double points. Thus, the mapping $t \mapsto \mathbf{x}(t)$ is no longer bijective (see Figure 2.53). There are necessary criteria for the recognition or avoidance of such situations, e.g., the condition for freedom from double points:

$$\mathbf{x}(t_1) = \mathbf{x}(t_2) \quad \Leftrightarrow \quad t_1 = t_2. \tag{2.27}$$

Direct formulas exist for discovery of double points up to a degree of 4, and iterative procedures (analogous to zero point determinations for polynomials) exist for higher degrees.

FIGURE 2.53 A fourth degree Bézier curve with a double point.

Local changes in the data (control points) eventually have an effect even globally; their influence is, however, only local in significance:

$$\mathbf{b}_i \mapsto \mathbf{b}_i + \mathbf{e}_i \quad \Rightarrow \quad \mathbf{x}(t) \mapsto \mathbf{x}(t) + B_i^n(t) \cdot \mathbf{e}_i .$$

Thus, the change $B_i^n(t) \cdot \mathbf{e}_i$ is significant only in the neighborhood of influence of the control point \mathbf{b}_i (see Figure 2.50). With respect to our two goals of localization and controllability, therefore, the situation is acceptable, but still not optimal.

2.4.2.2 B-Splines

Bézier curves are not the ultimate goal. Improvements are possible in both localization and controllability. If the curve to be modeled also has a very complicated shape, the number of required control points leads to a very high degree n of the polynomial. By $n = 10$ this is no longer practicable. For this reason, one proceeds to combined or piecewise continuous Bézier curves or Bézier splines $\mathbf{s}(u)$. This procedure is entirely analogous to polynomial interpolation in numerical analysis, where one gives up the simple Lagrange interpolation in favor of, say, a piecewise cubic spline. Unlike in the interpolation problem, here we "splice" locally defined Bézier curves $\mathbf{s}_i(t)$ with corresponding local parameters $t = (u - u_i)/(u_{i+1} - u_i), i = 0, \ldots, N$ to one another. As a function of the global parameter u, $\mathbf{s}_i(t(u))$ lives, therefore, on $[u_i, u_{i+1}]$. The interface points u_i are referred to as vertices, the corresponding control points $\mathbf{s}(u_i)$ are called vertex points, and the remaining control points, inner Bézier points. The vertex points are interpolated by the spline in terms of the properties of Bézier curves. See Figure 2.54, as well. As we shall see, the position of the control points is now subject to design criteria (e.g., smoothness conditions at the interface points); they are no longer the instrument of control. On the contrary, this role will be taken over by additional points \mathbf{d}_i.

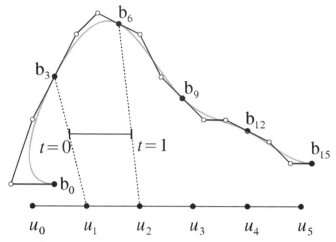

FIGURE 2.54 Bézier splines: vertices (solid circles) and inner Bézier points (hollow circles).

A smooth transition at the vertices u_i is, of course, the central point of the spline; ultimately, despite the reduced local degree of the polynomial, a maximum global smoothness will become possible. Consider two Bézier curves with the control points $\mathbf{b}_0, \ldots, \mathbf{b}_n$ and $\mathbf{b}_n, \ldots, \mathbf{b}_{2n}$, which are parametrized by $[u_0, u_1]$ and $[u_1, u_2]$, respectively, that are to be smoothly joined at u_1. It can be shown that the "global" curve on $[u_0, u_2]$ is continuous and r-differentiable at the point of intersection u_1 if

$$\mathbf{b}_{n+j} = \mathbf{b}_{n-j}^j(t), j=0, \ldots, r, \tag{2.28}$$

holds with $t=(u_2-u_0)/(u_1-u_0)$. At the same time, the $\mathbf{b}_{n-j}^j(t)$ are the intermediate quantities from the de Casteljau scheme (see Figure 2.51).

One can also consider deriving the resulting global curves at the vertex from the left and right. If, say, C^1-continuity is desired at the vertices ui, then we must have

$$\frac{ds(u)}{du}\bigg|_{u\uparrow u_i} = \frac{ds(u)}{du}\bigg|_{u\downarrow u_i}, \tag{2.29}$$

and, therefore,

$$\frac{1}{u_i-u_{i-1}} \cdot \frac{ds_{i-1}(t)}{dt}\bigg|_{t=1} = \frac{1}{u_{i+1}-u_i} \cdot \frac{ds_i(t)}{dt}\bigg|_{t=0}. \tag{2.30}$$

Given the above mentioned properties of Bézier curves (tangents at the end points), this requires collinearity of the three relevant control points, as well as a certain relationship among the separations of the control points,

$$\frac{\alpha}{\beta} = \frac{u_i - u_{i-1}}{u_{i+1} - u_i} \qquad (2.31)$$

(see Figure 2.55) and a suitable global parametrization of the curve $s(u)$. If C^2- continuity is desired in the case of the cubic splines illustrated in Figure 2.54, then the resulting smoothness conditions require the unique existence of additional auxiliary points d_i which lie at the points of intersection of the line through b_{3i-2} and b_{3i-1} with the line through b_{3i+2} and b_{3i+1}, while in each case the same length relationships must hold (see Figure 2.56).

FIGURE 2.55 C^1-conditions ($n=3$) that are satisfied (left) and not satisfied (right).

FIGURE 2.56 C^2-conditions that are satisfied (left) and not satisfied (right).

Finally, C^{n-1}-continuity is evidently the maximum possible smoothness for a general degree n.

If the Bézier spline is to have the maximum global smoothness C^{n-1}, it is uniquely determined by the choice of vertices u_i and by the points c_i of the so-called B-spline polygon. For $n=2$, the c_i are just the boundary control points b_0 and b_{2N}, along with the inner Bézier points (i.e., the b_{2i-1}), while in the cubic case ($n=3$) the two outermost control points on each side, b_0, b_1, b_{3N-1} and b_{3N}, along with the auxiliary points d_i introduced above, are the points of the B-spline polygon. The vertices u_i and the B-spline polygon then yield the corresponding control points b_i and their associated parameter abscissae merely from the smoothness conditions. For this reason, such Bézier splines are also referred to as B-splines. One now begins, therefore, with the vertices and the B-spline polygon and constructs the B-spline including the control points.

B-splines inherit many of the properties of Bézier curves:

- The B-spline lies in the convex shell of the Bézier points; more precisely, it lies in the union of the convex shells of the local control polygons or control polyhedra.
- B-splines are invariant under affine transformations.
- Symmetry holds at the points of the B-spline polygon.
- We again have end-point interpolation. The "B" in the term B-spline and B-spline polygon suggests further that a basis representation of minimum support splines $N_i^n(u)$ exists for B-splines as basis functions, i.e.,

$$s(u) := \sum_{i=0}^{N+n-1} c_i \cdot N_i^n(u), \qquad (2.32)$$

where the c_i, as before, are the points of the B-spline polygon. As opposed to the Bézier curves that have only been defined locally and joined together, the individual minimum support splines $N_i^n(u)$ are globally defined over the entire parameter range of u, so that, first, $N_i^n(u_i) = 1$, second, C^{n-1}-continuity is ensured, and, third, the support of $N_i^n(u)$ (the region of u over which $N_i^n(u)$ is nonvanishing) includes a minimum number of vertices. In the case of a linear B-spline ($n = 1$) with global continuity (C^0), the $N_i^n(u)$ are the well-known hat functions (see Figure 2.57). This construction is entirely analogous to the spline interpolation of numerical analysis. There, splines are first defined locally as piecewise polynomial curves and joined, before a global basis representation is specified with the aid of minimum support splines.

FIGURE 2.57 A linear B-spline with the corresponding basis function $N_i^1(u)$.

The decisive advantage of the spline procedure is localization: now local changes in a control point are really locally confined (to the local Bézier curve and, depending on the smoothness, to a part of both neighboring Bézier curves). We can now be satisfied with respect to localization and controllability.

2.4.2.3 NURBS

One problem remains: the previously studied (piecewise) polynomial curves are, indeed, invariant under affine mappings, but not under projective mappings. Such projections are, however, important in computer graphics. Suppose that a three-dimensional scene is to be mapped onto a plane by means of a perspective projection. It is known from conic sections (projections of parabolas specified in space onto a plane) that when polynomial curves that are specified in space are projected onto a plane, rational curves are generated in the plane (polynomial expressions in numerator and denominator). The polynomial curves we have used for modeling also yield rational curves on the screen. Then one can also use the greater power of the rational approach and do modeling with rational Bézier curves or rational spline curves in space; these arc, of course, closed under projective mappings. Rational B-splines are also known as NURBS (Non Uniform Rational B-Splines) and are standard for modeling of curves and surfaces today.

We begin with the three-dimensional rational Bézier curves of degree n, which we shall imagine as a projection of rational Bézier curves of degree n in \mathbb{R}^4 with the points (x,y,z,w) on the hyperplane $w=1$. It can be shown that a rational Bézier curve of this sort is specified by

$$\mathbf{x}(t) := \frac{\displaystyle\sum_{i=0}^{n} w_i \cdot \mathbf{b}_i \cdot B_i^n(t)}{\displaystyle\sum_{i=0}^{n} w_i \cdot B_i^n(t)}, \mathbf{x}(t), \mathbf{b}_i \in \mathbb{R}^3, \tag{2.33}$$

with weights w_i. As in the case of polynomials, the \mathbf{b}_i form the control polyhedron, which now is just the projection of the four-dimensional control polyhedron of the point $(w_i\mathbf{b}_i^T, w_i)^T$ of the polynomial pre-image $\mathbf{x}(t)$. If all the weights are equal, Equation (2.33) yields just the customary polynomial Bézier curve. Negative weights are usually excluded in order to avoid singularities. Rational Bézier curves possess all the important properties of their polynomial counterparts (affine invariance, etc.). The weights w_i are usually employed as form parameters. An elevated weight w_i increases the influence of the control point \mathbf{b}_i. The effect of a change in the weight is distinctly different from the effect of a shift in the control

point. The weights also bring additional modeling freedom into play (see Figure 2.58).

FIGURE 2.58 Influence of a shift in a control point (left) compared to that of an increased weight (qualitative).

Three-dimensional B-splines of degree n are entirely analogous to projections of four-dimensional rational B-splines on the hyperplane $w = 1$. They can be represented by

$$s(u) := \frac{\sum_{i=0}^{N+n-1} w_i \cdot c_i \cdot N_i^n(u)}{\sum_{i=0}^{N+n-1} w_i \cdot N_i^n(u)}, \tag{2.34}$$

where the $N_i^n(u)$, as before, are the (polynomial) basis splines and the c_i indicate the points of the B-spline polygon. Again, the c_i are the projections of the points of the corresponding four-dimensional B-spline polygon.

Modeling with rational splines is not especially different from modeling with their polynomial counterparts. The weights introduce additional flexibility and the effects of modifications in them are local. Thus, NURBS is the standard for modeling of free form curves.

2.4.3 Free Form Surfaces

It is now possible to move on to the modeling of free form surfaces proceeding from the different approaches to free form curve modeling in the previous section. One obvious possibility for obtaining free form surfaces from free form curves is the tensor product approach. The linear case is illustrated in Figure 2.48 with bilinear interpolation. The surface

$\mathbf{x}_{st}(s,t)$, $s,t \in [0,1]$ defined in this way is, so to speak, the simplest way of defining a surface between four points, can be interpreted as the smeared surface that arises through the movement of the two points \mathbf{P}_1 and \mathbf{P}_2 along straight lines to \mathbf{P}_3 or \mathbf{P}_4, respectively, by convection of the corresponding straight line joining the endpoints:

$$\mathbf{x}_{st}(s,t) := (1-s)\cdot(1-t)\cdot\mathbf{P}_1 + s\cdot(1-t)\cdot\mathbf{P}_2$$

$$+ \ (1-s)\cdot t\cdot\mathbf{P}_3 + s\cdot t\cdot\mathbf{P}_4, \tag{2.35}$$

where the parameters $s,t \in [0,1]$. In general, i.e., when linearity is waived, one arrives at the intuitive definition of a tensor product surface as the geometric locus of a curve moving through space and changing its shape in the process.

And in succession: we begin with a bilinear patch in Figure 2.48; now let the general curves $\mathbf{x}(s,0):=\gamma_0(s)$ pass from \mathbf{P}_1 to \mathbf{P}_2 (thus, $\gamma_0(0)=\mathbf{P}_1$ and $\gamma_0(1)=\mathbf{P}_2$) and $\mathbf{x}(s,1):=\gamma_1(s)$ from \mathbf{P}_3 to \mathbf{P}_4 (thus, $\gamma_1(0)=\mathbf{P}_3$ and $\gamma_1(1)=\mathbf{P}_4$) with $s \in [0,1]$. Finally, we let \mathbf{P}_1 and \mathbf{P}_2 migrate again along straight lines to \mathbf{P}_3 and \mathbf{P}_4, respectively, and obtain a so-called ruled surface:

$$\mathbf{x}(s,t) := (1-t)\cdot\mathbf{x}(s,0) + t\cdot\mathbf{x}(s,1), \tag{2.36}$$

where, again, $s,t \in [0,1]$. Thus, in the t direction, entire curves, and no longer just discrete points, are, as before, linearly interpolated (see Figure 2.59). This procedure is also known as transfinite interpolation.

FIGURE 2.59 Ruled surfaces (transfinite interpolation in one direction).

The Coons patch goes one step further [Coon67]. Now all four boundary curves, $\gamma_0(s)$ from \mathbf{P}_1 to \mathbf{P}_2, $\gamma_1(s)$ from \mathbf{P}_3 to \mathbf{P}_4, $\delta_0(t)$ from \mathbf{P}_1 to \mathbf{P}_3, and $\delta_1(t)$ from \mathbf{P}_2 to \mathbf{P}_4 can be specified arbitrarily:

$$\mathbf{x}(s,0) := \gamma_0(s), \quad \mathbf{x}(s,1) := \gamma_1(s),$$

$$\mathbf{x}(0,t) := \delta_0(t), \quad \mathbf{x}(1,t) := \delta_1(t), \tag{2.37}$$

again with $s,t \in [0,1]$. Building on this, we construct the two ruled surfaces $\mathbf{x}_s(s,t)$ and $\mathbf{x}_t(s,t)$:

$$\mathbf{x}_s(s,t) := (1-t)\cdot\mathbf{x}(s,0) + t\cdot\mathbf{x}(s,1) \tag{2.38}$$

and

$$\mathbf{x}_t(s,t) := (1-s)\cdot\mathbf{x}(0,t) + s\cdot\mathbf{x}(1,t), \tag{2.39}$$

with $s,t \in [0,1]$. Evidently, \mathbf{x}_s interpolates the γ-curves, but cannot reproduce the δ-curves. The opposite holds for \mathbf{x}_t. Each of the two ruled surfaces behaves correctly on two sides, but incorrectly, or more precisely, linearly, on two sides. Thus, the sum $\mathbf{x}_s+\mathbf{x}_t$ contains, at least on the edge, the excess linear parts. Subtracting the bilinear interpolant \mathbf{x}_{st}, defined as in Equation (2.35), yields the desired result at the edge. Accordingly, the Coons patch is defined as

$$\mathbf{x}(s,t) := \mathbf{x}_s(s,t) + \mathbf{x}_t(s,t) - \mathbf{x}_{st}(s,t), \tag{2.40}$$

with $s,t \in [0,1]$. The term transfinite interpolation is also customary for Equation (2.40).

The next generalization is readily available: instead of the linear factors $1-s,s,1-t$, and t in Equations (2.35)–(2.39), one can also use general interpolation functions $f_0(s)$ and $f_1(s)$ or $g_0(t)$ and $g_1(t)$, respectively, provided they obey

$$f_0(s)+f_1(s)=1 \quad \forall s\in[0,1],$$

$$g_0(t)+g_1(t)=1 \quad \forall t\in[0,1],$$

$$f_0(0)=f_1(1)=1,$$

$$g_0(0)=g_1(1)=1.$$

Subject to differentiability conditions at the resulting surface, one arrives at the general form of the Coons patch [Gord83, Fari90, Fari94]. The so-called bicubic Coons patch has gained special importance in this regard. Or, one admits just Bernstein polynomials and thereby obtains quadrilateral or tensor product Bézier surfaces of degree (m,n):

$$\mathbf{x}(s,t) := \sum_{i=0}^{n} \sum_{k=0}^{m} \mathbf{b}_{ik}\cdot B_i^n(s)\cdot B_k^m(t), s,t\in[0,1]. \tag{2.41}$$

At the same time, the $\mathbf{b}_{ik}\in\mathbb{R}^3$ are the Bézier points of the surface; they now establish (analogously to the control polygon for Bézier curves) a control lattice for the surface (see Figure 2.60).

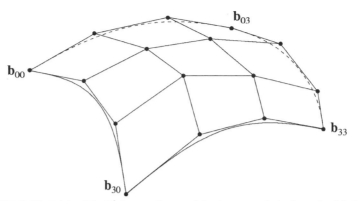

FIGURE 2.60 A bicubic Bézier surface with the associated control lattice.

It has the following properties:

- The four corner points \mathbf{b}_{00}, \mathbf{b}_{0m}, \mathbf{b}_{n0} and \mathbf{b}_{nm} lie on the surface, while the other points do not generally do so.
- The curves with constant t are Bézier curves with respect to s with the Bézier points $\mathbf{b}_i(t) := \Sigma_{k=0}^m \mathbf{b}_{ik} B_k^m(t)$. The corresponding statement holds for the curves with constant s. In particular, the four boundary curves of the Bézier surface are the Bézier curves described by the control points \mathbf{b}_{0k}, \mathbf{b}_{i0}, \mathbf{b}_{nk}, or \mathbf{b}_{im}, respectively $(0 \leqslant k \leqslant m, 0 \leqslant i \leqslant n)$.
- The Bézier surface lies in the convex shell of its control lattice.

Now we turn to the determination of a surface point $\mathbf{x}(s,t)$ for given parameters s and t. Proceeding from the two possibilities for the case of Bézier curves (recursive according to Equation (2.26) or per de Casteljau), there are now four ways to proceed: recursively in both parameters according to Equation (2.26); following de Casteljau in both parameters; or, recursively for one and according to de Casteljau for the other. We shall illustrate the last of these in somewhat more detail. First, one evaluates the Bernstein polynomial in s, as given in Equation (2.26) of Section 2.4.2.1, and thus calculates the values $B_i^n(s)$, $i = 0, \ldots, n$. Now one can obtain the Bézier points

$$\mathbf{b}_k(s) := \sum_{i=0}^n \mathbf{b}_{ik} B_i^n(s) \tag{2.42}$$

belonging to the curve with a fixed first parameter s. Finally, the desired value $\mathbf{x}(s,t)$,

$$\mathbf{x}(s,t) = \sum_{k=0}^m \mathbf{b}_k(s) \cdot B_k^m(t), \tag{2.43}$$

can be calculated by analogy to Section 2.4.2.1. in accordance with de Casteljau.

The Bézier surfaces described thus far have four boundary curves. Certainly, applications which require triangular surface segments often occur (see Figure 2.61). Approximating Bézier surfaces can also be specified for such surfaces with three boundary curves. Barycentric, i.e., center of gravity oriented coordinates, are now also necessary in the parameter space. For this we have three parameters $t_1, t_2, t_3 \in [0,1]$ with the secondary condition $t_1 + t_2 + t_3 = 1$.

FIGURE 2.61 Decomposition into triangular and quadrilateral Bézier surfaces.

Proceeding from this we define the following special Bernstein polynomials of degree n:

$$B_{ijk}^n(t_1, t_2, t_3) := \frac{n!}{i!j!k!} \cdot t_1^i t_2^j t_3^k,$$

with $t_i \in [0,1]$, $t_1 + t_2 + t_3 = 1$, $i+j+k = n$, $i,j,k \geq 0$. (2.44)

For all parameters t_1, t_2, and t_3 satisfying the above condition the triangular Bézier surface of degree n is then specified by the following definition:

$$\mathbf{x}(t_1, t_2, t_3) := \sum_{\substack{i,j,k \geq 0 \\ i+j+k = n}} \mathbf{b}_{ijk} \cdot B_{ijk}^n(t_1, t_2, t_3).$$ (2.45)

The points $\mathbf{b}_{ijk} \in \mathbb{R}^3$ are, again, referred to as Bézier points and cover the triangular control lattice (cf. Figure 2.62).

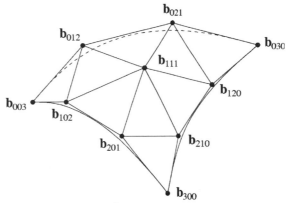

FIGURE 2.62 A cubic triangular Bézier surface with the corresponding control lattice.

It has the following important properties:

- The three corner points \mathbf{b}_{00n}, \mathbf{b}_{0n0}, and \mathbf{b}_{n00} lie on the surface, while the other points generally do not.
- The lines with fixed t_1 are, again, Bézier curves; similarly, the lines with fixed t_2 and t_3 are also Bézier curves. In particular, the three boundary curves of the Bézier surface are Bézier curves which are described by the control points \mathbf{b}_{0jk}, \mathbf{b}_{i0k}, or \mathbf{b}_{ij0}, respectively ($0 \leq i,j,k \leq n$).
- The surface lies in the convex shell of its control lattice.
- For determining a surface point $\mathbf{x}(t_1,t_2,t_3)$ for given t_1, t_2 and t_3 there are, again, several possibilities:
- by recursive calculation of the value of $B_{ijk}^n(t_1,t_2,t_3)$ using

$$B_{ijk}^r(t_1,t_2,t_3) := t_1 \cdot B_{i-1,jk}^{r-1} + t_2 \cdot B_{i,j-1,k}^{r-1} + t_3 \cdot B_{ij,k-1}^{r-1}. \tag{2.46}$$

- or by continued linear interpolation in accordance with de Casteljau:

$$\mathbf{b}_{ijk}^r = t_1 \cdot \mathbf{b}_{i+1,jk}^{r-1} + t_2 \cdot \mathbf{b}_{i,j+1,k}^{r-1} + t_3 \cdot \mathbf{b}_{ij,k+1}^{r-1}$$

with $i+j+k=n-r$ and $i,j,k \geq 0$. $\tag{2.47}$

Here $\mathbf{b}_{ijk}^0 = \mathbf{b}_{ijk}$ and $\mathbf{x}(t_1,t_2,t_3) = \mathbf{b}_{000}^n$.

FIGURE 2.63 de Casteljau construction for $n=3$.

As before with Bézier curves, the possibility of contact or self-penetration exists in the case of triangular and quadrilateral Bézier surfaces. In order to recognize situations of this sort, appropriate tests are again required. In general, this involves iterative procedures.

The lines of intersection of two Bézier surfaces can be represented as a set of higher degree Bézier curves. Algorithms exist for calculating the control points of these Bézier curves.

2.4.4 Attribution and Smooth Transition to Interfaces

Now the geometric information in the triangular and quadrilateral Bézier surfaces must be ordered along with the topological information in the vef graphs [BEH79]. For this we assume that the topological structure of the specified body described by the vef graphs only contains triangular or quadrilateral surface segments (i.e., surface segments with three or four bordering edges). Each of these surface segments is now to be attributed with a triangular or quadrilateral Bézier surface. This implies, as Figures 2.64 and 2.65 demonstrate, a parquetting of the Bézier points of the corresponding control lattice. The points, edges, and surface segments in the vef graph will then be attributed with the corresponding Bézier points or sets of Bézier points (see Figures 2.64 and 2.65).

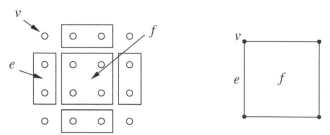

FIGURE 2.64 Parquetting of the Bézier points of a control lattice in the quadrilateral case ($n=3$).

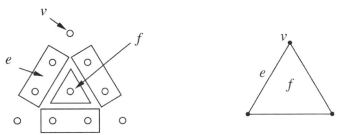

FIGURE 2.65 Parquetting of the Bézier points of a control lattice in the triangular case ($n=3$).

In this way a continuous transition between two neighboring surfaces is obtained, such that the common edges and the common points can have only one geometric attribution (see Figure 2.66). Greater smoothness is obtained using complicated secondary conditions which bring more points in the neighborhood of the boundary points into consideration. Here the same things have to be taken into account as in the construction of smooth splines (cf. the discussion in Section 2.4.2.2).

FIGURE 2.66 Parquetting of the Bézier points of two control lattices with only a single geometric attribution for the edge in common and the points in common.

3

GRAPHICAL REPRESENTATION OF THREE-DIMENSIONAL OBJECTS

Following the discussion in the previous chapter of how three-dimensional objects can be modeled, this chapter explains how two-dimensional pictures and thereby, for example, data for a virtual picture or, equivalently, picture screen data, can be created by means of appropriate transformations (e.g., projections) from the three-dimensional data output of the geometrical modeling process (cf. Figure 3.1).

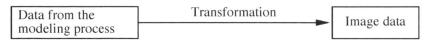

FIGURE 3.1 From the modeled scene to a picture.

In the following we shall limit ourselves, with few exceptions, to representation schemes in which the outer surfaces of complete objects are described by means of pure triangular or quadrilateral, plane surface segments, or in which the volumes are divided into pure, correspondingly bounded standard cells. If the result of the modeling process is provided for another representation scheme, a suitable transformation algorithm must perform a conversion into one of the three following schemes:

- surface representation with triangular or quadrilateral, flat surface segments,
- standard cell enumeration schemes (voxel schemes), or
- octal tree representation.

The essential advantage of a polygonal representation lies in the possibility of hardware support in dealing with polygons, so the associated picture data can be created very rapidly and efficiently.

The transformation of the three-dimensional data on the scene into two-dimensional (picture screen) data, i.e., the projection of the scene onto the plane of the picture, is, however, only one step in the creation of realistic pictures, our actual goal. Here some additional questions are of central importance: visibility, modeling of local illumination, including reflections, and problems associated with the gradation of color. Building on the following discussion of these basic topics, we then proceed, after a brief treatment of transparency, to the global illumination of scenes and present, as examples, two efficient procedures for creating photorealistic pictures: the ray tracing method, which reproduces highlights and specular (mirror) reflections outstandingly, and radiosity procedures, which are primarily suited to the realistic representation of (projection independent) diffuse light.

3.1 PARALLEL AND CENTRAL PROJECTION

Given the above limitation to outer surfaces which consist of pure, plane triangular and quadrilateral surface segments, the outer surface is completely described by the position of the corner points and the topological information on the edges. The projection of the object onto the picture plane thereby reduces to the projection of the corner points.

A projection P is generally taken to be a mapping from a space V into a lower- dimensional (affine partial) space U where P on U (construed as embedding in V) is the identity:

$$P:V\rightarrow U\subset V,$$

$$P|_U=\text{Id},$$

$$P^2=P. \tag{3.1}$$

In our situation V encompasses just the modeled scene (a partial set of \mathbb{R}^3, the world or model coordinates) and U contains the plane of projection (now construed as a partial set of \mathbb{R}^2, the virtual picture coordinates):

$$P:\begin{pmatrix} x \\ y \\ z \end{pmatrix} \mapsto \begin{pmatrix} u \\ v \end{pmatrix}. \tag{3.2}$$

In the simplest case the plane of projection (uv plane) covers the xy plane, is oriented in the z direction, and contains the origin of the xyz system (see Figure 3.2).

FIGURE 3.2 Screen plane (*vu*) and scene (*xyz*) in the simplest case.

The next simplest projection simply leaves out the z coordinates and uses the x and y coordinates directly as virtual picture coordinates. In this special case of parallel projection, the direction of projection $(x_P,y_P,z_P)^T$ is also orthogonal to the plane of projection (xy plane) and all projection rays pass parallel to the direction of projection (see Figure 3.3). Thus, we have

$$\begin{pmatrix} u \\ v \end{pmatrix} = \begin{pmatrix} x \\ y \end{pmatrix} = P \cdot \begin{pmatrix} x \\ y \\ z \end{pmatrix}, \quad P := \begin{pmatrix} 1 & 0 & 0 \\ 0 & 1 & 0 \end{pmatrix}, \tag{3.3}$$

with the direction of projection given by

$$\begin{pmatrix} x_P \\ y_P \\ z_P \end{pmatrix} := \begin{pmatrix} 0 \\ 0 \\ 1 \end{pmatrix}. \tag{3.4}$$

FIGURE 3.3 Parallel projection with projection directions along the z axis and in a general direction.

As opposed to this case, in general parallel projection, one chooses an arbitrary projection direction $(x_P, y_P, z_P)^T$ with $z_P \neq 0$ that is not orthogonal to the projection (display) plane (cf. Figure 3.3). In order to obtain the image matrix, we calculate the picture of an arbitrary point $(x, y, z)^T$, with $z \neq 0$, and, thereby, the intersection point $(u, v, 0)^T$ of the projected ray

$$g(t) := \begin{pmatrix} x \\ y \\ z \end{pmatrix} + t \cdot \begin{pmatrix} x_P \\ y_P \\ z_P \end{pmatrix} \tag{3.5}$$

with the plane of projection. As the z component must vanish here, because $z_P \neq 0$ the real parameter t obeys

$$z + t \cdot z_P = 0 \quad \Leftrightarrow \quad t = -\frac{z}{z_P}, \tag{3.6}$$

so that for u and v we have

$$u := x - \frac{z}{z_P} \cdot x_P,$$

$$v := y - \frac{z}{z_P} \cdot y_P. \tag{3.7}$$

We thereby obtain the appropriate projection matrix P,

$$\begin{pmatrix} u \\ v \end{pmatrix} = P \cdot \begin{pmatrix} x \\ y \\ z \end{pmatrix}, \qquad P := \begin{pmatrix} 1 & 0 & -x_P/z_P \\ 0 & 1 & -y_P/z_P \end{pmatrix}, \tag{3.8}$$

or, in homogeneous coordinates,

$$\begin{pmatrix} u \\ v \\ w \\ 1 \end{pmatrix} = \bar{P} \cdot \begin{pmatrix} x \\ y \\ z \\ 1 \end{pmatrix}, \qquad \bar{P} := \begin{pmatrix} 1 & 0 & -x_P/z_P & 0 \\ 0 & 1 & -y_P/z_P & 0 \\ 0 & 0 & 1 & 0 \\ 0 & 0 & 0 & 1 \end{pmatrix}. \tag{3.9}$$

The w component is ignored in the representation (uv plane). Nevertheless, it is advisable to preserve the z coordinates of the original picture vectors in this way, since they may be important in procedures concerned with visibility determinations, as discussed in Section 3.2.

The preceding discussion was limited to the xy plane ($z=0$) as the plane of projection (cf. Figure 3.2). An arbitrary plane of projection in three-dimensional space can be realized using the affine transformations mentioned in Section 1.3 (translations, rotations, reflections). For this reason, the entire scene, including the plane of projection, is subject to a suitable affine transformation which maps the plane of projection onto the $z=0$ plane. A subsequent parallel projection of the sort described above then yields the desired result.

The greatest disadvantage of parallel projection is the lack of perspective. The parallelism of all the projection rays means that objects are always imaged with the same magnification in the plane of projection, regardless of their distance from the latter; this prevents the printing of a picture with perspective and, therefore, of a picture that is viewable with spatial depth.

For this reason we now proceed to the more realistic central projection, which does take account of perspective (see Color Plate 24). The objects appear ever so smaller the further they are from the observer. Hence, in the central projection the observer's position (center of projection) B must also be specified, along with the plane of projection (cf. Figure 3.4).

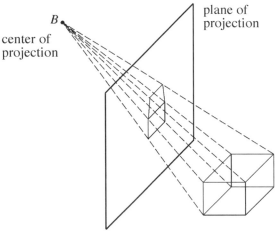

FIGURE 3.4. Central projection with the plane of projection and the center of projection.

Central projection recognizes no uniform projection direction. Rather, the projected picture points show up as the points of intersection of the projection rays from the center of projection to points in the object with the image (picture) plane. A similar situation occurs in the human eye or in a camera. There, however, the image plane lies behind the center of projection rather than in front of it. The image then appears on the retina in the back of the eye in the head and is specularly reflected, so that during the process of vision the different projections of seeing and looking must be distinguished (see Figure 3.5).

Two simple properties of central projection follow directly from the preceding remarks: lines or segments through the center of projection B degenerate to a point on the plane of projection and all other lines or segments in three-dimensional space are mapped onto lines or segments on the two-dimensional plane of projection.

In the simplest special case of central projection, the observer lies at the origin and the plane of projection is the plane $z=1$. For the image of a point $Q := (x, y, z)^T, z \neq 0$ we take the point $(x/z, y/z, 1)$ (cf. Figure 3.6). Here the central projection can be completely described by

$$u := x/z,$$

$$v := y/z,$$

$$w := 1. \tag{3.10}$$

FIGURE 3.5 Images in the human eye. There are two central projections involved in seeing. In one the object is refracted by the cornea and lens of the eye at rest onto the retina to form a real image, as indicated by the gray cone in the drawing. In this process, which is similar to image formation in a camera, the midpoint *P* of the pupil of the eye is the center of projection and only a small part of the field of vision is acquired sharply. When the head is stationary, the (full) field of vision can be perceived by rotating the eye. This yields a substantially wider range which is delimited in the figure by the dashed lines. In this process, which is more comparable to image acquisition in a scanner than in a camera, the center of projection lies at the midpoint *M* of the eye. The impression that the entire field of vision is seen sharply is created in the brain through constant eye movement and processing of the perceptions from different viewing directions. This impression is also not disturbed by movement of the head.

FIGURE 3.6 Central projection with the plane of projection $z=1$. The image of point Q is the point QZ.

In general the position of the center of projection B is arbitrary and the plane of projection is specified through the so-called optic axis point A. The optic axis, i.e., the ray from B passing through A, also gives the observer's direction of view and is perpendicular to the plane of projection, which generally contains A (cf. Figure 3.7).

FIGURE 3.7 The center of projection B, optical axis point B, and optical axis BA.

Now an affine transformation is to be sought for handling the general situation which

1. shifts B to the origin (translation),

2. maps the segment BA onto the z axis (three-dimensional rotation), and

3. fixes the uv coordinate system in its position relative to the z axis, as well as in its orientation. (see Figure 3.8; two-dimensional rotation, possibly reflection).

FIGURE 3.8 Establishing the u and v directions. The optical axis only fixes the plane of projection, but not the position or orientation of the u and v axes.

The following definition shows a possible realization and representation of such an affine transformation, which, for practical reasons, also includes a built-in (distortion free) scaling:

$$
\begin{pmatrix} \bar{x} \\ \bar{y} \\ \bar{z} \end{pmatrix} := P \cdot \begin{pmatrix} x - x_B \\ y - y_B \\ z - z_B \end{pmatrix},
$$

$$
P := \begin{pmatrix} s \cdot q & -t \cdot q & 0 \\ -t \cdot c & -s \cdot c & p \\ a & b & c \end{pmatrix}, \tag{3.11}
$$

where

$$
A := (x_A, y_A, z_A)^T,
$$

$$
B := (x_B, y_B, z_B)^T,
$$

$$
a := x_A - x_B,
$$

$$
b := y_A - y_B,
$$

$$
c := z_A - z_B,
$$

$$
p := \sqrt{a^2 + b^2},
$$

$$
q := \begin{cases} \sqrt{a^2 + b^2 + c^2} & : \quad p \neq 0 \\ c & : \quad p = 0, \end{cases}
$$

$$
s := \begin{cases} b/p & : \quad p \neq 0 \\ 1 & : \quad p = 0, \end{cases}
$$

$$
t := \begin{cases} a/p & : \quad p \neq 0 \\ 1 & : \quad p = 0. \end{cases}
$$

In both cases, ($p=0$, $p\neq0$) the columns of the matrix P are orthogonal and the determinants are $-2c^3\,(p=0)$ or $-q^3\,(p\neq0)$, respectively. In order to make the operation of the transformation defined by Equation (3.11) clear, let us consider the two points A and B in more detail. B is mapped onto the origin and A is first mapped onto $(a,b,c)^T$ by the translation and ultimately through subsequent multiplication by P onto $(0,0,q^2)$, a point on the \bar{z}-axis. In this way we have reduced the general situation to the initially mentioned special case and we obtain the image coordinates $u:=\bar{x}/\bar{z}$ and $v:=\bar{y}/\bar{z}$ (cf. Equation (3.10)).

Finally, we obtain the following computational rule:

Central projection (observer at B, viewing direction toward A):

$$D:=a\cdot(x-x_B)+b\cdot(y-y_B)+c\cdot(z-z_B),$$

$$u:=(s\cdot q\cdot(x-x_B)-t\cdot q\cdot(y-y_B))/D,$$

$$v:=(-t\cdot c\cdot(x-x_B)-s\cdot c\cdot(y-y_B)+p\cdot(z-z_B))/D. \tag{3.12}$$

We would like to conclude this section on central projection with a few basic comments:

1. From the sign of D it is possible to read off whether a given point $(x,y,z)^T$ is in the viewing direction of the observer ($D>0$) or behind the observer ($D<0$).

2. The equation $x-x_B=x-x_A+x_A-x_B=x-x_A+a$ can be used to specify the formulas for central projection with respect to A. Instead of Equation (3.12), we then obtain:

Central projection (A and B as before; specification with respect to A):

$$D:=a\cdot(x-x_A)+b\cdot(y-y_A)+c\cdot(z-z_A)+q^2,$$

$$u:=(s\cdot q\cdot(x-x_A)-t\cdot q\cdot(y-y_A))/D,$$

$$v:=(-t\cdot c\cdot(x-x_A)-s\cdot c\cdot(y-y_A)+p\cdot(z-z_A))/D. \tag{3.13}$$

3. If B is chosen to be far from the scene, then D is nearly constant and all the rays of projection are almost parallel. One can also regard parallel projection as central projection with an infinitely distant center of projection. Accordingly, with constant D the above Equations (3.12) and (3.13) just yield a parallel projection.

4. Roundoff errors are normally insignificant for central projection. Of course, the further B moves from the scene, the more difficult Equations (3.12) for B become, while the further A is taken to be from the scene, the more difficult Equations (3.13) for A become. Consequently, not just the projection center, but also the optical axis point, must lie far outside the scene.

5. Other aspects are also important in the choice of A and B. Large distances from A and B lead to small images. (Everything is mapped into a small region.) On the other hand, if A and B are too close to the scene, then the images will be very large, and, if anything, it is possible only to see segments of the scene. A suitable choice is, therefore, to put A in the scene and to position B sufficiently far away. Then Equation (3.13) yields optically satisfactory and reliable (precise) results.

Now, after a suitable projection has been used to create two-dimensional image data in virtual image coordinates from the three-dimensional data for the scene, a final step is necessary to transform into the integer device coordinates (cf. Section 1.5). This step is often referred to as the window-viewport transformation. Here the window denotes the segment of the picture in world or virtual image coordinates that is to be imaged and the viewport is taken to be the corresponding target segment in device coordinates.

3.2 VISIBILITY DETERMINATION

Display of the complete modeled scene on a screen leads, as a rule, to highly incomprehensible pictures: for example, drawing all the edges in the outer surface representation easily produces a jumble of lines on the front and back sides for complicated objects. In general, with fully or partially hidden objects it is immediately obvious what is happening (e.g., under certain circumstances the sequence of drawing plays a decisive role in what is ultimately to be seen). In order to create clarity here and come closer to the goal of realistic pictures it is therefore necessary to eliminate the hidden (by other objects) and, thus, normally invisible lines and surfaces or to sort them out on the output medium before display.[1]

[1]Other techniques are used, however, for wire models (here the display intensity as a function of distance is chosen using so-called depth cueing, in which the edges on the back side are displayed more weakly than those on the front; see Color Plate 26) or for transparent objects (see Section 3.5.) which do not entirely hide the objects which lie behind them.

The associated problems of visible-line/visible-surface (visibility) determination and hidden-line/hidden-surface removal are, therefore, among the most important tasks in the graphical display of three-dimensional objects. In addition, in principle for every projection ray and for every pixel it is to be decided whether one and, if need be, which object is visible. Often entire surface segments or even objects are left out from the start if they are completely hidden. In this section we shall study a few basic visibility determination techniques. Here we come first to clipping, which has already been discussed in Section 1.4. Because of his position and his angular field, the observer only sees a segment of the scene to be displayed. This fact is taken into account through three-dimensional clipping.

Visibility determination must be carried out in three-dimensional space before projection onto two dimensions destroys the necessary depth information. On the other hand, the decision is made pixelwise—ultimately it must be decided for each screen pixel which object of the scene is visible. For this reason a supplementary transformation is usually introduced: first the scene is transformed with three-dimensional perspective in a way such that a subsequent simple parallel projection yields the same result as a central projection of the scene. This supplementary transformation preserves the relative depth information for the scene and it conserves lines and planes. For example, a cube aligned in the direction of the projection yields the frustum of a pyramid with its base turned relative to the observer. The decisive advantage of this procedure is that, now, by suitable normalization, the pixel coordinates u and v can be chosen to be identical to the scene coordinates x and y. A visibility determination algorithm that is to process the pixels, therefore, has direct access to the depth information for the scene. We shall make use of this in z-buffers and in scan-line procedures. But, first we turn to three-dimensional clipping.

3.2.1 Three-Dimensional Clipping

Because of the limited extent of the picture plane or of the picture screen and because of the fixed direction of projection (for parallel projection) or center of perspective (for central projection), only part of the world or scene can be displayed. This potentially visible and, thereby, imageable region is a parallelepiped that is infinite in the direction of projection for parallel projection, while it is an infinite pyramid in the direction of the positive optic axis for central projection (see Figure 3.9).

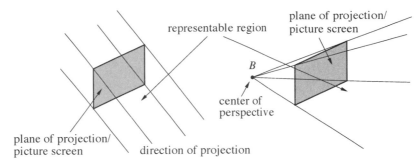

FIGURE 3.9 The region that can be displayed (represented) for parallel and central projection.

In practice, on the other hand, it often makes sense to limit the initially infinitely large representable region in both cases, since one is only mostly interested in a certain range of depth and other objects will only be a disturbance here. In a central projection, objects which are very close to the observer tend to fill the entire screen, while very distant objects can often yield tiny images. For this reason, so called front and back clipping planes are introduced (see Color Plates 24 and 25). Generally, the former lies in front of the center of perspective (center of projection) and the latter, behind the plane of projection. All three planes are parallel to one another. This results in a parallelepiped as the representable region for parallel projection and a truncated pyramid for central projection (see Figure 3.10).

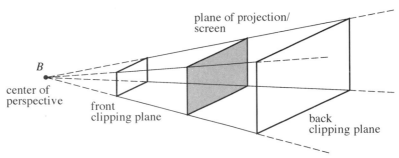

FIGURE 3.10 Front and back clipping planes for a central projection.

Clipping of objects in the three-dimensional scene must now be done, in the first case, relative to the two clipping planes and, in the second, relative to the remaining four sides of the truncated pyramid. In the course of the latter, for reasons (among others) of simplicity, usually after the object is projected on the image plane as a two-dimensional clipping (see Section 1.4), depth clipping must still be carried out in three dimensions in the z direction relative to the front and back clipping planes.

At this point we should like to limit ourselves to the comment that the current algorithms for two-dimensional clipping by Cohen and Sutherland (see Section 1.4), as well as those of Cyrus and Beck [CyBe78], Liang and Barsky [LiBa84], and Sutherland and Hodgman [SuHo84] can be generalized to the three-dimensional case. A simple and very efficient algorithm for three-dimensional clipping was subsequently published by Blinn [Blin91].

After clipping, all objects lying outside the represented region are entirely or partly eliminated. The question of visibility in the interior of the domain to be represented is to be settled next.

3.2.2 Back-Face Culling

In a first, preliminary step toward the elimination of hidden edges and surfaces all the back sides of objects are removed by so-called back-face culling operations, as these are certainly invisible to an observer located at the center of perspective B (see Color Plates 27 and 28). It is still clear that this does not solve the problem entirely, since front sides can, of course, be hidden by objects in front of them and, thereby, also be invisible. Nevertheless, back-face culling can often substantially reduce the number of objects or surfaces that ultimately have to be dealt with.

A back face is an segment of outer surface f whose (relative to the body in question) outer normal n_f points away from the observer. Now, in order to establish whether a surface f is a back face, one calculates the scalar product of the outer surface normal n_f and the vector $P_f - B$, where B is the center of perspective and P_f is a point in the interior of f (perhaps its center of gravity). If the result is negative, then n_f points back to the observer and f is not removed. If, on the other hand, the scalar product is positive, then f is recognized as a back side and is eliminated. In the case of a right angle the scalar product is zero and the surface degenerates to edges (see Figure 3.11).

FIGURE 3.11 Determination of back faces.

There are now various possibilities for determining the outer normal vectors of plane surface segments. If the n edge vectors e_0, \ldots, e_{n-1} of an outer surface polygon as observed from outside are oriented counterclockwise and enumerated, then the vector product $e_i \times e_{(i+1) \bmod n}$ provides an outer normal vector. In linear algebra the vector product is defined as

$$a \times b = \begin{pmatrix} a_1 \\ a_2 \\ a_3 \end{pmatrix} \times \begin{pmatrix} b_1 \\ b_2 \\ b_3 \end{pmatrix} := \begin{pmatrix} a_2 b_3 - a_3 b_2 \\ a_3 b_1 - a_1 b_3 \\ a_1 b_2 - a_2 b_1 \end{pmatrix}, \tag{3.14}$$

while $|a \times b| = |a| \cdot |b| \cdot |\sin \varphi(a,b)|$. The vector $a \times b$ is perpendicular to the plane formed by a and b and is oriented so that $(a,b,a \times b)$ forms a right handed system (provided that a and b are linearly independent).

A second possibility for determining the outer normal is the so-called corner point sum. Here let the n corner points (vertices) v_0, \ldots, v_{n-1} of an outer surface polygon as viewed from the outside be ordered counterclockwise. Then for $v_i = (x_i, y_i, z_i)^T$, where $i = 0, \ldots, n-1$,

$$\begin{pmatrix} \displaystyle\sum_{i=0}^{n-1} (y_{(i+1) \bmod n} - y_i) \cdot (z_{(i+1) \bmod n} + z_i) \\ \displaystyle\sum_{i=0}^{n-1} (z_{(i+1) \bmod n} - z_i) \cdot (x_{(i+1) \bmod n} + x_i) \\ \displaystyle\sum_{i=0}^{n-1} (x_{(i+1) \bmod n} - x_i) \cdot (y_{(i+1) \bmod n} + y_i) \end{pmatrix} \tag{3.15}$$

is an outer normal vector of the observed outer surface polygon.

In conclusion, we maintain that in terms of back-face culling, an edge can naturally only be removed if all the surfaces bordering it have been identified as back sides.

Now that the visible domain has been limited by three-dimensional clipping and the complexity of the scene has been reduced by back-face culling, we turn to the actual procedure for visibility determination.

3.2.3 The *z*-Buffer Procedure

The starting point for this procedure [Catm74] is imaging onto a raster picture screen. A *z*-buffer is a two-dimensional field corresponding to the pixel resolution of the screen. The *z* coordinate, i.e., the *z* coordinate of the visible point on the polygon or in the background, is entered for each pixel. At the same time, the corresponding color or brightness information is kept in primary screen storage (frame buffer) (see Figures 1.39 and 1.50 in Section 1.6). The basic algorithm has a quite simple form:

z-Buffer Algorithm:

set all entries in the *z*-buffer to z_{max} (background);
set all entries in the frame buffer to the background color;
\forall polygons P:
begin

project the polygon P ;onto the plane of the screen;
transform the result into raster coordinates (pixels);
\forall relevant pixels (u, v):
 begin

$pz := z$ coordinate of the polygon at pixel (u, v);
$zz :=$ entry in the *z*-buffer for the pixel (u, v);
if $pz < zz$:
 begin

z-buffer$(u, v) := pz$;
frame buffer$(u, v) := $ color(P, u, v);
 end
 end
end;

At the beginning, therefore, all entries in the *z*-buffer are set to a maximum (background) value and all entries in the frame buffer are set to the background intensity or color. Then one enters a loop over all the polygons and carries out the following three steps:

1. projection of the polygon onto the image plane;

2. raster conversion of the projected polygon into a pixel set; and,

3. comparison of the *z* value with the values in the *z*-buffer for each affected pixel. If the new polygon P is in front of the previously stored one at the pixel in question, then the intensity value (color) for the new polygon P is written in the screen memory and the new *z* value is written in the *z*-buffer.

Calculation of the z coordinate from pixel to pixel in a polygon can be done by means of simple incremental techniques, since all the surfaces as polygons are planar. If, say, the polygon lies in the plane

$$a x + b y + c z + d = 0 \qquad (3.16)$$

after the supplementary perspective transformation in the scene mentioned at the beginning of Section 3.2, then, indeed, x and y correspond precisely to the screen or pixel coordinates u and v. Consequently, for the z components $z_{new} := z_{old} + \Delta z$ in pixel $(u+1,v)$ on proceeding from z_{old} in pixel (u,v), we have

$$0 = a\,(u+1) + b\,v + c\,(z_{old} + \Delta z) + d$$

$$= a\,u + b\,v + c\,z_{old} + d + a + c\,\Delta z$$

$$= 0 \quad + a + c\,\Delta z \qquad (3.17)$$

and, therefore,

$$\Delta z = -\frac{a}{c}. \qquad (3.18)$$

The (real) increment Δz is, thus, constant for the entire observed polygon. The analog holds true for the transition from pixel (u,v) to the neighboring pixel $(u,v+1)$.

In conclusion, we summarize the most important properties of the z-buffer procedure (see Color Plates 27 and 29):

1. This procedure is memory intensive, as an additional entry is necessary for each pixel. As a remedy, one can retain only a few screen rows in the z-buffer instead of the entire screen content. In this case, however, the polygons must be processed repeatedly.

2. This procedure is computationally intensive. The decision is made for each pixel in a polygon, not for the whole polygon at once.

3. z-buffer algorithms are easily implemented. Furthermore, hardware support is possible: today even simple graphical computers have hardware z-buffers. This fact has contributed to substantial dissemination of z-buffer procedures.

4. Presorting of the objects is not required and comparisons between different objects are not necessary.

5. Since the outer loop in the appropriate algorithm runs over the polygons, the average total cost is

$$N_{Pol} \cdot N_{Pix},$$

where N_{Pol} is the number of polygons and N_{Pix} is the average number of pixels per polygon. The screen resolution enters the cost only indirectly (cf. Section 3.2.7).

6. This procedure is easily made parallel. In particular, the sequence in which the polygons are processed is unimportant.

7. Shadows can be realized by an extension of the z-buffer procedure [Will78]. With the aid of a second z-buffer for which the light source is taken to be the center of projection, it can be established whether a point viewed by the observer lies in the shadow of an object or not.

8. The restriction to polygons or to polygonally bounded objects is not obligatory.

3.2.4 List-Property Procedures

In this procedure the objects are presorted so that drawing in the corresponding order leads to a correct picture. Naturally, problems arise here in the case of mutually or cyclically overlapping objects (see Figure 3.12), where no ordering of this sort exists. In a situation of this type the overlapping objects have to be split up (see, for instance, [NNS72]).

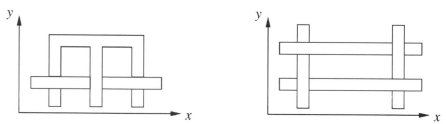

FIGURE 3.12 Mutual (left) and cyclical (right) overlap of objects.

There is also a need for procedures with which one can track down overlapping. A simple sufficient (but not necessary) criterion for freedom from overlapping between two objects can be given immediately. Let $x_{min}^{(i)}, x_{max}^{(i)}, y_{min}^{(i)}$ and $y_{max}^{(i)}$ with $i \in \{1,2\}$, be the minimum and maximum x or y coordinates of Objects 1 and 2, respectively. Then we have

$$[x_{min}^{(1)}, x_{max}^{(1)}] \cap [x_{min}^{(2)}, x_{max}^{(2)}] = \{\} \quad \vee \quad [y_{min}^{(1)}, y_{max}^{(1)}] \cap [y_{min}^{(2)}, y_{max}^{(2)}] = \{\}$$

\Rightarrow Object 1 and Object 2 do not overlap one another.

Extensive and complicated tests are required for all those pairs of objects for which this criterion does not eliminate overlapping, in order to permit the required splitting of the objects in an appropriate fashion.

A simple special case for which the list-priority procedure is very suited is the so-called $2\frac{1}{2}$D-representations. Here all the objects have constant z coordinates or occupy constant and disjunctive z intervals. The objects can then be sorted simply according to their z coordinates and finally drawn from the back to front. As this procedure corresponds to painting with opaque oil paint, it is also referred to as the painter algorithm.

3.2.5 Scan-Line Algorithms

Raster-oriented output devices are assembled from a matrix of individual pixels (picture points). A row of these matrices, i.e., a horizontal line of these pixels, is also referred to as a scan line. Accordingly, scan-line algorithms[2] [WREE67, Bouk70, BoKe70, Watk70] construct a picture row-by-row, and numerous tables (lists) are kept as data structures for organizing the visibility determination. The projection of all objects in the scene onto the plane of projection (the uv plane) follows readily.

- The edge table (ET)gives a list of all nonhorizontal edges sorted by decreasing v component of the two edge end points. If the latter is the same for multiple edges, they will be sorted by the corresponding u components. The following values are listed for each edge in the edge table: v_{min} (the smallest v component), u (the u component corresponding to v_{min}; (u,v_{min}) thus denotes the end point of the edge), v_{max} (the largest v component), and Δu (the increment in u on going from one scan line to the next, i.e., from v to $v+1$), as well as the numbers of the polygons to which the edge belongs:

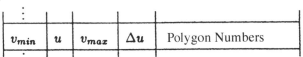

v_{min}	u	v_{max}	Δu	Polygon Numbers

- The polygon table (PT) is a list of all the polygons. Besides a number for unique identification, the table lists the coefficients a, b, c, and d in the corresponding equation (3.16) of the plane,[3] color or

[2]Scan-line procedures are also referred to as sweep-line algorithms in the literature.

[3]Here we again mean the equation of the plane following the supplementary perspective transformation mentioned at the beginning of Section 3.2.

brightness information, and a flag, which indicates whether the current position on the scan line lies inside (1) or outside (0) the polygon:

Polygon No.	a	b	c	d	Intensity	Flag

Note that the scan-line procedures described here assume a consistent brightness or color.

- The active edge table (AET) is a list of variable length that contains all the edges which intersect the scan line currently being processed. The entries are sorted by the u component of the corresponding intersection point. Figure 3.13 shows an example of the content of an AET at three different times, i.e., on three different scan lines.

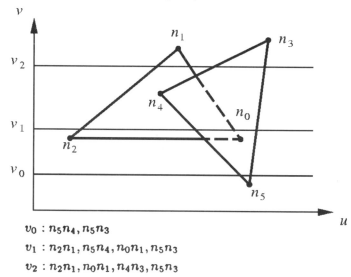

$v_0 : n_5 n_4, n_5 n_3$

$v_1 : n_2 n_1, n_5 n_4, n_0 n_1, n_5 n_3$

$v_2 : n_2 n_1, n_0 n_1, n_4 n_3, n_5 n_3$

FIGURE 3.13 Content of the active edge table for three scan lines.

With the aid of these three tables we can now show the basic pattern for a scan-line algorithm:

Scan-Line Algorithm:

```
∀ scan lines v (v=0 . . . V):
begin
        update the AET;
        set all flags in PT to 0;
        ∀ intersections on the scan line according to the AET:
        begin
                update the flags in the PT;
```

determine the visible polygon *P*;
set the colors according to the entry for *P* in the PT
end
end;

The determination of the visible polygons is done using the equations of the plane for all the active polygons, i.e., all polygons whose flag is set to one. A z value can be calculated for each such polygon using the equation $a u + b v + c z + d = 0$. The smallest of these z values then indicates the visible polygon.

The most important difference between the scan-line algorithms and the previous procedures lies in the choice of the outer loop. While the latter processed all the objects (polygons or edges) beforehand, now for the first time the entire screen is scanned, independently of the number or position of the objects to be drawn. Since it is necessary to proceed along a scan line only from one active edge to the next, rather than from pixel to pixel, here, as opposed to the case of the ray-casting procedure mentioned in Section 3.2.7, the screen resolution is no longer the decisive factor in the computational effort.

3.2.6 Recursive Procedures

Recursive procedures for visibility determination rely on the "divide and conquer" principle. The basic region is decomposed recursively into multiple partial regions. If the visibility determination problem is solved in a partial region, then it will be drawn. Otherwise, it must be subdivided further. Since it is clear that for a prespecified number of polygons and progressively smaller partial regions, as a rule ever fewer polygons will overlap with a partial region, termination will generally occur before the smallest resolution is reached.

Two widespread representatives of this class of procedures are the area subdivision techniques [Warn69, WeAt77, Catm78a, Carp84] and the octal tree methods [DoTo81, Meag82, GWW86]. In the first group, e.g., the algorithm of Warnock [Warn69], the plane of projection, i.e., the screen, is successively subdivided. The second group uses the depth information that is already contained in the (recursive) octal tree data structure in order to determine the visibility recursively.

3.2.7 Ray Casting Procedures

The general principle of this class of procedures is based on ray tracking (primary sources in [Appe68, MAGI68, GoNa71]; reviews in [Glas89, Haen96]). Here a ray is tracked from the center of perspective out through each pixel in the three-dimensional space. To determine the

visible points in the picture one must calculate the point of intersection of the projection rays with the outer surface of the body and distinguish the following cases (Figure 3.14):

1. There is no point of intersection: then the background color is used.

2. Points of intersection exist: then one determines the point of intersection closest to the image plane. This is visible and the others are hidden.

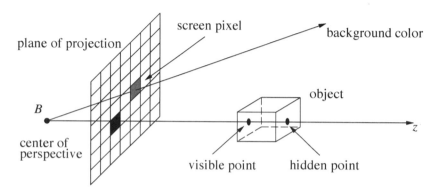

FIGURE 3.14 Ray tracing through each pixel by ray casting.

Beyond a pure visibility determination, the information gained in this fashion can be used in combination with illumination models or repeated (recursive) ray tracking through mirroring to create very realistic images (ray tracing;[4] see Figure 3.7),

The basic structure of a ray casting algorithm is, therefore, quite simple:

Ray Casting Algorithm:

\forall scan lines v ($v=0 \ldots V$):
begin
 \forall pixels (u, v) ($u=0 \ldots U$):
 begin
 determine the ray from B through (u,v);
 $pz := z_{max}$;

[4] The concepts of ray casting and ray tracing are often used synonymously. In the following, however, we regard ray casting methods as applicable to simple visibility determinations and ray tracing methods as suitable for more extended applications (shadowing, illumination, mirroring) and, in general, for the creation of high quality, photorealistic images.

```
              set the color in (u, v) to the background color;
              ∀ objects in the scene:
              begin
                      if a ray ↔ object intersection point (x, y, z)^T
                      exists and if  z<pz:
                      begin
                          pz:=z;
                          reset the color in (u, v) accordingly;
                      end
              end
      end
end;
```

The major disadvantage of ray casting is that it is very computationally expensive and, therefore, slow, since each (ray, object) pair must be checked for the existence of points of intersection. It is, however, easy to run in parallel. With p processors, one simply divides the screen into p disjunctive, equally sized rectangles and compute the ray tracking in parallel for each part of the screen. Here, of course, the overall data for the three-dimensional scene must be kept separately on each processor. If one wants to avoid this and also subdivide the data, then parallelism becomes more difficult.

The large computational effort has, by contrast, some important advantages. Besides the already mentioned simplicity and the great potential with respect to realistic and high quality images, here it should be pointed out that ray casting procedures can be simply adapted to various three-dimensional representation schemes, such as CSG, outer surface representation, etc., since only operations such as the computation of points of intersection of a ray with an object or the calculation of the angle between a ray and the normal to a surface, etc., have to be carried out.

The main problem in ray casting procedures is, therefore, the calculation of points of intersection of rays with the objects in the scene.[5] With complicated objects a direct analytic determination of the points of intersection may not be possible and numerical methods for approximate determination of zero positions must be invoked instead, so that the computational effort is increased further. It is thus obvious that one must restrict oneself to classes of objects in representation schemes such as cell decomposition or the CSG scheme (cf. Section 2.2.1), for which possible piercing points of rays can be ascertained easily. Below, we consider two examples of a sphere and a plane, polygonally bounded surface. First a ray S moving out of B is specified in parametric form as

[5] For typical scenes up to 95 points of intersection.

$$S(t) := B + t \cdot (P - B), \quad t \geqslant 0, \tag{3.19}$$

or

$$\begin{pmatrix} x \\ y \\ z \end{pmatrix} := \begin{pmatrix} x_B \\ y_B \\ z_B \end{pmatrix} + t \cdot \begin{pmatrix} x_P - x_B \\ y_P - y_B \\ z_P - z_B \end{pmatrix}$$

$$= \begin{pmatrix} x_B \\ y_B \\ z_B \end{pmatrix} + t \cdot \begin{pmatrix} x_S \\ y_S \\ z_S \end{pmatrix}, \quad t \geqslant 0, \tag{3.20}$$

where P denotes the midpoint of an arbitrary pixel.

In the case of a sphere of radius R about the midpoint M,

$$(x - x_M)^2 + (y - y_M)^2 + (z - z_M)^2 = R^2, \tag{3.21}$$

substituting the values from Equation (3.20) for x, y, and z yields a quadratic equation in the parameter t:

$$0 = t^2 \cdot (x_S^2 + y_S^2 + z_S^2)$$

$$+ 2\, t \cdot (x_S(x_B - x_M) + y_S(y_B - y_M) + z_S(z_B - z_M)) \tag{3.22}$$

$$+ (x_B - x_M)^2 + (y_B - y_M)^2 + (z_B - z_M)^2 - R^2.$$

If Equation (3.22) has no real solutions, then there is no point of intersection. When there is exactly one real solution, the ray grazes the sphere, and when there are two different real solutions, entry and exit points exist. Only points with positive t can be visible and, if the occasion arises, the point with smaller positive t is visible.

In the case of a polygon, the calculation of the point of intersection breaks down into two subproblems. First it has to be established whether and, if appropriate, where the ray intersects the plane in which the polygon lies. Afterwards, it is to be found whether a possible point of intersection lies inside or outside the polygon. Thus, on setting the values from Equation (3.20) for x, y, and z in the equation of the plane,

$$a\,x + b\,y + c\,z + d = 0, \tag{3.23}$$

one obtains

$$t = -\frac{a\,x_B + b\,y_B + c\,z_B + d}{a\,x_S + b\,y_S + c\,z_S}, \tag{3.24}$$

provided the denominator $a\,x_S + b\,y_S + c\,z_S$ is nonzero. Otherwise, the ray passes without intersection parallel to the plane (numerator nonzero) or

with infinitely many points of intersection in the plane (numerator equal to zero). If there is a unique point of intersection according to Equation (3.24), then it must be tested whether this point lies in the polygon or not. Such a problem formulation is standard in computational geometry [PrSh85, Nolt88] and will not be discussed further here.

As opposed to z-buffer procedures, in which work is only done at a pixel with respect to an object which will effectively be imaged, among others, onto this pixel, with ray casting a test is carried out for each (pixel, object) pair. For a screen resolution of, say, 1280 x 1024 pixels and, say, 100 surfaces, this yields about 131 million cutting operations. Thus, the goal of any optimization must be either to avoid such tests from the start or, on the other hand, to carry them out as efficiently as possible. Here, again, the importance of the techniques discussed in Sections 3.2.1 and 3.2.2 for sorting out irrelevant objects or surface segments or edges becomes evident.

Cutting operations can be avoided, for example, when both the plane of projection (the set of all pixels or rays) and the scene are decomposed into disjunct partial regions in a way such that subsequently a partial set of rays need be checked later only for intersections with objects in certain partial regions of the scene (cf. Figure 3.15). Techniques based on decomposing the scene into equally sized cubes (voxels, see Section 2.2.1.A) as well as the octal tree algorithms (see Section 2.2.1.C) are good examples of prototypes for a procedure based on such a spatial partitioning.

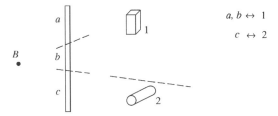

FIGURE 3.15 Avoiding calculations of intersections during ray casting by decomposing the plane of projection and the scene into partial regions. Here objects in partial region 1 cannot be affected by rays through pixels in region c.

In addition, hierarchical concepts in which entire groups of objects are circumscribed in a simple way (e.g., by cuboids or spheres) often make it possible to reduce many tests to one. If a ray does not encounter an outer box, then it does not encounter the objects contained in the box. This so-called clustering can, of course, also be carried out recursively (cf. Figure 3.16).

FIGURE 3.16 Recursive hierarchical clustering of objects in a scene to avoid calculation of intersections during ray casting.

The efficiency of cutting operations can be increased by calculating certain terms only once in advance. For example, the quadratic term $x_S^2 + y_S^2 + z_S^2$ in Equation (3.22) does not depend on the specific observed object, but is the same for all objects. On the other hand, the constant term $(x_B - x_M)^2 + (y_B - y_M)^2 + (z_B - z_M)^2 - R^2$ in Equation (3.22) depends only on the actual sphere, and not on the specific ray under consideration. For complicated objects the cutting operations can be made cheaper by analogy to the procedure for clustering under certain circumstances, in that bodies can be circumscribed by simple shells. Thus, if a ray does not intersect the shell, the costly test does not have to be carried out at all for the bodies themselves (see Figure 3.17).

FIGURE 3.17 Efficient determination of (the absence of) points of intersection by circumscribing a (simple) shell.

3.3 LOCAL ILLUMINATION AND REFLECTIONS

Modeling the illumination of a scene is of great importance for the realism of the images that are to be provided. Thus, intensity distinctions, as well as glare and mirror effects, enhance the quality of a display. In this section we are concerned first with local illumination, i.e., with the

proportions of light at a point in the scene. The influence of interactions of the surfaces of objects through multiple reflections and, thereby, questions connected with global illumination will be discussed later. In the following we present the most important illumination models for ambient light and for idealized light emanating from point sources.

3.3.1 Ambient Light

The so-called ambient light does not come from a defined source, but rather from all directions. Thus, it is a question of a uniform background light which, perhaps as a result of multiple reflections, illuminates all the objects nondirectionally or diffusely (see Color Plate 30). In particular, every outer surface receives the same set of ambient light, independently of its orientation. Depending on the material and the color of the outer surface, certain fractions of the light are reflected and others absorbed or even allowed to pass through transparently (see Section 3.5). For example, if white light is incident on an optically opaque red object, the red part of the light will be reflected and the rest absorbed. That is what creates the impression of red.

For a formal description of the relationship just described, we introduce the concepts of ambient light intensity and reflectivity (reflection coefficient). The ambient light intensity I_a, with

$$I_a := \begin{cases} I_a \in [0,1] & \text{(black-white),} \\ (I_{a,R}, I_{a,G}, I_{a,B})^T \in [0,1]^3 & \text{(color),} \end{cases} \qquad (3.25)$$

describes the strength of the ambient light. The reflectivity (reflection coefficient) $R^{(i)}$, with

$$R^{(i)} := \begin{cases} R^{(i)} \in [0,1] & \text{(black-white),} \\ (R_R^{(i)}, R_G^{(i)}, R_B^{(i)})^T \in [0,1]^3 & \text{(color),} \end{cases} \qquad (3.26)$$

is a parameter of the material for each surface i that specifies the (possibly color dependent) fraction of the light that is reflected.

This yields the intensity $V_a^{(i)}$ of the ambient light for a visible surface i:

$$V_a^{(i)} := I_a \times R^{(i)}$$

$$:= \begin{cases} I_a \cdot R^{(i)} & \text{(black-white),} \\ (I_{a,R} \cdot R_R^{(i)}, I_{a,G} \cdot R_G^{(i)}, I_{a,B} \cdot R_B^{(i)})^T & \text{(color).} \end{cases} \qquad (3.27)$$

The evident disadvantage of an illumination model employing only ambient light is that all the visible outer surfaces will be displayed with equal intensities, which is hardly realistic. The first step in alleviating this difficulty is to introduce point light sources.

3.3.2 Point Light Sources with Diffuse Reflection

In addition to the ambient light, one or more point light sources will now be taken into account as well (see Color Plate 31). Examples of such idealized light sources reduced to a single point include light bulbs and the sun. Light rays emanate outward from a point light source, i.e., the light is directed. The incident luminous flux and, therefore, the intensity of a point on a surface now depend on the position and orientation of the surface relative to the light source. Reflection, on the other hand, is diffuse, as before; that is, all incident rays will be uniformly reflected in all directions. In the following we limit ourselves to the case of a color display. The situation for achromatic (black-white) light can be handled in a way similar to that of the previous section.

The intensity of the point light source P_j is I_j, i.e.,

$$I_j := (I_{j,R}, I_{j,G}, I_{j,B})^T \in [0,1]^3. \tag{3.28}$$

The resulting intensity $V_j^{(i)}$ of a visible point on a surface i from the point source P_j is now given by

$$V_j^{(i)} := I_j \times R^{(i)} \cdot \langle l_j, n \rangle, \tag{3.29}$$

where $R^{(i)}$ is again the material dependent reflectivity[6] and $-l_j$ and n denote the normalized incident light vector[7] and the normalized outer surface normal, respectively (see Figure 3.18). In this way the scalar product $\langle l_j, n \rangle = \cos \alpha$ takes into account the dependence of the intensity for point sources on the angle of incidence α of the light (see Figure 3.18). Note that n is constant for flat outer surfaces over the entire surface i, while l_j varies from point to point. According to Equation (3.29) the resultant intensity $V_j^{(i)}$ from P_j is zero if l_j is perpendicular to n, so that it hits the surface i. $V_j^{(i)}$ is the largest when the light is normally incident from P_j.

[6] Instead of the parameter $R^{(i)}$ which is identical in Equations (3.26) and (3.29), different reflectivities $R_a^{(i)}$ and $R_j^{(i)}$ can be used for ambient light and for point light sources with diffuse reflection.

[7] We denote the normal incidence vector (the vector from the light source to the object point) by $-l$ in order to maintain a unified orientation for all the vectors n, l, etc. from the object point in the following figures and formulas.

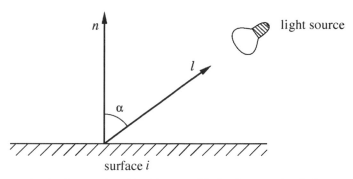

FIGURE 3.18 The angle of incidence of light for a point light source.

In practice Equation (3.29) is often extended with a further parameter $C_j^{(i)}$ in order to account for the distance of the light source P_j from the scene. Thus, for example,

$$C_j^{(i)} := \min\left\{ 1, \frac{1}{\alpha_0 + \alpha_1 \cdot d_j^{(i)} + \alpha_2 \cdot (d_j^{(i)})^2} \right\} \tag{3.30}$$

may be chosen, where $d_j^{(i)}$ denotes the (average) distance of the point source P_j from the surface i and α_0, α_1, and α_2 are parameters to be chosen by the user.

Thus, as a whole, we obtain the following refined model for the light intensity $V^{(i)}$ at a surface i including both the ambient light and the diffusely reflected light from m point sources:

$$V^{(i)} := V_a^{(i)} + \sum_{j=1}^{m} V_j^{(i)}$$

$$= I_a \times R^{(i)} + \sum_{j=1}^{m} I_j \times R^{(i)} \cdot \langle l_j, n \rangle \cdot C_j^{(i)}. \tag{3.31}$$

Here $V_a^{(i)}$ is the diffuse and $\sum_{j=1}^{m} V_j^{(i)}$ is the point-source portion of the reflected light.

In practice this model also yields relatively dull images, but shading is quite well recognizable. Further improvements in the quality require that specular reflections be included, along with diffuse reflection, which depends only on the angle of incidence with reflected light emerging uniformly in all directions.

3.3.3 Specular Reflection

The models for specular reflection discussed in this section are based on the fact that light incident on a smooth or shiny surface is not scattered

diffusely in all directions but primarily into a specific direction. In addition, for reflected light the color of the object plays only a subordinate role compared to the color of the light from the source. The direction in which the light is reflected for perfect mirroring is given by the well known relationship angle of reflection=angle of incidence (3.32). The eye is only struck by a narrow bundle of rays, since the light source is only reflected into the eye from a small region on the outer surface. This means that in Figure 3.19 only the rays from the gray shaded bundle of rays enter the eye, while the other rays do not.

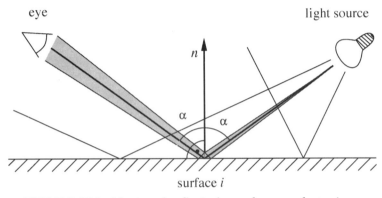

FIGURE 3.19 Incident and reflected rays for a perfect mirror.

This assumption of a perfect mirror is still not realistic. In practice a mirror surface is normally not absolutely flat. This can be seen by observing a real mirror surface with a microscope. Various mirror models exist for taking this fact into account. We shall discuss two of them briefly here: the theoretically based models of Torrance and Sparrow, Blinn, and Cook and Torrance, and the heuristic model of Phong Bui-Tong (see Color Plate 32).

In the following, $-l$ denotes the incident and r the (perfectly) reflected ray,[8] n is, as before, the outer surface normal, and a denotes the ray from the object point to the eye. In addition, the bisector h of the angle between l and a is introduced (see Figure 3.20). In addition, all vectors are normalized to unit length.

[8]See footnote 7 in Section 3.3.2 regarding the orientation of the vectors.

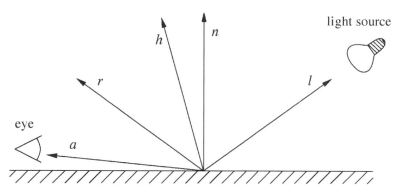

FIGURE 3.20 The rays l or $-l$ (incident ray), r (perfectly reflected ray), a (ray from the object point to the eye), and $h := (a+l)/\|a+l\|$.

A) The Torrance-Sparrow, Blinn or Cook-Torrance Model:

This model [TSB66, ToSp67, Blin77, CoTo82] is based on the notion that the outer surface is made up of very many small, flat, and differently oriented facets, all of which are perfect mirrors (see Figure 3.21). Proceeding from this model assumption, certain circumstances must be taken into account for each object point:

i) the fraction of the facets which reflect right into the eye and are, therefore, responsible for mirror and glare effects;

ii) the fraction of the outer surface (i.e., the number of facets) which is actually "visible" to the observer and to the light;

iii) the fractions of the incident and reflected light which are lost on the way to the eye owing to the roughness of the surface; and,

iv) the fraction of the light which is reflected overall.

FIGURE 3.21 Illustrating the structure of outer surfaces in the facet model.

Comments on i):

Certain facets, which are associated with a point on the surface in this idealized version, reflect directly into the eye because of their location ($a=r$ or $n=h$), while the others do not. The fraction of perfectly reflecting facets is customarily described by a parameter $D \in [0,1]$. D is greatest if the surface is precisely aligned ($n=h$) and is smallest for the worst possible alignment ($n \perp h$). There are numerous variants for modeling the distribution of D over the angle between n and h. One possibility is

$$D := \left(\frac{K}{K+1-\langle n,h \rangle} \right)^2 , \qquad (3.33)$$

where $K>0$ is a glare parameter to be specified by the user. For small K we obtain a very strong angular dependence and, accordingly, a lot of glare, and for large K a uniform appearance. Table 3.1 gives the values of D for extreme values of K and $\langle n,h \rangle$.

K \ $\langle n,h \rangle$	0	1
0.01	0.000098	1
100	0.980296	1

TABLE 3.1 Values of D as functions of the glare parameter K and of the angle between n and h.

Other possibilities for the choice of the parameter D include the Phong distribution [Phon75]

$$D := \langle n,h \rangle^k, \quad k \geqslant 0,$$

the Trowbridge-Reitz distribution [TrRe75, Blin77]

$$D := \frac{c^2}{\langle n,h \rangle^2 \cdot (c^2-1)+1}, \quad 0 \leqslant c \leqslant 1,$$

the Gauss distribution [ToSp67]

$$D := d \cdot e^{-(\langle n,h \rangle/m)^2}, \quad d \geqslant 0,$$

or the Beckmann distribution [BeSp63, CoTo82]

$$D := \frac{1}{4\, m^2 \cdot \langle n,h \rangle^4} \cdot e^{-(\tan\varphi/m)^2}.$$

Here φ is the angle between n and h (i.e., $\cos\varphi=\langle n,h\rangle$), k is the specular reflection exponent in the Phong illumination model to be described later under B), c and d are constants to be chosen appropriately, and, finally, m is the root mean square of the facet inclinations.

Comments on ii):

Depending on the angle of incidence of the light or on the angle between the ray a to the observer and the surface normal n, a variable fraction of the surface is "visible" for the light source or for the observer, respectively. In addition, the visible fractions are greater the more shallowly l and a are dispersed relative to the surface, as can be seen in Figure 3.22. This effect is taken into account by including the factors $1/\langle l,n\rangle$ and $1/\langle a,n\rangle$ in the equation for specular reflection.

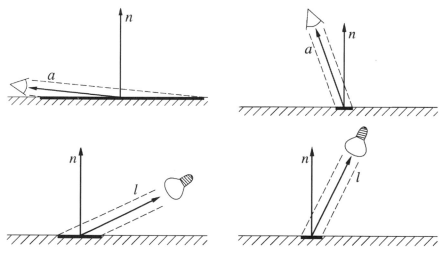

FIGURE 3.22 The visible portions of a surface as functions of $\langle a,n\rangle$ and $\langle l,n\rangle$ for the eye (above) and for the light (below), respectively.

Comments on iii):

The roughness of the surface made up of facets can block incident or reflected light, since the facets shadow one another under certain conditions (see Figure 3.23). This circumstance is modeled by introducing a parameter $G \in [0,1]$ which specifies the fraction of the light that propagates unhindered. G is calculated according to

$$G:=\min\{1,G_l,G_a\}, \tag{3.34}$$

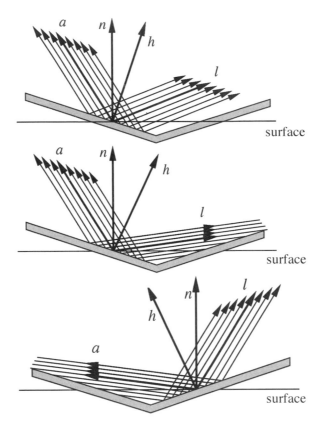

FIGURE 3.23 Unhindered propagation of incident and reflected light (top), blocking of incident light (middle), and blocking of reflected light (bottom).

where G_l describes the fraction of undistorted incident light and G_a, the fraction of undistorted reflected light. l_f is the size of a facet and l_b, the size of that portion of the facet by which the light is blocked as it leaves (see Figure 3.24); we then have

$$G_l := 1 - \frac{l_b}{l_f} \quad \text{or} \quad G_a := 1 - \frac{l_b}{l_f}. \tag{3.35}$$

Blinn has obtained the following relation for calculating G_l and G_a:

$$G_l := 2 \cdot \frac{\langle n,h \rangle \cdot \langle n,l \rangle}{\langle l,h \rangle},$$

$$G_a := 2 \cdot \frac{\langle n,h \rangle \cdot \langle n,a \rangle}{\langle a,h \rangle}. \tag{3.36}$$

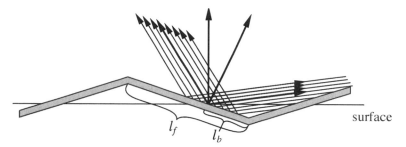

FIGURE 3.24 Facet fraction of blocked incident or reflected light.

Comments on iv):

Depending on the angle of observation and the wavelength λ of the incident light, not all of the light will be reflected, but some of it will be absorbed, while some will be transmitted transparently (cf. Figure 3.5). This relationship is modeled with the aid of a third parameter, $F_\lambda \in [0,1]$, which is calculated using the Fresnel formula as follows:

$$F_\lambda := \frac{1}{2} \cdot \left(\frac{g-c}{g+c} \right)^2 \cdot \left(1 + \left(\frac{c(g+c)-1}{c(g-c)+1} \right)^2 \right), \qquad (3.37)$$

where

$$c := \langle l, h \rangle,$$

$$g = \sqrt{\eta^2 + c^2 - 1},$$

$\eta :=$ effective refractive index (quotient of the refractive indices of the two media) as a function of wavelength λ).

The refractive index of a medium is the ratio of the velocity of light in a vacuum to that in the medium.

As an illustration we shall study two cases. If the light is in back of the observer, then l and n are almost parallel and we have $c = \langle l, h \rangle \approx 1$, as well as $g \approx \eta$. This implies that

$$F_\lambda \approx \left(\frac{\eta - 1}{\eta + 1} \right)^2 \qquad (3.38)$$

with a strong dependence, through η, on the material for F_λ. In the case of backlighting, l and h are, on the contrary, almost perpendicular to one another. Then $c \approx 0$ and $F_\lambda \approx 1$. This is consistent with experience in that almost all materials operate as mirrors or have glare with backlighting, whereas glare depends very strongly on the material for illumination from "behind" the observer (see Figure 3.25).

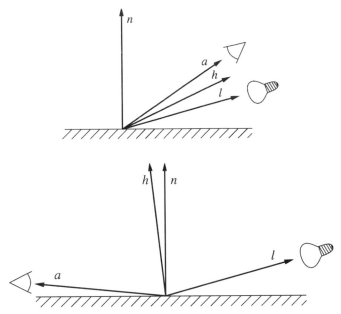

FIGURE 3.25 Material dependent glare with illumination from behind (above) and the general glare with backlighting (bottom).

Since the effective refractive indices for arbitrary materials and wavelengths are not known in general, these must be approximated. Usually one determines the value of F_λ for a given wavelength λ by measurement with $l=h$ (i.e., $c=1$). Since

$$F_\lambda = \left(\frac{\eta - 1}{\eta + 1} \right)^2 \tag{3.39}$$

for $c=1$, the effective refractive index η for the given wavelength λ can be determined (e.g., for the primary colors red, green, and blue, i.e., $F_\lambda = (F_R, F_G, F_B)^T \in [0,1]^3$).

Altogether, we obtain the following formulas for the intensity of the specular reflection $V_{j,r}^{(i)}$ at a point of a surface i with a point light source P_j:[9]

$$V_{j,r}^{(i)} := I_j \times F_{\lambda,j} \cdot R_S^{(i)} \cdot \frac{D_j \cdot G_j}{\langle l_j, n \rangle \cdot \langle a, n \rangle} \cdot C_j^{(i)}. \tag{3.40}$$

The intensity I_j of the point light source P_j, as well as the parameter $C_j^{(i)}$ for taking the distance $d_j^{(i)}$ of the source P_j from surface i into account, are defined as in Section 3.3.2. In the end, the strength of the specular reflection can be controlled using a color independent material parameter $R_S^{(i)} \in [0,1]$, the so-called specular reflectivity.

[9] See Equation (3.27) for a definition of the product $I_j \times F_{\lambda,j}$.

We now consider ambient light together with diffusely and specularly reflected light to obtain the total intensity $V^{(i)}$ for m point light sources,

$$V^{(i)} := V_a^{(i)} + \sum_{j=1}^{m} (V_j^{(i)} + V_{j,r}^{(i)})$$

$$= I_a \times R^{(i)} +$$

$$\sum_{j=1}^{m} \left(I_j \times R^{(i)} \cdot \langle l_j, n \rangle \; + \; I_j \times F_{\lambda,j} \cdot \frac{R_S^{(i)} \cdot D_j \cdot G_j}{\langle l_j, n \rangle \cdot \langle a, n \rangle} \right) \cdot C_j^{(i)}. \tag{3.41}$$

Again, as in Equation (3.31), the first summand represents the diffuse part of the light and the sum $\Sigma_{j=1}^{m}$, the point source part.

B) The Model of Phoung Bui-Tong:

This simple and widespread, purely heuristic model [Phon75] is based on the realization that specular reflection is strongest if a perfectly reflected ray enters the eye precisely ($r=a$) and becomes weaker as the angle φ between r and a becomes larger (cf. Figure 3.26).

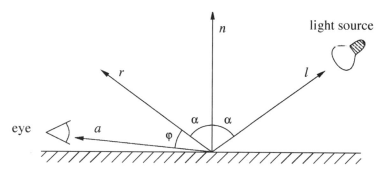

FIGURE 3.26 Rays and angles in the Phong model.

The strength of specular reflection and its angular dependence are described through two color independent parameters of the material, the above mentioned specular reflectivity $R_S^{(i)}$ and the so-called specular reflection exponent k. $R_S^{(i)}$ should properly depend on the angle α, but it is customarily assumed constant, at a value essentially determined experimentally from an aesthetic standpoint. In general, k can take values between one and a few hundred; for a perfect mirror k would be infinite (see Figure 3.27). The model yields the following intensity $V_{j,r}^{(i)}$ for specular reflection and a point light source P_j at a point on surface i:

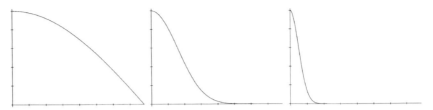

FIGURE 3.27 Angular dependence of specular reflection in Phong's model. Shown here is the term $\langle r,a \rangle^k = \cos^k \varphi$ as a function of φ for different values of k: $k=1$ (left), $k=10$ (middle), and $k=100$ (right).

$$V_{j,r}^{(i)} := I_j \cdot R_S^{(i)} \cdot \langle r_j, a \rangle^k \cdot \; C_j^{(i)}, \tag{3.42}$$

and the total intensity of the light is given by

$$V^{(i)} := V_a^{(i)} + \sum_{j=1}^{m} (V_j^{(i)} + V_{j,r}^{(i)})$$

$$= I_a \times R^{(i)} +$$

$$\sum_{j=1}^{m} (I_j \times R^{(i)} \cdot \langle l_j, n \rangle + \; I_j \cdot R_S^{(i)} \cdot \langle r_j, a \rangle^k) \cdot C_j^{(i)}. \tag{3.43}$$

For color displays, the vector $I_j = (I_{j,R}, I_{j,G}, I_{j,B})^T$ for specular reflection $V_{j,r}^{(i)}$ is multiplied by the scalars $R_S^{(i)}$, $\langle r_j, a \rangle^k$, and $C_j^{(i)}$.

As a final comment, we should point out that the color of object i in the Phong model has no effect at all through the Fresnel term F_λ in $V_{j,r}^{(i)}$ and in the models of Torrance and Sparrow, Blinn, or Cook and Torrance, this effect is weak, while $V_a^{(i)}$ and $V_j^{(i)}$ depend strongly on the color of object i through the reflectivity $R^{(i)}$.[10] If specular reflection dominates in this way, then the color of the light from the source is decisive, and this often leads to the observed light-colored or white glare on specularly reflecting surfaces

3.4 SHADING

In this Section we again limit ourselves to the case in which the outer surfaces of the objects to be represented are polygonal lattices or can be approximated by these. The concept of shading is taken to be the very

[10] The failure to take the color of the object into account in the Phong model presents no difficulty with outer surfaces of plastic or waxlike materials (billiard balls, apples), but for metallic surfaces the model presented in A) is already clearly superior.

general assignment of brightness or color values to the individual image points. Shading also, therefore, encompasses the choice of a suitable local illumination model, including the decision as to which image points the given model should be applied explicitly and to which cheaper interpolation models should be applied. The latter are required since the explicit calculation of the intensity or color values for each pixel, as in, say, ray tracing, using the illumination model is too expensive (cf. Section 3.7), especially for interactive real-time applications. In the following, therefore, we discuss a few efficient shading techniques which require the explicit determination of intensity or color at only a few points or which simplify their calculation.

3.4.1 Constant Shading

The simplest approach is so-called shading. Here the local illumination model is applied only to one point of the polygon (e.g., its center of gravity). The value obtained in this way is then assumed for all pixels of the polygon (see Color Plate 33). Evidently, this is a great simplification, for the scalar products $\langle l,n \rangle$ and $\langle a,n \rangle$, which appear in the illumination models are generally not constant over a polygon, unless the light source and observer are infinitely distant from the scene. In addition, strong intensity discontinuities can show up at edges; these are especially undesirable when the polygonal lattice is supposed to approximate a curved and smooth outer surface. The discontinuities in intensity or color are also enhanced by the so-called Mach streak effect. This makes a dark surface appear yet darker along an edge where it meets a brighter surface, while the brighter surface seems brighter along the edge, so that the edge is accentuated further (see Figure 3.28).

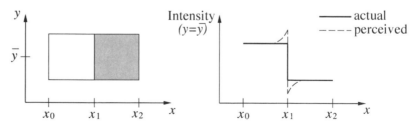

FIGURE 3.28 The Mach streak effect: discontinuities in intensity are perceived as stronger.

3.4.2 Interpolated Shading

In order to get a better grasp of the above problem, we proceed from constant to interpolated shading [WREE67]. The basic principle of

Gouraud shading [Gour71] involves using the local illumination model explicitly only in the corners of the polygon or of the polygonal lattice. Linear interpolation is used along the edges and appropriate interpolation techniques come into action in the interior of the polygons. We no longer proceed from a fixed intensity or color value per polygon, but from values of these per corner point. Another way is Phong shading [Phon75], in which normal vectors, rather than intensities, are interpolated.

3.4.2.1 Gouraud Shading

With Gouraud shading [Gour71] the intensity or color information is interpolated. In this way, discontinuities in intensity or color along the edges are eliminated. For explicit calculation of the values at the corner points the normals are required there. These can be obtained either directly from an analytic description of the outer surface or by taking the average of the surface normals of adjacent polygons. The following steps are involved:

1. Compute the corner normals (analytically or by taking the average of the surface normals of all adjacent polygons).

2. Compute the corner intensities using the corner normals based on the appropriate local illumination model.

3. Determine the intensities along the edges by linear interpolation of the corner intensities.

4. Determine the intensities in the interior of the polygon along each scan line by linear interpolation of the edge intensities (see Figure 3.29).

For transitions that are not actually smooth, e.g., for representing the boundary between sectors of the wing on the fuselage of an airplane, the edges must remain explicitly visible. This can be achieved by calculating two normals in step 1 of the above algorithm, with only the surface normals "on the side" being used for the average. In Figure 3.30, for example, the segment from A to B must remain visible as a sharp edge. For that purpose the two normals $n_{P,1}$ and $n_{P,2}$ are calculated at the point P, as well as the two resulting intensities $I_{P,1}$ and $I_{P,2}$. Then $I_{P,1}$ will be used for interpolation in polygons 1 and 2 and $I_{P,2}$, for interpolation in polygons 3 and 4. Intensity discontinuities are then produced along the segment AB such that the corresponding edges remain visible.

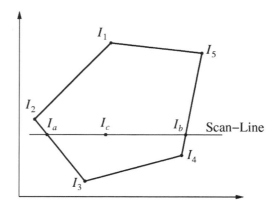

$$I_a = I_2 \cdot \frac{x_3 - x_a}{x_3 - x_2} + I_3 \cdot \frac{x_a - x_2}{x_3 - x_2}$$

$$I_b = I_4 \cdot \frac{x_5 - x_b}{x_5 - x_4} + I_5 \cdot \frac{x_b - x_4}{x_5 - x_4}$$

$$I_c = I_a \cdot \frac{x_b - x_c}{x_b - x_a} + I_b \cdot \frac{x_c - x_a}{x_b - x_a}$$

FIGURE 3.29 Interpolation of intensities in Gouraud shading.

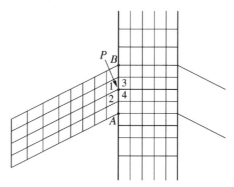

$$n_{P,1} := \frac{n_1 + n_2}{\| n_1 + n_2 \|} \Rightarrow I_{P,1}$$

$$n_{P,2} := \frac{n_3 + n_4}{\| n_3 + n_4 \|} \Rightarrow I_{P,2}$$

$$n_i : \text{ surface normal in polygon } i$$

FIGURE 3.30 Visible edges in Gouraud shading: in order for the edge *AB* to remain visible, two normals and, therefore, two intensities, will be calculated at all points *P* along *AB*.

3.4.2.2 Phong Shading

As opposed to Gouraud shading, here normal vectors will be interpolated [Phon75], rather than intensities. This yields the following algorithm:

1. Compute the corner normals (as in Gouraud shading).

2. Determine the normals along the edges by linear interpolation of the corner normals with subsequent normalization. From that, calculate the intensities at the edge using the local illumination model.

3. Determine the normals in the interior of the polygon along each scan line by linear interpolation of the edge normals with subsequent normalization. From that, calculate the intensities in the interior using the local illumination model.

Since all the normal vectors must also be normalized and the local illumination model is used explicitly at each point, Phong shading is considerably more expensive than Gouraud shading. However, fast software implementation is available for Phong shading. Yet, in terms of hardware solutions, Gouraud shading still has distinct advantages, so that Gouraud shading is mostly used for real-time applications.

By contrast, Phong shading provides images that are to some extent substantially better in quality, especially with local illumination models that take account of specular reflection (see Color Plates 34 and 35). With a better approximation for the normals, here the curvature of surfaces and the resulting illumination effects show up more realistically. Thus, Phong shading, particularly in combination with the Phong illumination model of Section 3.3.3, does a better job of preserving, for example, the local characteristics of glare and mirror effects (highlights) at corners with high specular reflection exponents k (cf. Figure 3.27) and, thereby, permits a realistic reproduction of the material properties of smooth outer surfaces, while Gouraud shading, with its linear interpolation of intensity, greatly exaggerates the area over which glare effects are important. In this way the glare is reduced and "watered down."

3.5 TRANSPARENT OBJECTS

Besides undergoing diffuse and specular reflection or absorption, light rays are also transmitted by many materials. Here we distinguish transparent materials, such as glass, through which, despite possible refraction, objects can be seen clearly, and translucent materials, which include transparent materials, but also such materials as frosted glass, which do let light pass but through which objects cannot be recognized. Here we briefly discuss the treatment of transparent objects.

3.5.1 Transparency Without Refraction

Simple models for transparency ignore the refraction of light. Here three approaches can be distinguished: interpolated transparency, screen-door transparency, and filtered transparency. In the following a transparent object (Polygon 1) screens the view of an opaque object (Polygon 2) (see Figure 3.31).

Polygon 1 Polygon 2

FIGURE 3.31 A two-dimensional example of transparency: Polygon 1 (transparent) screens Polygon 2 (opaque).

3.5.1.1 Interpolated Transparency

Here the resulting interpolated intensity I_p at a pixel is given by

$$I_P := (1 - k_t) \cdot I_1 + k_t \cdot I_2, \tag{3.44}$$

where I_1 and I_2 are the intensity or color values at the given pixel according to the local illumination model for Polygon 1 and Polygon 2, respectively. The so-called transmission coefficient k_t specifies how transparent the material in Polygon 1 is. If $k_t = 1$, then Polygon 1 is completely transparent and, therefore, "invisible." In the other extreme case, $k_t = 0$, Polygon 1 is opaque, so that Polygon 2 is entirely hidden.

3.5.1.2 Screen-Door Transparency

Depending on the degree of transparency, some pixels will take the intensity or color value I_1 of Polygon 1, while others will take the value I_2 of Polygon 2 (cf. Figure 3.32):

$$I_P \in \{I_1, I_2\}. \tag{3.45}$$

With this procedure, problems can arise in the case of multiple transparent objects behind one another if the corresponding patterns overlay one another in an unfavorable manner.

FIGURE 3.32 Two examples of screen-door transparency. On the left, the pixels are set alternatingly with the intensities I_1 and I_2, and on the right, two pixels with I_1 follow one with I_2 (displaced from row to row).

3.5.1.3 Filtered Transparency

Here Polygon 1 can operate as a filter and light at certain wavelengths preferentially transmitted, i.e.,

$$I_{P,\lambda} := (1 - k_t(\lambda)) \cdot I_1 + k_t(\lambda) \cdot I_2. \tag{3.46}$$

The transmission coefficient $k_t(\lambda)$ depends on wavelength. In this way, a material such as red glass can be modeled for Object 1, with $k_t(\lambda)$ very low in the red but high in the complementary cyan region.

3.5.2 Transparency with Refraction

The situation is more complicated if the refraction of the light must also be modeled (see, for example, [Thom86, Musg89]). Then the fact that a ray of light may be refracted on passing from a medium with refractive index η_1 into another with refractive index η_2 and, thereby, change its direction (cf. Figure 3.33), must be taken into account. Here the exit angle β can be calculated from the angle of incidence and the refractive indices of the two materials using Snell's law:

$$\frac{\sin\alpha}{\sin\beta} = \frac{\eta_2}{\eta_1}. \tag{3.47}$$

Here there is an added difficulty in that refraction depends on wavelength, as can be seen in the dispersion of light by a prism. In addition, such effects as total internal reflection must be taken into account: on passing into an optically thinner medium, i.e., a medium with a lower refractive index ($\eta_2 < \eta_1$), the exit angle exceeds the angle of incidence ($\beta > \alpha$). If the latter is sufficiently large, then no ray can pass into the optically thinner medium according to Equation (3.47); that is, the ray will be completely reflected or absorbed and not transmitted (see Figure 3.34). This leads to the same behavior as for opaque materials.

The plate captions can be found on pages 241–244

Color Plate 1

Color Plate 2

Color Plate 3

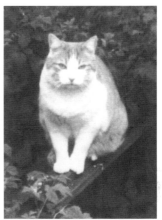

Color Plate 4

Color Plate 5

Color Plate 6

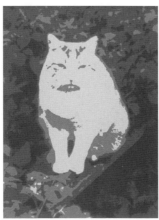

Color Plate 7

Color Plate 8

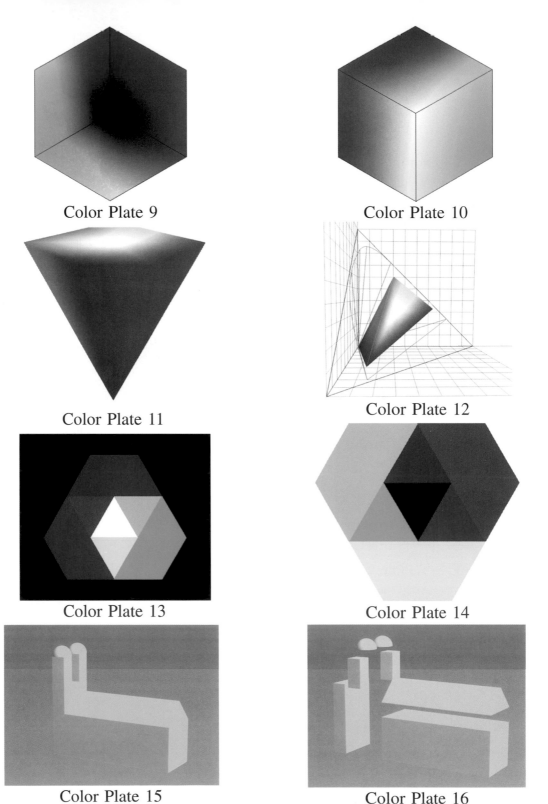

Color Plate 9

Color Plate 10

Color Plate 11

Color Plate 12

Color Plate 13

Color Plate 14

Color Plate 15

Color Plate 16

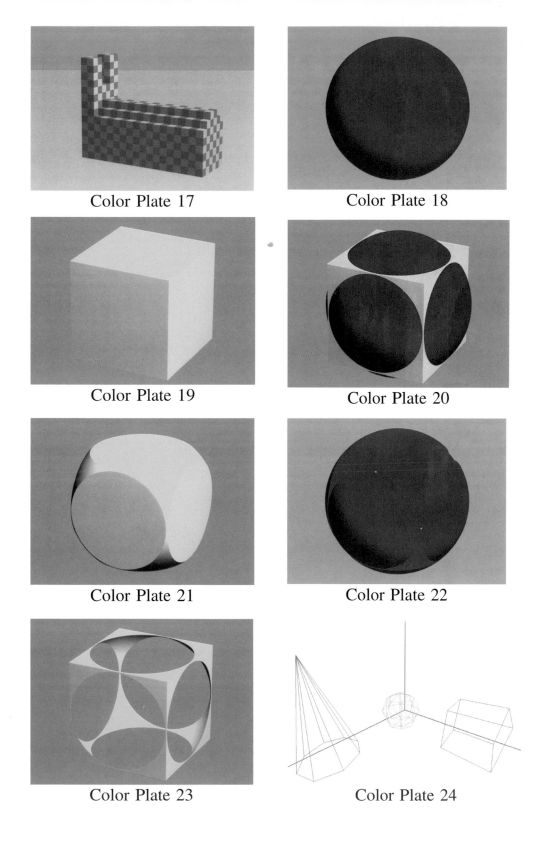

Color Plate 17

Color Plate 18

Color Plate 19

Color Plate 20

Color Plate 21

Color Plate 22

Color Plate 23

Color Plate 24

Color Plate 25

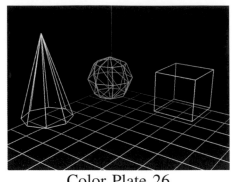

Color Plate 26

Color Plate 27

Color Plate 28

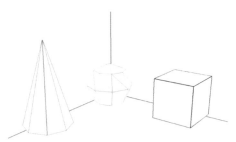

Color Plate 29

Color Plate 30

Color Plate 31

Color Plate 32

Color Plate 33

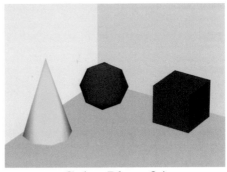

Color Plate 34

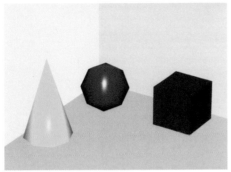

Color Plate 35

Color Plate 36

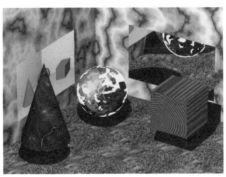

Color Plate 37

Color Plate 38

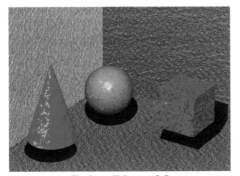

Color Plate 39

Color Plate 40

Color Plate 41

Color Plate 43

Color Plate 44

Color Plate 45

Color Plate 42

Color Plate 46

Color Plate 47

Color Plate 48

Color Plate 49

Color Plate 50

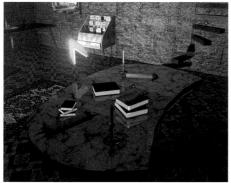

Color Plate 51

Color Plate 52

Color Plate 53

Color Plate 54

Color Plate 55

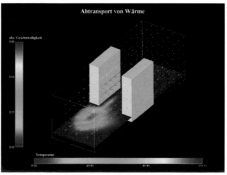

Color Plate 56

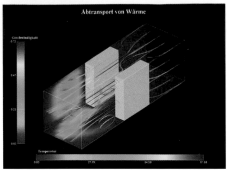

Color Plate 57

Color Plate 58

Color Plate 59

Color Plate 60

Color Plate 61

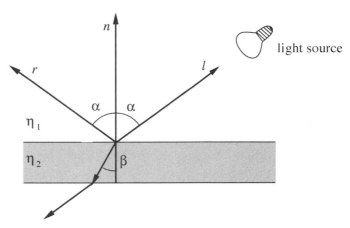

FIGURE 3.33 Refraction of a ray of light on passing through another material ($\eta_2 > \eta_1$).

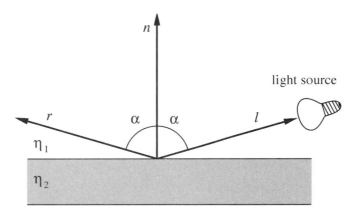

FIGURE 3.34 Total internal reflection. The gray material has a lower index of refraction ($\eta_2 < \eta_1$).

There is, furthermore, a reduction in the intensity of light as it propagates through a transparent object. This reduction is determined by the transmission (coefficient):

$$T := te^{-ad}. \tag{3.48}$$

Here d is the path length of the ray in the transparent object. The transparency t is the fraction of the light which is not reflected. The absorption coefficient a is an indicator of how fast the light will be attenuated by a material (a and t are properties of the material). In this way, the transparency properties can be calculated in ray tracing. If the intensity of the

light is I_{in} on entering a given object, then the light leaves the object with an intensity I_{out} such that

$$I_{out} := T \cdot I_{in}. \tag{3.49}$$

3.6 GLOBAL ILLUMINATION

In Section 3.3 we studied various local illumination models in order to be able to describe the relationships among light at a given point in the scene. However, the modeling of global illumination, i.e., the interactions of light from all the objects in the scene, is also of outstanding importance for the creation of photorealistic images. This will be discussed in the following section.

The first approach, so-called ray tracing, goes back to Whitted (1980) and Appel (1968) [Appe68, Whit80]. It can reproduce specular reflection perfectly, but cannot diffuse illumination or ambient light at all. The resulting pictures appear synthetic and too perfect. Accordingly, the antithesis, in the form of the radiosity procedure, which reproduces diffuse illumination perfectly, was introduced by Goral et al. in 1984 [GTGB84]. Specular reflections, of course, are entirely impossible in this case. The resulting images seem more natural but still not realistic; mirroring and glare effects are lacking. Subsequently, numerous approaches with a combination of ray tracing and radiosity have been developed, ranging from simple applications to excessively complicated procedures. Nevertheless, problems remain with the reproduction of indirectly mirrored illumination (as by a mirror), i.e., so-called caustics. Further developments included path tracing [Kaji86] and light or backward ray tracing [Arvo86]. Both of these are, in principle, in a position to solve the global illumination problem, but they still have problems with computational cost or limitations of geometrical description. One significant improvement is Monte Carlo ray tracing with photon maps [Jens96], which can efficiently reproduce the so-called caustics with satisfactory quality.

3.6.1 Radiometric Quantities

Radiometry is the study of the (physical) measurement of electromagnetic energy. Some of the important radiometric quantities are significant for the following discussion. Here the references are to an observed surface A in the scene. $x \in A$ denotes a point on the observed surface, and $\omega \in S^2$ and $\omega \in H^2$ refer to the direction of a ray in terms of the unit sphere S^2 or the unit hemisphere H^2, respectively. We also introduce the concept of solid angle, which is generally measured in terms of

the area on the outer surface of H^2 and has a maximum value of 2π, or $2\pi\,sr$ in terms of the artificial unit steradian. For a surface segment on a hemisphere of arbitrary radius r, the solid angle is given simply by dividing the area by r^2. Finally, the angle $\theta = \theta(x,\omega)$ represents the angle between the surface normal at x and the direction ω of the ray (see Figure 3.35). We now proceed to the radiometric quantities of interest:

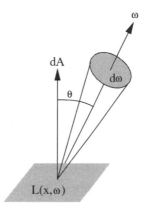

FIGURE 3.35 An oriented surface element and solid angle.

- The radiant energy Q is the electromagnetic energy or light energy (unit: Joule).
- The radiant power (flux) Φ is the energy arriving or leaving per unit time (unit: Watt; normally only the static case is treated, so the concepts of radiant energy and radiant flux are synonymous):

$$\Phi \;:=\; \frac{\partial Q}{\partial t}. \tag{3.50}$$

- The radiance $L(x,\omega)$ is the radiant power in an infinitesimally thin ray or the radiant power per unit surface $dA\cos\theta$ perpendicular to the ray and per solid angle $d\omega$ in the direction ω of the ray (unit: $W/m^2/sr$). L_i, L_o, L_r, and L_e denote the incident, outgoing, reflected, and emitted radiances, respectively.
- The irradiance E is taken to be the incident radiant power per unit area (unit: W/m^2; a sum or integral is taken over all the incident directions ω_i):

$$dE := L_i(x,\omega_i)\cos\theta_i\,d\omega_i,$$

$$E(x) \;:=\; \int_{H^2} L_i(x,\omega_i)\cos\theta_i\,d\omega_i. \tag{3.51}$$

- The radiosity (exitance) B, on the other hand, is the outgoing radiant power per unit area (the units are also W/m^2, with a sum or integral over all the outgoing directions ω_o):

$$dB := L_o(x,\omega_o)\cos\theta_o \, d\omega_o,$$

$$B(x) := \int_{H^2} L_o(x,\omega_o)\cos\theta_o \, d\omega_o. \tag{3.52}$$

- The radiant intensity I is the outgoing radiant power per solid angle (unit W/sr; a sum or integral is taken over all surface elements A, i.e., over $\Omega := \cup A$):

$$dI := L_o(x,\omega_o)\cos\theta_o \, dA,$$

$$I(\omega_o) := \int_{\Omega} L_o(x,\omega_o)\cos\theta_o \, dA. \tag{3.53}$$

The interrelationships of these quantities are evident from some multiple integrals:

$$\Phi_o = \int_{H^2} I(\omega_o) \, d\omega_o = \int_{\Omega} B(x) \, dA = \int_{\Omega}\int_{H^2} L_o(x,\omega_o)\cos\theta_o \, d\omega_o \, dA,$$

$$\Phi_i = \int_{\Omega} E(x) \, dA = \int_{\Omega}\int_{H^2} L_i(x,\omega_i)\cos\theta_i \, d\omega_i \, dA.$$

In the case of complete reflection (no transparency or refraction, no absorption), we always have $\Phi_o = \Phi_i$ for a surface A.

The radiance has two important properties: it is constant along a ray, provided the ray strikes no surface, and it is the decisive quantity in the response of a light sensitive detector (cameras, the eye).

Finally, all the above quantities actually depend on the wavelength of the light. Thus, theoretically a further integral over the wavelength appears, but in practice this is limited to the three-dimensional RGB vector (R,G,B) for the primary colors red, green, and blue.

3.6.2 The Rendering Equation

We return once more briefly to local illumination. As we have already seen in Section 3.3, a description of reflection is decisive for modeling the optical appearance of surfaces. Reflection depends on the direction of the incident and outgoing light, on the wavelength of the light, and on the corresponding point on the surface. The most important means of description in this regard are the Bidirectional Reflection Distribution Functions

(BRDF) $f_r(x, \omega_i \rightarrow \omega_r)$ which give the dependence of the outgoing (reflected) light on the incident radiance:

$$dL_r = f_r(x, \omega_i \rightarrow \omega_r)\, dE = f_r(x, \omega_i \rightarrow \omega_r) L_i(x, \omega_i) \cos\theta_i\, d\omega_i\,. \qquad (3.54)$$

Note that the reflected radiance is related to the incident irradiance, rather than to the incident radiance. (The justification for this is beyond the scope of the present discussion.) In general, the BRDF are anisotropic; a rotation of the outer surface can, therefore (for unchanged incident and outgoing directions), lead to a different reflected light.

The so-called reflectance equation,

$$L_r(x, \omega_r) = \int_{H^2} f_r(x, \omega_i \rightarrow \omega_r) L_i(x, \omega_i) \cos\theta_i\, d\omega_i\,, \qquad (3.55)$$

can be derived from Equation (3.54). It gives the (local) relationship between incident and reflected light. The BRDF provide a very general way of describing reflection. Because of the complexity, in practice simple (local) reflection models are used for the different classes of BRDF and these should primarily reduce the number of parameters (see Figure 3.36.):

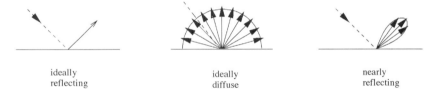

| ideally | ideally | nearly |
| reflecting | diffuse | reflecting |

FIGURE 3.36 Different reflection behavior and different types of BRDF.

- With ideal specular reflection an incident ray is reflected into exactly one direction, in accordance with Snell's law for reflection. The BRDF is modeled using Dirac δ-functions.
- With nearly specular reflection, the light is reflected into a distribution that is sharply concentrated about the ideal direction of reflection.
- In Lambertian or diffuse reflection the incident light is reflected in all directions equally, so the corresponding distribution is uniform.

General reflection or illumination models often combine all the approaches (cf. the models of Torrance-Sparrow, Blinn, Cook-Torrance, and Phong discussed above). Transparency and refraction can easily be built in by including the lower or inner hemisphere as possible "directions of reflection." For the sake of simplicity, in the following all the integrals will only be formulated with respect to H^2. At this point, however, in every case a description is only given of how the light is

incident and what happens to the incident light. To answer the question of how the incident light has arisen requires yet another step.

That is, how is the incident light configured? In order to clarify this question we first consider the local case: a point light source at x_s has intensity I_s. The radiance L_i at a point x in the scene is then given by

$$L_i(x,\omega) = \begin{cases} I_s \cdot |x - x_s|^{-2} & \text{for } \omega = \omega_s := x - x_s, \\ 0 & \text{otherwise} \end{cases} \tag{3.56}$$

The integral (3.55) then degenerates to the expression (integrating formally over a Dirac spike)

$$L_r(x,\omega_r) = \frac{I_s}{|x - x_s|^2} f_r(x, \omega_s \to \omega_r)\cos\theta_s, \tag{3.57}$$

or to a sum of n such terms for n point light sources in an admittedly primitive illumination model. Global illumination, however, is more than a local treatment at all points of the scene. The interplay of the individual surfaces must be correctly reproduced. This interplay is nothing other than energy transport: light sources emit radiation which is reflected, refracted, or absorbed at the scene. The light which ultimately reaches the eye or camera must be calculated. To do this the radiance must be integrated over the corresponding visible surfaces for every image pixel. The resultant radiant power then defines the brightness and color of the pixel. The radiance leaving a point x in direction ω_o is made up of (self-) emitted and reflected radiances:

$$L_o(x,\omega_o) = L_e(x,\omega_o) + L_r(x,\omega_o). \tag{3.58}$$

With Equation (3.55) this yields the rendering equation [Kaji86]:

$$L_o(x,\omega_o) = L_e(x,\omega_o) + \int_{H^2} f_r(x,\omega_i \to \omega_o)L_i(x,\omega_i)\cos\theta_i \, d\omega_i, \tag{3.59}$$

which describes the global energy balance for the light from the scene. The geometry of the scene, the BRDF of the outer surfaces, and the light sources (interpreted as purely self-emitting surfaces) completely determine the distribution of the light.

The rendering equation (3.59) is still not entirely satisfactory: first of all, the incident radiance appears under the integral while the outgoing radiance appears on the left hand side; second, the integral over the hemisphere is somewhat unwieldy. For a more convenient way of writing the rendering equation, we need the visibility function $V(x,y)$ given by

$$V(x,y) := \begin{cases} 1: & x \text{ sees } y, \\ 0: & \text{otherwise}. \end{cases} \tag{3.60}$$

Here $x \in A_x$ and $y \in A_y$ are two points on two surfaces A_x and A_y in the scene. With this visibility function we obviously have

$$L_i(x,\omega_i) = L_o(y,\omega_i) V(x,y). \tag{3.61}$$

In order to change the region of integration, we relate $d\omega_i$ to the surface segment dA_y from which the light originates:

$$d\omega_i = \frac{\cos\theta_y \, dA_y}{|x-y|^2}. \tag{3.62}$$

With the definition

$$G(x,y) := V(x,y) \cdot \frac{\cos\theta_i \cos\theta_y}{|x-y|^2} \tag{3.63}$$

we then obtain the following, second form for the rendering equation:

$$L_o(x,\omega_o) = L_e(x,\omega_o) + \int_\Omega f_r(x,\omega_i \to \omega_o) L_o(y,\omega_i) G(x,y) \, dA_y. \tag{3.64}$$

With the integral operator

$$(Tf)(x,\omega_o) := \int_\Omega f_r(x,\omega_i \to \omega_o) f(y,\omega_i) G(x,y) \, dA_y \tag{3.65}$$

Equation (3.64) simplifies to

$$L_o = L_e + TL_o \text{ or, briefly, } L = L_e + TL. \tag{3.66}$$

The luminous transport operator T also transforms the radiance at A_y into the radiance at A_x (after one reflection). Applying Equation (3.66) recursively yields

$$L = \sum_{k=0}^{\infty} T^k L_e, \tag{3.67}$$

where L_e is for emitted light, TL_e is for direct illumination, and $T^k L_e$, with $k > 1$, is for indirect illumination after $k-1$ reflections.

The global illumination is now determined by solving the rendering equation in the integral equation form (3.59) or (3.64). This will be discussed in the next section.

3.6.3 Solving the Rendering Equation

3.6.3.1 Classification of Procedures

Most procedures for solving the global illumination problem make a more or less direct attempt to solve the rendering equation approximately. They can be classified in terms of the depth to which they account for different types of interactions of light (characterized by a series of reflections along the way from the light source to the eye). Using the notation L for the light source, E for the eye, D for a diffuse reflection, and S for a specular reflection, an optimal procedure must be able to account for all sequences of the type of the regular expression

$$L\,(\,D\,|\,S\,)^*\,E \tag{3.68}$$

(see Figure 3.37 and [Kahl99]). Since "mirror" transparency (transparent, e.g. glass) and diffuse transparency (translucent, e.g. frosted glass) can be distinguished, all cases are actually covered by Equation (3.68). In addition, if X denotes a point in the scene, then the following types of illumination can be distinguished for that point:

$L\,X$ direct illumination,

$L\,(\,D\,|\,S\,)^+\,X$ indirect illumination,

$L\,D^+\,X$ purely diffuse indirect illumination,

$L\,S^+X$ purely specular indirect illumination. $\tag{3.69}$

Since the last case is especially "burning," the corresponding illumination phenomena are referred to as caustics.[11]

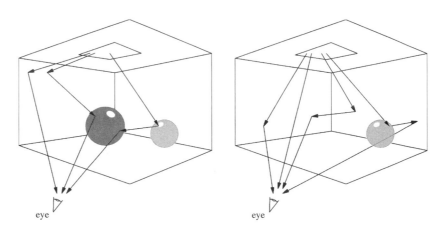

FIGURE 3.37 Different light paths: *LDE*, *LDSE*, *LSSE*, and *LDE*, *LE*, *LDDE*, *LSDE* (from left to right, respectively).

[11] Greek kaustikos, from kaiein, to burn.

3.6.3.2 Ray Tracing

Ray tracing is the oldest and quite the simplest procedure for global illumination. The projection of shadows, as well as ideal specular reflection and refraction, is included, but diffuse illumination is not. The algorithmic basis is the same as for ray casting in Section 3.2.7, specifically ray tracking. Some light rays are tracked, which from the standpoint of an observer, propagate and terminate the first time they strike an object in the scene, while, in some cases, they never end. Energy is transported in the form of radiance.

We shall examine the algorithm, as well as its different variants and possibilities for optimization, in detail in Section 3.7. Here we limit ourselves to its qualities with regard to global illumination. A ray is launched outward from the observer via each image pixel to the scene (primary rays). If a ray strikes no object, then the pixel retains the background color. Otherwise, three types of secondary rays start from the nearest intersection point x: perfectly reflected rays (for material that is not entirely dull), perfectly refracted rays (for translucent material), and the so-called shadow rays to all light sources. Each light source that is reached by the corresponding shadow ray without hindrance (i.e., an object in the scene) illuminates x directly. The radiance propagating from x to the observer is then recursively determined from the radiance values contributed by all the secondary rays, from the respective directions, and the BRDFs in x according to the local illumination model with Equation (3.57). A maximum recursion depth or a minimum radiance must be set in order to terminate the recursion. The missing diffuse reflection is ultimately modeled with a constant term for ambient light.

According to the classification of Equation (3.68), ray tracing again yields all paths of the type

$$L D S^* E. \tag{3.70}$$

The factor D in Equation (3.70) is necessary since the shadow rays viewed from the light source can take directions that are arbitrary and independent of any "direction of incidence." Paths of the type $L S^* E$ cannot be represented, as light sources are not treated as objects and, accordingly, can only be struck by shadow rays.

The determination of the radiance propagating to the observer at an intersection point x is obtained, as noted above, on the basis of a local illumination model (3.57). In the original ray tracing, the arriving radiance was simply multiplied by a material dependent reflection or refraction coefficient, independently of the incoming or outgoing direction. Similarly to the rendering equation in the form (3.67), we can now write the ray tracing function in its generalized form as

$$L = L_0 + \sum_{k=1}^{\infty} T_0^k L_e, \tag{3.71}$$

where L_0 represents the ambient term. There is no L_e term, since point sources are not treated as emitting objects. As opposed to T, T_0 is not an integration, but, rather, a simple summation operator which takes the sum of the three terms corresponding to direct illumination, reflected light, and refracted light. From the form of the rendering equation which is to be solved this means that, instead of taking the integral over all incident directions, we sample a pair of rigorously specified directions, namely the perfectly reflected, the perfectly refracted, and those which lead to light sources.

3.6.3.3 Path Tracing

Path tracing (also referred to as Monte Carlo ray tracing or Monte Carlo path tracing) was proposed by Kajiya in 1986 [Kaji86]. The idea is to tackle the rendering equation (3.59) directly and solve it by Monte Carlo integration. As with ray tracing, we replace the integral over all directions with samples in a finite number of directions. The directions to the light sources are retained (random rays cannot strike point light sources, although they are very important), but the perfectly reflected and perfectly refracted rays are replaced by a few rays whose directions are determined randomly (whence the term Monte Carlo). In this way, the cascading recursion of ray tracing is replaced by a linear recursion, a path for the rays (whence the name path). The recursion depth can be rigidly specified, chosen adaptively, or determined by Russian roulette, according to which it is randomly determined in each case whether the path is to end or to continue (to the maximum depth, just as in Russian roulette).

Instead of a uniform distribution over all directions, it is possible to use a weighted distribution based on the BRDF, which uses the most important directions in the BRDF to be favored in the sample in accordance with

$$\rho(x, \omega_o) := \int_{H^2} f_r(x, \omega_i \to \omega_o) \cos\theta_i \, d\omega_i \tag{3.72}$$

as

$$\frac{f_r(x, \omega_i \to \omega_o) \cos\theta_i}{\rho(x, \omega_o)} \tag{3.73}$$

for a distribution over H^2, as an estimator for the integral in Equation (3.59). The direction ω_i obtained from this distribution then gives

3 Graphical Representation of Three-Dimensional Objects 157

$$\rho(x,\omega_o)\cdot L_i(x,\omega_i). \tag{3.74}$$

It is important to introduce a distribution, as in Equation (3.73), since only by means of a preference in the directions "close to" a perfectly reflected ray is it actually possible to distinguish between diffuse and specular reflection.

Since only a few directions are used as a sample for determining the integral in path tracing, a significant amount of noise results. Although linear (path) recursion must remain untouched for reasons of efficiency, one now shoots several rays, rather than just one, through each pixel in the scene and takes the average of the result.

As for the classification according to Equation (3.68), path tracing can reproduce all the desired paths

$$L D (D \mid S)^* E \tag{3.75}$$

in principle. The first D must appear for the same reasons as in ray tracing. Otherwise, because of the random choice of directions, there is no difference between specular and diffuse reflection for path tracing. (In choosing a distribution as in Equation (3.73), the directions of perfectly reflected or perfectly refracted rays will be "proposed" only by chance.) Thus, two major deficiencies are to be noted. First, despite the linear recursion now in use, path tracing is still extremely costly, since between 25 and 100 rays must be launched per pixel for typical scenes in order to obtain a satisfactory result. Second, some difficulties remain in the reproduction of caustics. According to Equation (3.69) these are characterized as $L\ S{+}X$ or $L\ S{+}D\ E$. Let us consider the example of a mirror whose surface is illuminated indirectly. Direct light from a light source to the surface would be handled separately by shadow rays, but the light emerging from the mirror (which now serves to some extent as a secondary light source) is not. Here chance must ensure that this is taken care of in the framework of the Monte Carlo process, but this only happens with a certain probability.

3.6.3.4 Radiosity Procedures

Radiosity is the name of both the quantity introduced in Equation (3.52) and of a procedure for global illumination. This was proposed by Goral et al. in 1984 [GTGB84] and uses a fundamentally different starting point that is not ray oriented.

Radiosity dispenses with specular reflections and begins with exclusively diffusive surfaces. Thus, the light sources are now interpreted as objects in the scene and, therefore, as surfaces. Consequently, none of the

BRDFs depend on the direction of the incident or outgoing light and in the rendering equation of the form (3.64), the BRDFs can be put in front of the integral:

$$L_o(x, \omega_o) \;=\; L_e(x, \omega_o) \;+\; \int_\Omega f_r(x, \omega_i \to \omega_o) L_o(y, \omega_i) G(x, y)\, \mathrm{d}A_y$$

$$=\; L_e(x, \omega_o) \;+\; \int_\Omega f_r(x) L_o(y, \omega_i) G(x, y)\, \mathrm{d}A_y$$

$$=\; L_e(x, \omega_o) \;+\; f_r(x) \cdot \int_\Omega L_o(y, \omega_i) G(x, y)\, \mathrm{d}A_y. \tag{3.76}$$

Since the radiance leaving a diffuse outer surface manifests no directional dependence, Equation (3.76) can also be formulated in terms of $B(x)$ to yield the so-called radiosity equation, a Fredholm integral equation of the second kind:

$$B(x) \;=\; B_e(x) \;+\; \frac{\rho(x)}{\pi} \cdot \int_\Omega B(y) G(x, y)\, \mathrm{d}A_y. \tag{3.77}$$

Here the reflectance $\rho(x)$ obeys

$$\rho(x) \;:=\; \int_{H^2} f_r(x) \cos\theta_i\, \mathrm{d}\omega_i \;=\; f_r(x) \cdot \int_{H^2} \cos\theta_i\, \mathrm{d}\omega_i \;=\; \pi \cdot f_r(x) \tag{3.78}$$

[(cf. Equation (3.72)].

Radiosity is independent of the viewing configuration. The global illumination is, therefore, calculated once for the entire scene and not for a particular observer position. To solve it, the radiosity equation (3.78) is discretized in the finite element sense. All surfaces in the scene are covered with a lattice of flat surface segments f_i with areas A_i, with $1 \leqslant i \leqslant n$, where there is no longer a distinction between light sources and objects, as such. (Note the new meaning of A_i.) Luminous transport from f_i to f_j is described by introducing form factors F_{ij}. Here F_{ij} gives the fraction of the radiant power $A_i \cdot B_i$ (the power leaving f_i) which reaches f_j. Evidently, therefore, $0 \leqslant F_{ij} \leqslant 1$. De facto, the form factors essentially correspond to the function G in Equations (3.63) or (3.77). Then Equation (3.77) becomes

$$B_i \;=\; B_{e,i} \;+\; \rho_i \cdot \sum_{j=1}^{n} \frac{B_j \cdot A_j \cdot F_{ji}}{A_i} \quad \forall\; 1 \leqslant i \leqslant n. \tag{3.79}$$

The factor π^{-1} has been subsumed in the form factor. Equation (3.79) can be simplified using the relation

$$A_i \cdot F_{ij} = A_j \cdot F_{ji} \tag{3.80}$$

to obtain the discrete radiosity equation:

$$B_i = B_{e,i} + \rho_i \cdot \sum_{j=1}^{n} B_j \cdot F_{ij} \ \forall \ 1 \leqslant i \leqslant n. \tag{3.81}$$

The two essential tasks for radiosity procedures can be seen in Equation (3.81): first, the form factors have to be calculated and, second, the resulting system of linear equations has to be solved numerically. This we shall do in Section 3.8. At the moment we are only interested in the light path.

Radiosity only considers diffuse outer surfaces. Thus, only light paths of the type

$$L D^* E \tag{3.82}$$

can be simulated. The direct path $L E$ is possible, since light sources and surfaces are treated equally. As opposed to ray tracing, the result does not consist of a raster image for a given view of the scene, but of the radiosity values of all the (discrete) surfaces f_i. Thus, following the time-consuming radiosity computation, a (hardware accelerated) z-buffer procedure can be used for generating particular views and permits, for example, a real-time flight through the scene.

But ray tracing can also be used for generating views. A kind of series of ray tracing and radiosity makes light paths of the type $L \ D^+S^*E$ possible. This is better than any independent solution, but caustics still cannot be represented. Thus, further generalizations have been developed (extended form factors), which should also integrate caustics. However, the difficulty remains that radiosity always operates with flat surface segments, so that many caustics cannot be reproduced.

3.6.3.5 Light Ray Tracing

Light ray tracing or backward ray tracing goes back to Arvo [Arvo86] and was developed especially for simulating indirect illumination.

In a first path-tracing step, rays are shot from the light sources into the scene. If such a ray strikes an at least partly diffuse surface, its radiance is reduced after the reflection and the difference in energy is credited to the surface and stored in an illumination map. The concept is entirely similar to texture maps (see Section 4.2). In the second step a conventional ray tracing is performed in which the illumination maps of the surfaces enter in the illumination calculation.

Light ray tracing is the first of the procedures discussed so far that can deal with caustics. The computational effort is, of course, extremely

large, since the resolution of the illumination maps is high and the number of rays in the first pass must, therefore, be very large. Moreover, the need for parametrizing the outer surfaces through the illumination map limits the shape of the surfaces. Finally, the energy at a site exists over the illumination map, but not the direction from which the light was incident, and this can be a disadvantage for the second step (calculating the outgoing radiance).

3.6.3.6 Monte Carlo Ray Tracing with Photon Maps

Monte Carlo ray tracing with photon maps or, in short, photon tracing was introduced in 1995/1996 by Jensen [Jens96]. At present it is one of the best methods for global illumination, particularly in the following regards:

Quality: the keystone is path tracing, a good initial solution for the illumination problem. A light ray tracing step is available for reproducing caustics. The information from this step is stored in photon maps, which are similar to illumination maps.

Flexibility: photon tracing builds only on ray tracing techniques. Neither a restriction to polygonal objects (as in the radiosity technique) nor a parametrization of the outer surface (as with illumination maps) is necessary. Even fractal objects can be used.

Speed: the second step uses an optimized path tracer whose run time can be reduced using information from the photon map.

Parallel operation: like all ray tracing procedures, photon tracing can also easily and efficiently be made to run in parallel.

As with light ray tracing the first step is made up of a path tracing out from the light source. Photons, i.e., energy bearing particles, are shot from the light sources into the scene. If a photon strikes an outer surface, both its energy and its direction of incidence are entered in the photon map. Then the photon is reflected randomly or it comes to an end (is absorbed). At the conclusion of this phase the photon map gives an approximation to the light proportions in the scene: the higher the density of photons is, the more light there is. Note the distinctive difference between an illumination map and a photon map: the former are local, associated with every surface and require a parametrization, which maps a two-dimensional array onto these surfaces. The latter is global and dwells in three-dimensional world coordinates. In addition, both the energy and the direction of incidence are stored. Hence, the photon map is a huge scattered data set in 3D.

In the second step an optimized path tracer is used. After only a few recursion steps the path is broken and the illumination proportions are

We conclude with two comments:

- In many places diffuse and specular reflections are distinguished. A normal path tracer does not provide this distinction (explicitly) at all, but for photon tracing it is still written down.
- Special data structures which perform coordinate bisection, such as kd-trees, are available for storing the photons in three-dimensional space or for rapidly locating neighbors (see Figure 3.38).

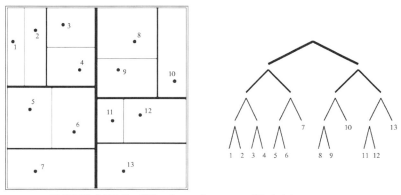

FIGURE 3.38 Partitioning of space with kd-trees.

This discussion of the different starting points for solutions and the particular contributions of each show that global illumination is, as much as ever, one of the central, exciting topics in computer graphics.

Because of their outstanding importance, in the following we shall examine two of these procedures for solving the global illumination problem, ray tracing and radiosity, in somewhat more detail below.

3.7 Ray Tracing

We have already become acquainted with ray tracing in Section 3.2.7. The ray casting described there serves for solving the visibility problem. As we saw in the preceding section, techniques that rely on ray tracing can still provide photorealistic images which, for example, cannot be created by a combination of the z-buffer algorithm and Gouraud or Phong shading (see Color Plates 15–23 and 30–32, as well as 38 and 39). In this section we should now consider in more detail the algorithmic aspects of so-called recursive ray tracing[12] which transcend simple ray casting and the illumination characteristics for the realization of shadows, reflection, and refraction [KaKa86, Glas89, Haen96].

[12] For a definition of the concepts of ray casting and ray tracing, see footnote 4 in Section 3.2.7.

approximated by estimating the density distribution of the photons in the neighborhood of the associated point. In this way the photon map can also be used for simulating caustics.

First pass:

First the emission of the photons must be established. Here the light sources are chosen randomly taking their output into account. For point light sources the starting point is trivial, while for the others the size and other characteristics affect this choice. The direction of radiation is entirely uniform in distribution for point sources, but for realistic lamps, etc., the emission characteristics of the source have to be taken into account. The output of all photons is constant, but often, of course, variations in the RGB combination are allowed.

The "further journey" of a photon can either come to an end (complete absorption, breaking of the path) or pass further into a randomly determined direction based on a BRDF distribution. Depending on the model, the energy of the photon remains fixed or is reduced by a constant or by a direction dependent fraction.

Two goals are attained with the photon map: the first is approximating the light proportions and the second is simulating caustics. A low accuracy is sufficient for the first, while caustics require precision. Thus, two maps are implemented: a global photon map for the indirect illumination and a caustics photon map for caustics. In the latter, all the photons which hitherto have exclusively struck mirror surfaces are collected, while the others are entered in the global photon map. In order to obtain an enhanced precision for caustics, distinctly more photons have to be shot into regions with mirror surfaces.

Second pass:

The second step is a path tracer. One sets out with two means for improvement. First, speeding up at each point where the outgoing radiance is to be determined by deciding whether it should be calculated as accurately as possible or approximated. Usually it is an approximation, as long as the path already has a diffuse reflection behind it. Moreover, if there is a very large number of specular reflections, then it is, likewise, approximated. In this case "to approximate" means using the information in the global photon map and "to calculate exactly" means to follow the path further. The second means of improvement serves to raise the quality. At all points where the exact radiance is desired, the radiance obtained from the caustics photon map is added.

The first extension of the simple ray casting algorithm from Section 3.2.7 was developed by Appel [Appe68] for the representation of shadows. At the same time, additional shadow rays are traced to all the light sources from each visible intersection point P of a ray from the observer with an object in the scene (see Figure 3.39). If a shadow ray of this sort reaches "its" light source without hindrance, then its influence on the intensity at point P will be taken into account in the calculation. If, however, a shadow ray intersects an object in the scene on its way to the light source, then the point P lies in the shadow with respect to this light source and it will be neglected in the intensity calculation for P or, if a transparent material is involved, it will just be attenuated in the intensity calculation.

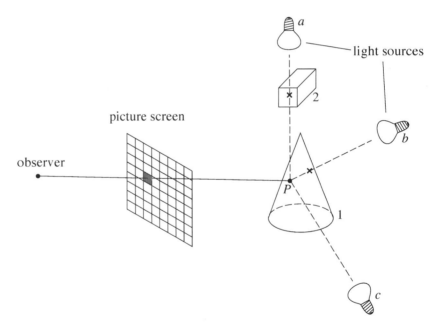

FIGURE 3.39 Determination of shadows in ray tracing. The shadow ray from P to light source a intersects object 2 and the shadow ray from P to light source b intersects object 1 another time (on exit). The ray from P to light source c, on the contrary, reaches it unhindered.

The next step, developed by Whitted [Whit80] allows the inclusion of specular reflection (cf. Section 3.3.3) and transparency with refraction of the light taken into account (cf. Section 3.5.2). Besides the shadow ray, now, as introduced in the preceding section, a ray, or possibly two (depending on the properties of the material), from the observer to an object in the scene is traced: a (perfectly) reflected ray (if the object allows specular reflection), along with a refracted ray (if the object is transparent and no total internal reflection occurs, see Section 3.5.2).

There are, by now, at most three additional rays emerging from an intersection point, which are also referred to as secondary rays, as opposed to the primary rays emerging from the observer (see Figure 3.40).

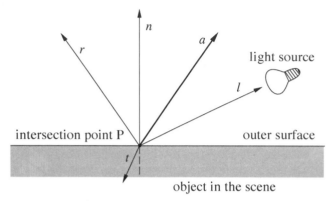

FIGURE 3.40 Primary and secondary rays in ray tracing: the primary ray *a* from or to the observer, along with the secondary rays *l* (to the light source), *r* (perfectly reflected ray), and *t* (refracted ray).

We now arrive at the recursive ray tracing algorithm, whereby the two secondary rays *r* and *t*, like *a* before, are continued (see Figure 3.41). The recursion terminates either when a ray that intersects no object passes out of the scene being represented (and thus enters the background) or when a prespecified maximum recursion depth is reached.

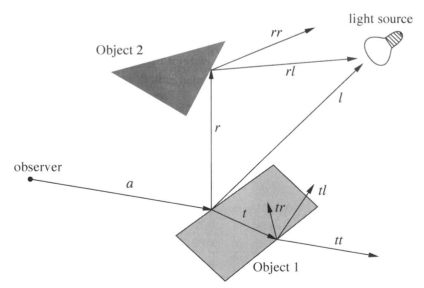

FIGURE 3.41 Recursive ray tracing to a recursion depth of 2: Object 1 is transparent and Object 2 is translucent.

Whitted [Whit80] used the model of Phong[13] as an illumination model (cf. Section 3.3.3), to which he added a component for the further traced reflected and the further traced refracted rays (for the definition of the rays, see Figure 3.41):

$$V^{(i)} := I_a \times R^{(i)}$$

$$+ \sum_{j=1}^{m} (I_j \times R^{(i)} \cdot \langle l_j, n \rangle + I_j \cdot R_S^{(i)} \cdot \langle h_j, n \rangle^k) \cdot C_j^{(i)}$$

$$+ R_S^{(i)} \cdot I_r + R_t^{(i)} \times I_t. \tag{3.83}$$

Here $R_t^{(i)} \in [0,1]$ or $[0,1]^3$ denotes the material dependent transmission coefficients and I_r or I_t give the (recursively calculated) intensity values at the next segments of the outer surface encountered by the reflected ray r or the refracted ray t. Here I_r and I_t can also be multiplied by an additional factor to account for the attenuation of the light with distance by analogy with the definition (3.30).

The Phong model can be replaced by the more exact and better suited for, say, metals, model of Torrance and Sparrow, or Blinn, or Cook and Torrance (see Section 3.3.3). In this model, Equation (3.41), which is the analog of Equation (3.83), can be extended with terms to account for I_r and I_t.

In conclusion, we would like to briefly return to the possibilities already discussed in Section 3.2.7 of optimizing (accelerating) ray casting or ray tracing. The techniques discussed there (efficient calculation of intersection points, hierarchical clustering, spatial partitioning, enveloping complicated objects) are naturally applicable to recursive ray tracing. A further possibility for acceleration of ray tracing, in particular, has been proposed by Hall and Greenberg [HaGr83]. With so-called adaptive depth control the recursion depth is not rigidly specified, but is fitted adaptively to the proportions of the scene and to the properties of the material. As in Equation (3.83), it has to be established at every recursion step whether the contribution of the secondary rays is further attenuated by the factors $R_S^{(i)}$ and $R_t^{(i)}$. For glass the approximate value is $R_S^{(i)} \approx 0.2$, so that by three recursion steps (three reflections) the resulting ray only contributes with a weight of 0.008 to the intensity calculation at the intersection point of the primary ray with the corresponding object.

[13] More precisely, we are not dealing with the original Phong model of Equation (3.43), but with a slight modification by Blinn [Blinn77], who replaces $\langle r, a \rangle^k$ in Equation (3.42) with $\langle h, n \rangle^k$. Note that the angle between r and a is twice that between h and n (cf. Figure 3.20).

Thus, it makes sense to ignore such negligible effects and to terminate the recursion when the products of the coefficients fall below a specified level.

3.8 RADIOSITY PROCEDURES

Independently of whether an efficient polygonal shading procedure, as described in Section 3.4, or the costly pixel oriented ray tracing capable of images of the highest quality (cf. Section 3.7) is used to obtain the intensity and color values, the illumination models of Section 3.3 rely on a term for modeling the ambient light. This is based on the knowledge that on the average some 30% of the light in the scene has been reflected one or more times on surfaces. Peak values of up to 80% are reached. Only one constant term I_a or $V_a^{(i)}$ (cf. Section 3.3.1) may be unsatisfactory for describing the complicated proportions involved in multiple reflections and, thereby, the origin of ambient light can be seen in the example of the often too-synthetic-looking images generated by ray tracing: the shadows are too sharp and the transitions too stark. Here the radiosity procedure discussed in Section 3.6.3.4 offers some relief. Once we have studied their illumination characteristics, we shall touch upon a few algorithmic aspects. A detailed discussion is given in [GTGB84, NiNa85, KaKa86, Hanr93, Gepp95] and some results are shown in Color Plates 36 and 37.

3.8.1 Computation of Form Factors

We return to the discrete radiosity equation (3.81). Before it is solved, the form factors F_{ij} must be determined. Since these are independent of the wavelength of the light, but depend only on the geometry of the scene, they can be calculated once at the beginning and stored. For varying material properties $(B_{e,i}, \rho_i)$ or changing illumination, they can be transferred.

The form factor F_{ij} represents the fraction of the light energy going out from f_i, $B_i A_i$, which arrives at f_j. It can be shown (see [FDFH97], for example) that F_{ij} obeys

$$F_{ij} = \frac{1}{A_i} \cdot \int_{f_i} \int_{f_j} \frac{\cos\theta_i(x_i, x_j) \cdot \cos\theta_j(x_i, x_j)}{\pi \cdot r^2(x_i, x_j)} V(x_i, x_j)\, dA_j\, dA_i$$

$$= \frac{1}{A_i} \cdot \frac{1}{\pi} \cdot \int_{f_i} \int_{f_j} G(x_i, x_j) dA_j dA_i \qquad (3.84)$$

where θ_i and θ_j denote the angles between the line segment from x_i to x_j and the surface normals n_i of f_i at x_i and n_j of f_j at x_j, respectively, and

r is the distance between x_i and x_j (see Figure 3.42). The functions V and G are defined as in Equations (3.60) and (3.63).

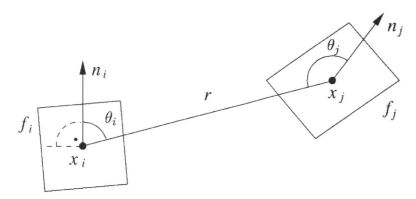

FIGURE 3.42 Surface segments f_i and f_j with marked points x_i and x_j, the surface normals n_i and n_j, and the angles θ_i and θ_j between n_i or n_j and the line segment of length r from x_i to x_j.

Even for simple geometrical proportions the evaluation of the integral in Equation (3.84) is very time consuming. Thus, efficient procedures for approximating the form factors are of great importance. One possibility for simplifying Equation (3.84) is to assume that the angles θ_i and θ_j, as well as the distance r, are constant over the surfaces f_i or f_j, although the resulting loss of quality may be too big under certain conditions.

One widely used method for approximating the form factors F_{ij} originates with Cohen and Greenberg [CoGr85]. Since it can be shown that an exact calculation of the inner integral over f_j in Equation (3.84) corresponds to the calculation of the content of the surface $\overline{f_j}$ obtained by a central projection of f_j on the unit hemisphere surrounding $x_i \in f_i$ (whose base circle is coplanar with f_i) and results in an adjacent orthogonal parallel projection on the base circle (see Figure 3.43), Cohen and Greenberg replaced the half circle with a half cube whose outer surface is divided into square surface elements (see Figure 3.44). The resolution typically amounts to between fifty and a few hundred elements in each direction. For each of these surface elements a form factor can be calculated in advance and stored in a table. Finally, the surface segments $f_j, j \neq i$ are projected onto the sides of the cube and the form factors that have been calculated in advance are added to the relevant surface elements, thereby solving the visibility question in a z-buffer approach. The outer integral in Equation (3.84) is often neglected, since, for small patches f_i and distances r that are large compared to A_i, the variation over the different $x_i \in f_i$ only has a small effect.

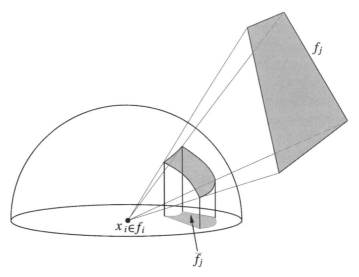

FIGURE 3.43 Calculating the form factors by means of projections.

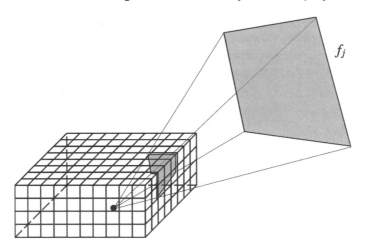

FIGURE 3.44 Cohen and Greenberg's form factor approximation.

3.8.2 Solution of the Radiosity Equation

We now discuss the solution of the radiosity equation. As a whole, the n balance equations form a linear system of equations

$$M \cdot B = E \tag{3.85}$$

where

$$B := (B_1, \ldots, B_n)^T \in \mathbb{R}^n,$$

$$E := (E_1, \ldots, E_n)^T := (B_{e,i}, \ldots, B_{e,n})^T \in \mathbb{R}^{n \times n},$$

$$M := (m_{ij})_{1 \le i,j \le n} \in \mathbb{R}^{n \times n},$$

$$m_{ij} := \begin{cases} 1 & - \rho_i \cdot F_{ii} \quad \text{for } i=j, \\ & -\rho_i \cdot F_{ij} \quad \text{otherwise,} \end{cases}$$

$$M := \begin{pmatrix} 1 - \rho_1 F_{11} & -\rho_1 F_{12} & -\rho_1 F_{13} & \cdots \\ -\rho_2 F_{21} & 1 - \rho_2 F_{22} & -\rho_2 F_{23} & \cdots \\ -\rho_3 F_{31} & -\rho_3 F_{32} & 1 - \rho_3 F_{33} & \cdots \\ \vdots & \vdots & \vdots & \ddots \end{pmatrix}.$$

The quadratic matrix M is strictly diagonal dominant since $0 < \rho_i < 1$ and $\Sigma_{j=1}^n F_{ij} \le 1$ for all $i = 1, \ldots, n$. Certainly, M is not symmetric, which is a disadvantage for a series of iterative solution procedures. In order to be able to work with a symmetric matrix, we multiply the radiosity equation for f_i by the factor A_i / ρ_i and thereafter treat R_i as an unknown, but now with $E_i \cdot A_i / \rho_i$ as the component on the right side. Thus, from Equation (3.85) we obtain

$$\bar{M} \cdot B = \bar{E}, \tag{3.86}$$

where

$$\bar{E} := (E_1 \cdot A_1 / \rho_1, \ldots, E_n \cdot A_n / \rho_n)^T \quad \text{and}$$

$$\bar{M} := \begin{pmatrix} \rho_1^{-1} A_1 - A_1 F_{11} & -A_1 F_{12} & -A_1 F_{13} & \cdots \\ -A_2 F_{21} & \rho_2^{-1} A_2 - A_2 F_{22} & -A_2 F_{23} & \cdots \\ -A_3 F_{31} & -A_3 F_{32} & \rho_3^{-1} A_3 - A_3 F_{33} & \cdots \\ \vdots & \vdots & \vdots & \ddots \end{pmatrix}.$$

The matrix \bar{M} is, again, strictly diagonal dominant and, because of the symmetry condition (3.80), also symmetric and, therefore, positive definite. In addition, both M and \bar{M} are typically little filled, since in ordinary scenes with very many surface segments, light from a surface f_i only reaches a few other surfaces f_j. Note finally that the F_{ii}, with $1 \le i \le n$, are generally close to zero, but do not always vanish. For a concave surface f_i, light may also come out of f_i directly to f_i.

Procedures such as the Gauss-Seidel or Jacobi iteration procedures are available for solving the system of Equations (3.85). Since the matrix M is strictly diagonal dominant, both iteration procedures converge. $R^{(0)} := E$ is chosen as a starting value. In this connection, Jacobi iteration

permits an interesting interpretation: the emitted light alone serves as a starting value, after the first iteration the simply reflected light is also taken into account, the second iteration brings twice reflected light into play, and so on. The scheme for Jacobi iteration with s iterations is illustrated by the following:

$$
\begin{aligned}
&\text{it} = 1,2,\ldots,\text{s:} \\
&\quad \text{i} = 1,2,\ldots,\text{n:} \\
&\qquad S_i := (E_i + \rho_i \cdot \Sigma_{j \neq i} B_j F_{ij})/(1 - \rho_i F_{ii}); \\
&\quad \text{i} = 1,2,\ldots,\text{n:} \\
&\qquad B_i := S_i;
\end{aligned}
$$

The image quality increases with the number s of reflection steps that are taken into account. This is also, of course, true of the computational effort, which is of order $O(n^2 \cdot s)$.

Note that the systems of Equations (3.85) and (3.86) are written separately for each wavelength λ or each band (i.e., each range $[\lambda_i, \lambda_{i+1}], i = 0, \ldots, n-1$) and must be solved separately, since, as opposed to the form factors F_{ij}, both ρ_i and E_i are material parameters that depend on the wavelength λ of the light. Radiosity values must be calculated at least for the three (screen) primary colors, red, blue, and green.

3.8.3 Concluding Remarks

Thus far, radiosity values have been obtained for each surface segment f_i. If the results of the radiosity procedure are now to be coupled with an interpolating shading procedure such as Gouraud shading (cf. Section 3.4.2.1), then radiosity values will be required at the vertices of the polygonal outer surfaces. The standard way of determining these quantities is to get the radiosity values at the vertices by appropriate averaging of the radiosity values of adjacent patches [CoGr85] and then interpolate these quantities in accordance with the shading procedure.

The classical radiosity procedure discussed here involves very large computational times and memory requirements. A scene with 10,000 surface segments requires the calculation of fifty million form factors using Equation (3.80) and even for a weakly-populated matrix, a not inconsiderable amount of memory. This quadratic computational time and memory requirement, as well as the fact that a complete Gauss-Seidel or Jacobi step is to be expected before the next output, are an impediment to efficient implementation of the radiosity procedure. Two approaches have been developed for solving this problem:

1. Step-by-step refinement [CCWG88] reverses the previous procedure: in accordance with the Jacobi iteration indicated in the previous section, in each iteration step the contributions from the neighborhood of a surface f_i are collected (gathering) and used to update R_i. Now, on the other hand, the surfaces f_i are treated successively in a way such that their outgoing light energy is sent out into the surroundings (shooting). Instead of summing the contributions

$$\frac{\rho_i \cdot B_j \cdot F_{ij}}{1 - \rho_i F_{ii}} \tag{3.87}$$

for all $f_j, j \neq i$, in step i to B_i, now, in reverse, the contributions of f_i to all $B_j, j \neq i$, are included:

$$\frac{\rho_j \cdot \Delta B_i \cdot F_{ji}}{1 - \rho_j F_{jj}} = \frac{\rho_j \cdot \Delta B_i \cdot F_{ij} \cdot A_i / A_j}{1 - \rho_j F_{jj}}. \tag{3.88}$$

Here ΔB_i is the newly accumulated radiosity of f_i since the last emission from B_i. At the beginning the ΔB_i or B_i are set to E_i. Then the light flux is always sent from the surface f_i for which the value of $\Delta B_i \cdot A_i$ is highest. In this way, the radiosity values can be calculated step-by-step and incrementally: first the surfaces with high radiosity (primarily light sources) are considered, which already gives a good approximation to the illuminated image. The iteration is terminated when $\Delta B_i \cdot A_i$ falls below a specified limit ε for all i.

We thus obtain the following algorithm:

Step-by-Step Refinement:

```
∀ surfaces fⱼ:
begin
        Bⱼ:=Eⱼ;
        ΔBⱼ:=Eⱼ;
end
while ¬(ΔBⱼ·Aⱼ<ε  ∀j):
begin
        determine i:ΔBᵢ·Aᵢ⩾ΔBⱼ·Aⱼ  ∀j;
        ∀ surfaces fⱼ≠fᵢ:
        begin
            contribution :=ρⱼ·ΔBᵢ·Fᵢⱼ·Aᵢ/(Aⱼ·(1−ρⱼFⱼⱼ));
            ΔBⱼ:=ΔBⱼ +  contribution;
            Bⱼ:=Bⱼ +  contribution;
        end
        Δbᵢ:=0;
end;
```

2. Adaptive partitioning (recursive substructuring) of the surface segments [CGIB86, CoWa93] makes it possible to begin with few surfaces and then, just where the calculated radiosity values differ greatly from neighboring surface segments, to divide the surfaces further. At those points where the resolution is to be increased the form factors must also be calculated anew. This adaptive procedure makes it possible to concentrate the computational effort in regions where a high resolution (i.e., many surface segments) is also necessary for an attractive image quality.

Recently, modern numerical approaches such as higher order starts [TrMa93, Zatz93] or wavelets [GSCH93] have been used in radiosity algorithms.

In conclusion, we maintain that the radiosity procedure is indeed a very computationally intensive technique, but one which is suitable for the modeling of diffuse light in photorealistic images. The resulting pictures are independent of viewing angle as far as illumination is concerned, i.e., diffuse light is undirected. Thus, the procedure is very well suited for interactive and animated applications with changing perspective (e.g., virtually entering buildings, travelling through or flying over cities, etc.; cf. the section on virtual reality).

The disadvantage, of course, is that direction dependent illumination properties such as glare cannot be realized at present. However, there are extensions of the radiosity procedure [ICG86] which also take specular reflection into account. The combined use of ray tracing and radiosity has also been studied [Rush86, WCG87, SiPu89, Rush93]. These approaches rely on two separate passes to reproduce a scene, of which the first is view independent (radiosity) and the second depends on the viewing configuration (ray tracing). Without going into the details here, it should also be pointed out that simply adding the pixel intensity values obtained in these two passes to get the desired combination of ray tracing and radiosity is not sufficient.

4

SELECTED TOPICS AND APPLICATIONS

After dealing with the basic techniques for modeling and representation of three- dimensional bodies on a computer, we now address a few selected topics and areas of application that have acquired great importance in modern computer graphics. A detailed discussion cannot be the goal at this point. The relevant specialist books or original publications are needed for that. Here the reader will merely become acquainted with the important concepts, problem statements and solution techniques.

4.1 RENDERING

The concept of rendering is surely one of the most overworked words in computer graphics. In its original use, it means nothing other than reproduction or representation. A renderer is thus a program or programming system which creates two-dimensional images from three-dimensional scenes and displays these, for example, on a picture screen. The essential function of a given renderer can be described by a so-called rendering pipeline, which is a sequence of individual processing steps. A very simple pipeline results for ray tracing (see Figure 4.1), since all the calculations (illumination, etc.) are done in world coordinates.

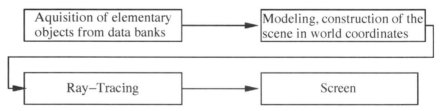

FIGURE 4.1 A rendering pipeline for ray tracing.

On the other hand, the rendering pipelines for efficient renderers made up of many partial steps, such as those employing z buffer techniques or the shading procedures of Section 3.4, have a complicated structure (see Figure 4.2).

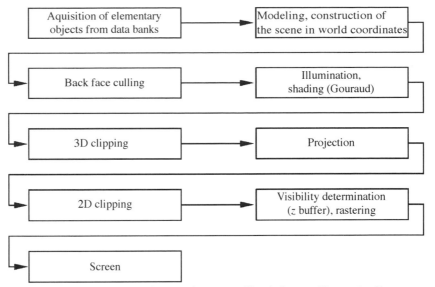

FIGURE 4.2 Rendering pipeline in the case of back face culling, *z* buffer procedure, and Gouraud shading.

Besides this original and general meaning for the concept of rendering, rendering techniques have come to signify rapid and efficient techniques for representation, as opposed to the powerful, but time consuming ray tracing techniques of Section 3.7. This has been especially true since the center of gravity of activity in computer graphics has shifted from the creation of high quality images to animation and interactive real time applications, along with the simple, rapid, and hardware-supported polygonal shading procedures needed for these.

4.2 MAPPING TECHNIQUES

The pursuit of photorealism creates a need to account for the details in a scene. In order to limit the resulting effort, so-called mapping techniques which make it possible to avoid the explicit modeling of details of this sort have been introduced. For computer graphics it is also true that you can cheat a bit if the optical impression is right.

4.2.1 Texture Mapping

A texture generally means surface details and, therefore, additional representation information with which the outer surfaces of bodies may be supplied. These may include, for example, hatching, patterns, or entire pictures, as well as structures in relief such as the folds in a tablecloth or built up areas and vegetation in landscapes (e.g., in flight simulators).

The first approach to the realization of textures is, of course, explicit geometric modeling. That is, the texture is not detached from the object, but is treated as a part of the object and modeled with it. For this, two hierarchical grades of polygons are introduced: large basis polygons, which describe the gross structure of an object's surface, and small surface detail polygons which are used to represent the details. Thus, for example, a picture mount without a frame might serve as a basis polygon and the picture, itself, might be realized through many small surface detail polygons which are all coplanar with the basis polygon. In a visibility determination at first only the basis polygon would be tested. If that is entirely visible or entirely invisible, then the same is true for all its surface detail polygons and the costly testing of all the detail polygons can be omitted. With shading, i.e., when calculating intensity or color values, the surface detail polygons are more influential.

Evidently, these procedures are only suitable for coarse structures (e.g., windows and doors in the wall of a house; cf. Figure 4.3), but not for complicated details, for in that case explicit modeling by polygons is far too costly. Besides, surface detail polygons (coplanar with the appropriate basis polygon) can only be used to generate patterns and not deformations, such as in cloth drapery.

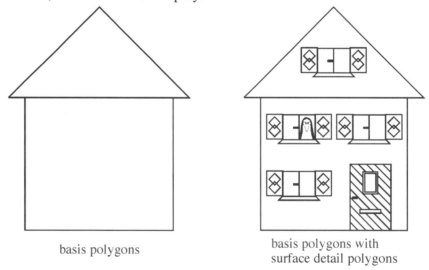

basis polygons

basis polygons with surface detail polygons

FIGURE 4.3 Realization of textures using surface detail polygons.

For complicated textures the technique of texture mapping [Catm74, BlNe76] has gained acceptance as an alternative. The texture to be applied is stored as individual picture elements (texels) in a matrix (texture map) which contains the intensity or color information. These rectangular textures are then mapped onto the corresponding surface by a map T^{-1} (cf. Figure 4.4 and Color Plate 38).

texture map surface of the object

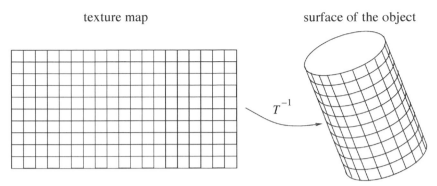

FIGURE 4.4 Texture mapping: mapping of the texture map onto the surface of an object.

The intensity or color value for a pixel i is now calculated, by first mapping its four corner points with a mapping S onto the object surface to be represented and then by a mapping T onto the texture map. The joining of the four image points by straight lines creates a square on the texture map which approximates the image of pixel i with the mapping $T \circ S$ and, under certain conditions, partially overlaps multiple texels (see Figure 4.5). To establish the desired value for pixel i, the intensity or color values of the relevant texels are weighted according to their degree of overlap and summed.

texture map outer surface of the object segment of the screen

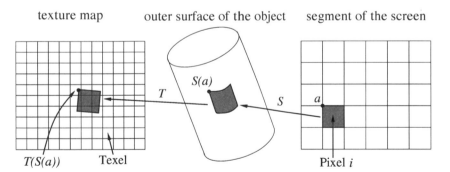

FIGURE 4.5 Texture mapping: mapping of a pixel via the outer surface to the texture map.

4.2.2 Bump Mapping

So-called bump mapping [Blin78], a variant of texture mapping, has been introduced for representing textures with a relief (deformations of the outer surface, (see Color Plate 39). By analogy to the texture map above, the bump map now contains information on the texture, i.e., entries $B(i,j)$ indicating how much the surface at a lattice point (i,j) of the texture is to be deformed in the direction of the normal (cf. Figure

4.6). A bilinear interpolation can be made between the lattice points (i,j), so that $B(u,v)$ is available as a function on the overall texture. If $P = (x(s,t),y(s,t),z(s,t))$ is now a parametrized representation of a point P on the outer surface of the object, then the normal n at P can be obtained with the aid of the vector product (3.14) of the tangent vectors at P:

$$n := \frac{\partial P}{\partial s} \times \frac{\partial P}{\partial t}. \tag{4.1}$$

This yields the new, shifted point P',

$$P' := P + B(T(P)) \cdot \frac{n}{\|n\|}. \tag{4.2}$$

Finally, Blinn has shown that

$$n' := \frac{n+d}{\|n+d\|}, \tag{4.3}$$

where

$$d := \left(\frac{\partial B}{\partial u} \cdot \left(n \times \frac{\partial P}{\partial t} \right) - \frac{\partial B}{\partial v} \cdot \left(n \times \frac{\partial P}{\partial s} \right) \right) / \|n\| \tag{4.4}$$

is a good approximation for the normal vector n' at the shifted point P'.

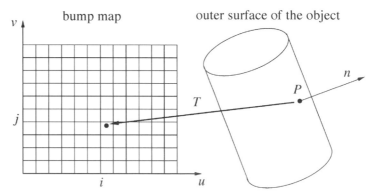

FIGURE 4.6 Bump mapping.

4.2.3 Environment Mapping

A similar technique is so-called environment mapping or reflection mapping [BlNe76, Gree86, Hall86], which has been developed for simple realization of reflections. Here the environment of an object which is to be reflected onto the object is first projected onto a sphere surrounding the

object, which is then treated as a two-dimensional texture map (spherical coordinates). In this way mirroring between objects (specular interreflections) can be realized in a simple manner by means of ray tracing.

Texture mapping and its derivatives have recently gained some importance as higher-priced work stations, not just large graphics computers, and are now equipped with hardware-supported texture mapping. Thus, real time applications of texture mapping, which were previously restricted to very expensive special graphics computers (as for flight simulators), are now possible in work station environments.

4.3 STEREOGRAPHY

Besides animation, which is discussed in Section 4.5, the creation of "real" three-dimensional pictures which not only provide a perspective projection but also give an impression of a real spatial image is among the most fascinating challenges of computer graphics. Also, because of an enormous market that places a premium on realistic three-dimensional television, intense research on the relevant procedures is currently under way in many places. Other domains of application of three-dimensional vision include video games, virtual reality (architecture, medicine, flight control systems), and the visualization of numerical simulations (see Color Plates 40 and 41).

4.3.1 Basics

First we consider how the impression of three-dimensional images develops in natural vision. Two classes of factors are to be distinguished here: physiological effects caused by the superposition of the two (different) images perceived by the left and right eyes and psychological depth indications. These include perspective, impressions of illumination and color (e.g., the so-called atmospheric blue cast: things in the distance often seem blue-weighted), occultations, and size or depth effects (only that which is near can be recognized in detail). These psychological indications can be taken into account very well using the techniques discussed in Chapter 3. Thus, central projection reproduces perspective, the atmospheric blue cast can be built in using the z value in shading, depth cueing (cf. footnote 1 in Section 3.2) makes it possible to strengthen the impression of depth, occultations are handled through the visibility determination, and textures on distant objects can be represented as blurred, e.g., by smoothing (averaging) the intensity or color values of the pixels.

Realizing the physiological effects, on the other hand, is more difficult. The conventional way for realizing a three-dimensional impression is the technique of stereography (see, for example, the review in [Mess94]). Here, by analogy with natural vision, two separate pictures are created for the left and right eyes. The impression of three dimensions is obtained by stereoscopic superposition.

There are now numerous approaches for creating the two separate pictures, beginning with the classical stereoscope of the 19th century (cf. Figure 4.7) and moving on to modern head mounted displays (see Color Plate 46). The goal of research in this area is a realization by means of cheap standard equipment which permit an arbitrary observer position in front of the screen and for which no costly auxiliary apparatus such as special glasses are necessary. One possible classification of stereoscopic screen systems is shown in Figure 4.8. (Also, see [Hodg92, HoMA93, Lipt93, McAl93]).

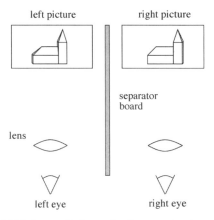

FIGURE 4.7 Schematic layout of an early stereoscope.

The pictures for the left and right eyes are alternately shown on the screen using so-called field sequential or time multiplex procedures. Since this lowers the actual picture frame frequency from 60 or 50 Hz to 30 or 25 Hz, it can lead to a bothersome flicker and, thus, a higher repetition rate is often required. Since each eye only actually sees "its own" pictures, a synchronized shutter system must be installed that obscures one eye in turn. Here we distinguish between active systems, in which the shutter mechanism is integrated into a pair of glasses, and passive systems, in which the shutter is realized by alternating polarizing filters in front of the screen and the observer must wear glasses containing the corresponding polarizers. Besides these modern electro-optical systems there are the classical mechanical variants: here a cylinder with alternating slits for the left and right eyes is positioned in front of the observer and rotated at the appropriate speed.

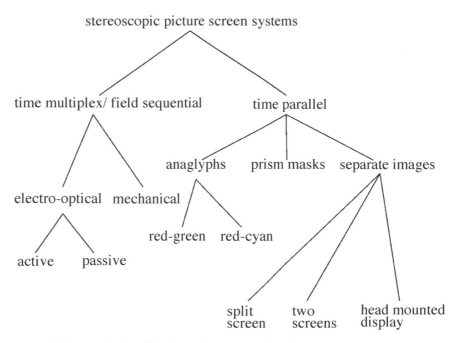

FIGURE 4.8 Classification of stereoscopic picture screen systems.

In so-called time parallel procedures, on the other hand, the two views are not alternated, but shown at the same time. This, of course, requires optical vision aids for correct separation of the images. In the anaglyph method,[1] which we shall examine in somewhat more detail in the Appendix, the two views are shown in complementary colors, slightly shifted on the screen. The observer wears a pair of glasses with two corresponding color filters. In the prism mask technique a large number of small prisms, oriented in two directions, are mounted as a mask in front of the picture or screen. The difference in refraction yields two separate pictures for both eyes. Of course, the anaglyph and prism mask methods both presuppose a fixed observer position. An alternative possibility is the display of two separate pictures. These can appear beside one another on a screen, in which case a separator, such as the board in the classical stereoscope of Figure 4.7, is required, or they can be shown on two screens next to one another, and separation is again by means of

[1]Greek for relief, or relief-like sculpture or structures.

polarization (filters in front of the screens plus corresponding glasses) and each eye obtains the correct perspective using optical aids (mirrors or lenses). We shall present a modern variant that does not require great technical effort below. Finally, in a modern head mounted display, two small monitors are positioned directly in front of the eyes, so that no separator is required.

4.3.2 Anaglyphs

The anaglyph procedure [Muck70] has been a widespread technique for creating three-dimensional impressions since the 1950s. Red and green were conventionally used for black and white pictures, and red and cyan, for color displays. In the case of a bright background the superposition points were mostly indicated by black and in front of a dark background, by yellow. The red-green glasses worn by the observer (red usually on the left) then ensure that, in the ideal case, the left eye only sees the green picture and the right, only the red. The two pictures are shifted on the screen owing to the use of two different projectors for red and green (cf. Figure 4.9 and Color Plates 40 and 41).

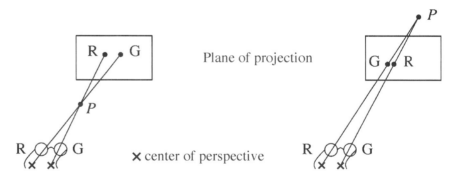

FIGURE 4.9 Creation of red and green pictures in the case of points *P* in front of and behind the plane of projection.

Naturally, this method is subject to a series of limitations. Since the colors on the screen and in the glasses do not generally overlap exactly, residual images appear. The green picture does not vanish entirely behind the green filter in the glasses, and the same holds true for the red picture. In addition, aliasing effects can appear with complicated pictures. For example, with many close parallel lines the pairwise ordering may be unclear (see Figure 4.10). Finally, the observer's eyes will generally not lie precisely at the centers of perspective assumed for calculating the images. All this can lead to some clutter in the perception of three dimensions.

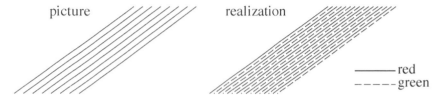

FIGURE 4.10 Aliasing effects in anaglyph procedures: the red and green lines pass so close to one another that their pairwise ordering is no longer clear.

4.3.3 Time Parallel Polarization Procedures

An alternative possibility for time parallel display is the projection of two differently polarized pictures on top of one another. For this the observer wears a cheap pair of polarizing glasses (simple sheeting or glasses without a synchronization mechanism) and the observer's position is not fixed. The quality of the three-dimensional impression is usually very convincing, and neither colors nor animated picture sequences present any problems. In the latter case, of course, the two images must be synchronized, most simply by superimposing duplicate images (both views generated together and shown next to one another; see Figure 4.11), which is conventionally provided today as output by different graphics and visualization systems. This procedure can be realized without costly or hardwired equipment, so it is suited to mobile applications.

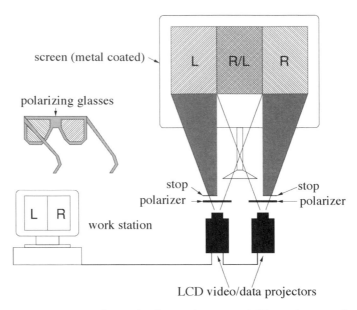

screen (metal coated)

polarizing glasses

L | R

work station

stop
polarizer — — polarizer
stop

LCD video/data projectors

FIGURE 4.11 Stereoscopic projection using two LCD projectors. Duplicate images are created in the computer (slight perspective shift to account for the distance between the eyes) and projected in overlap onto a screen (metal coated for quality) by two LCD projectors. Polarizers in front of the projectors ensure that the light has different polarizations (matched to the observer's polarizing glasses) and additional stops eliminate the unnecessary halves of the duplicate images. A congruent superposition of the left and right views is produced on the screen.

If a high cost is acceptable, then both pictures can also be displayed directly in front of the eyes in a head mounted display.

Note that all the stereoscopic procedures described above convey a more or less realistic three-dimensional impression, but still rely on (two) purely two-dimensional images of the same scene. At present, the only real three-dimensional possibility for three-dimensional recording and reconstruction is holography, in which the three-dimensional impression is captured in just one picture. Of course, holography is a purely photographic procedure, so it is only of limited suitability for the display of artificially created scenes. Holography makes use of the interference of light waves, so that phase-pure light (e.g., laser light) must be used to obtain perfect displays. Roughly speaking, in principle the interference pattern of light reflected from the scene is recorded by a reference beam on film. Ideally, by projecting the reference beam the reflected light and, thereby, the three-dimensional view of the scene can be reconstructed, independently of the observer's perspective. Fortunately, the original laser light is not always necessary and often laser light is not needed at all.

4.4 REPRESENTATION OF NATURAL OBJECTS AND EFFECTS

Unlike artificially created objects, many natural objects, such as mountains, trees, river beds, or coastlines, as well as natural effects such as fire, fog, or smoke, display uneven, jagged, and often random looking edge and outer surface structures because of their highly dynamic geometric appearance and, even, topology. In this section we shall consider possible ways of representing structures of this type.

4.4.1 Fractals

A direct approximate description of natural objects by, e.g., Bézier curves or polygons and Bézier surfaces is very costly and, because of inadequate optical quality in the result, only partially satisfactory. The goal must, therefore, be to specify production principles which permit complete generation of curves and surfaces for the representation of natural objects by a computer and, along the way, do this on the basis of a small amount of input data from the user as beginning or end points or other parameters. This can be done by using fractal curves and surfaces. The concept of fractal geometry was first coined by Mandelbrot [Mand77, Mand87], who took up and further developed the ideas of the mathematicians Hausdorff and Julia.

We begin by informally introducing the two central concepts of self similarity and fractal dimension:

Self similarity, fractal:
An object is self similar if it consists of partial images similar to itself. In other words, it doesn't matter from what distance or at what magnification it is viewed, the same structure can be recognized. The infinite components inherent in this definition must, of course, be limited in graphics. That is, this statement applies only to the finest resolution involved. With statistical self similarity the similarity does not have to be exact, as statistical distortions are permitted. As opposed to the strict mathematical definition, in computer graphics the concept of fractal encompasses everything connected to some extent with self similarity.

Fractal dimension:
The customary concept of dimension is topologically based and integral (one, two, or three-dimensional, etc.), so the assignment of a dimensionality to a geometric structure usually creates no problems: points are zero-dimensional shapes; curves, one-dimensional; surfaces, two-dimensional; and solids, three-dimensional. This classical concept of dimensionality, however, runs into trouble because

of, among other reasons, the so-called "space filling" curves of Peano and Hilbert and shapes which arise in a limiting process from a sequence of curves and occupy entire surfaces. The first steps on the way to so-called Hilbert curves shown in Figure 4.12 illustrate the principle for generating such a sequence. The limit of the sequence, i.e., the Hilbert curve, reaches all the points in the square. Here a (one-dimensional) curve has completely painted over a (two-dimensional) surface. Mandelbrot gives a graphic example of the difficulties with the classical concept of dimensionality [Mand87]: from afar a ball of wool is a (zero-dimensional) point, then it is a (two-dimensional) surface, and on closer observation, it can be recognized as a three-dimensional shape, and then again as one-dimensional (a wool thread) or, again, as three-dimensional. (Finally, does the thread have a positive cross sectional area?).

FIGURE 4.12 The first steps on the way to a Hilbert curve, the limit of the sequence.

A quite recent generalization of the conventional concept of dimensionality for fractal structures is the Hausdorff-Besicovitch dimension [Haus19]. Although they are often difficult to determine in practice, here we shall introduce a related, more intuitive fractal dimensionality that extends into fractal geometry. Let us divide an object into N equal parts and replace each of the N parts with the original object scaled by a factor of $1/s$. The fractal dimension d is then the quantity

$$d := \frac{\ln N}{\ln s}.$$
(4.5)

We now illustrate the concept of fractal dimension with a few examples:

1. A straight line: here the unit interval is divided into N equally long segments of length $1/N$. Thus,

$$\frac{1}{s} = \frac{1}{N},$$

and the fractal dimension is

$$d = \frac{\ln N}{\ln s} = 1.$$

(see Figure 4.13).

FIGURE 4.13 A straight line as a fractal curve.

2. A rectangle: here a given rectangle is divided into N equally large and similar rectangles, so the scaling factor in each coordinate direction amounts to

$$\frac{1}{s} = \frac{1}{\sqrt{N}}.$$

The resulting fractal dimension is

$$d = \frac{\ln N}{\ln \sqrt{N}} = 2.$$

(see Figure 4.14).

FIGURE 4.14 A rectangle as a fractal surface.

These two examples show that the conventional concept of dimensionality can be interpreted as a special case of the definition (4.5). In the next, third example, on the other hand, the difference between the conventional and fractal dimensions will become clear.

3. The Koch curve: this curve, which is also known as the Koch snowflake because of its shape, is obtained via a limiting process whose first six steps are shown in Figure 4.15. Here each line segment of length l_i in the i^{th} step is replaced by four correspondingly ordered segments of length $l_i/3$ in step $i+1$. Thus, $N=4$ and $s=3$. The fractal dimension is thus the nonintegral

$$d = \frac{\ln 4}{\ln 3} \doteq 1.2619.$$

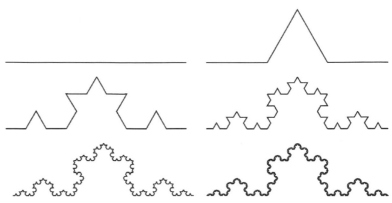

FIGURE 4.15 The first six steps in constructing a Koch curve.

4. A favorite example of fractal structures in nature is coastlines. Here self similarity is manifested by the fact that an observer sees similar structures regardless of distance (e.g., in satellite photographs or from the field of view of a lighthouse). The experimental value of the fractal dimension for typical coastlines is $d \in [1.15, 1.25]$. Another example is the arteries in the human body: here the fractal dimension is about 2.7.

5. The Hilbert curve, which is the limit of the sequence in Figure 4.12, has a nominal fractal dimension of 2. After all, it does cover a surface!

Fractal objects are primarily known through the graphical representation of self similar sets from function theory or the theory of complex dynamic systems [PeRi86, PeSa88]. This refers to Julia-Fatou, as well as Mandelbrot, sets:

- An example of a Julia-Fatou set:

$$z, c \ \in \ \mathbb{C},$$

$$\alpha_0 \ := \ z,$$

$$\alpha_i \ := \ \alpha_{i-1}^2 + c \quad (i \geqslant 1),$$

$$JF(c) \ := \ \{z \in \mathbb{C} : \text{The sequence } (\alpha_i) \text{ does not converge (even toward } \infty)\};$$

- An example of a Mandelbrot set:

$$M := \{c \in \mathbb{C} \ : \ JF(c) \text{ is connected}\}.$$

Fractal curves are generated on the screen using recursive routines that terminate when the pixel size is reached. For the case of the Koch

curve, now with some statistical noise, this gives the following algorithmic formulation:

```
procedure Koch(P₁,P₂);
begin
    if ‖P₁−P₂‖>ε
    begin
        M₁:=(2P₁+P₂)/3+d₁;
        M₂:=(P₁+2P₂)/3+d₂;
        M₃:=construct(M₁,M₂);
        Koch(P₁,M₁);
        Koch(M₁,M₃);
        Koch(M₃,M₂);
        Koch(M₂,P₂);
    end
    else  print(P₁,P₂);
end;
```

The procedure print (P_1,P_2) draws the line segment P_1P_2 on the screen and the function construct (M_1,M_2) calculates the point M_3 in a suitable fashion. In the statistical noise term d_1 and d_2 range over the distance from P_1 to P_2, so that the fractal dimension of the curve is a normally distributed random variable (see Figure 4.16).

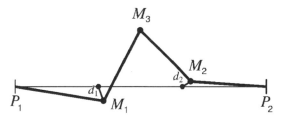

FIGURE 4.16 Creation of a (statistically noisy) Koch curve.

For creating fractal surfaces on a screen, one can pick, for example, a triangle as the starting object. One then proceeds recursively according to the following two steps until the triangles are small enough:

1. Divide each edge into two segments subject to a noise source.
2. Subdivide the resulting polygon into four new triangles.

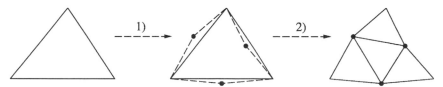

FIGURE 4.17 Creation of a (statistically noisy) fractal surface.

Here an edge in common must be subdivided the same way for each of the adjacent surfaces. This leads to a repeated calculation which can be avoided by clever programming.

Fractal curves and surfaces can, therefore, be used to create images with realistic natural structures (mountains, surface textures) relatively easily (see [Voss87] and Figure 4.18). The next two sections also deal with the goal of a realistic representation of natural objects or effects.

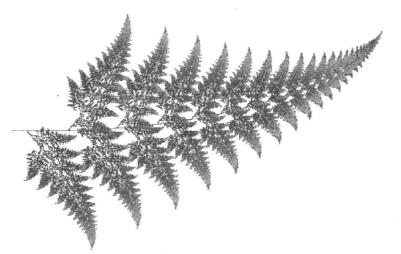

FIGURE 4.18 A fern created using xfractint.

4.4.2 Grammatical Model

In grammatical models [Lind68, Smit84] a grammar is defined whose productions are all applied simultaneously in order to ensure uniform growth of the structure to be modeled. A word generated in this manner is interpreted as a topological structure like a plant, from which a realistic representation is created using biological and geometrical information.

Let us consider the modeling of a deciduous tree as an example. In the simplest case, describing its topological structure requires symbols for the limbs (A), leaves (B), and branchings in the limbs. A 45° side limb is thus denoted using parentheses. With the alphabet

$$\{A,B,(,)\}, \tag{4.6}$$

the axioms A and B, and the productions

$$A \rightarrow AA$$

$$B \rightarrow AA(B)A(B) \tag{4.7}$$

we obtain an initial grammar for describing deciduous trees. Depending on whether A or B is chosen as the axiom, one obtains the following initial three generations (see Figure 4.19, as well):

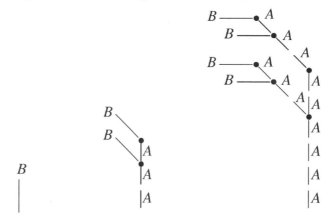

FIGURE 4.19 Representation of a tree in the first three generations from axiom B.

In Figure 4.19 all the new side limbs are at an angle of 45° to the main limb. With additional bracket symbols [], which denote new limbs at −45°, and a second production

$$B \rightarrow AA(B)A[B] \tag{4.8}$$

right away we obtain the realistic picture of Figure 4.20 instead of the $B \rightarrow AA(B)A(B)$ in Equation (4.7). Note that the word for the i^{th} generation appears twice in the word for the $i+1^{\text{st}}$ generation. This can again be interpreted as a kind of self similarity (cf. Section 4.4.1).

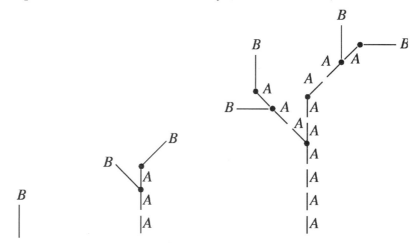

FIGURE 4.20 Representation of a tree in the first three generations from the axiom B with different branching angles.

It is clear that this process for word generation can only describe the topological structure of a deciduous tree. Additional biological and geometrical information, concerning, for example, the actual branching angle, the strength of the limbs, the upward regeneration of limbs, the shape and length of the limb segments, or the shape of the leaves, is required to create realistic images [PLH88, REFJP88]. Beyond that, randomizations, which introduce a probabilistic component into the thus far deterministic creation process, are customary.

4.4.3 Particle Systems

In the two previous sections we have become familiar with a series of applications in which classical geometrical modeling (cf. Chapter 2) reaches its limits. This happens, first of all, because the requirement of a realistic representation with geometric modeling of natural objects leads to computational and memory cost that is hard to meet even with giant computers. The situation is even more problematic when the time behavior of objects can be described by a volume or surface representation only at considerable expense. This occurs, in particular, when the topology of the bodies, as well as their geometry, changes in time. Examples of this include wisps of fog that merge and then separate again or flames in a fire (see Figure 4.21).

FIGURE 4.21 The time variability of a flame.

The so-called particle systems [Reev83,ReBL85] have been developed for these cases, as well as for such applications as fireworks, explosions, and flying sparks or grass in the wind. A particle system is defined as a (very large) set of particles which evolve in time according to certain deterministic or stochastic rules. Thus, new particles can be created and

old particles can be lost, and the particles can move or change their attributes (color, etc.).

At first individual particles or small sets of particles were used in computer graphics, mainly in early video games, where flying bullets or explosions were realized in this manner. The behavior of these particles was purely deterministic and had to be specified explicitly for each of them. In modern applications of particle systems, on the other hand, the particles are automatically created, eliminated, changed, and moved, while the bulk of the control is stochastic. The procedures employed for particle systems, thus, depend strongly on the current application.

- When modeling trees with the aid of particle systems buds are created on the trunk which can then grow into a leaf or a branch at a certain rate and in a given direction. Here, of course, additional geometrical information is required and a knowledge of the particular species must enter in the control. In a representation of prairie grass in the wind, individual particles are distributed over the tips and lengths of the blades of grass and move accordingly.
- For modeling fire, typically arborescent, hierarchical particle models are used. Individual particles can produce successors which can, again, break away (isolated sparks). Unlike the representation of plants, with fire the arborescence itself (i.e., the branches) is ignored in creating the picture.
- The modeling of explosions requires yet another procedure. Here a bullet stuffed with particles is placed at the center of the explosion. At the time of the explosion all the particles experience a powerful, outward acceleration which then is combined with external influences (gravitation, wind, random variables).
- Finally, particle systems are used for visualizing numerical simulations (cf. Section 4.6), for example the representation of time varying flow phenomena. Figure 4.22 shows twelve snapshots from a simulation of a jet. Here individual particles are injected at the flow inlet at certain distances. Their (deterministic) paths owing to the velocity profile of the flow are then followed.

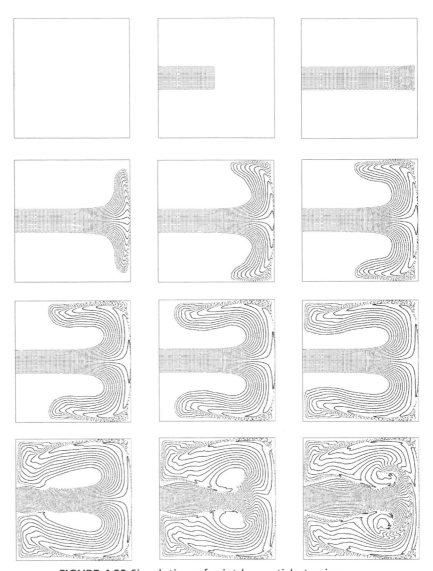

FIGURE 4.22 Simulation of a jet by particle tracing.

The creation of the pictures themselves, and, therefore, the representation of particle systems in the narrow sense, is a nontrivial problem. Ray tracing is prohibitive, since a profile calculation of, say, a million rays with many millions of particles is far too costly. Thus, special efficient rendering techniques are required. In the case of fire, for example, each particle can be modeled as a moving light source. Within the time frame of a picture (e.g., 1/25 s) the path would now be calculated for each particle and projected onto the image plane. The values for each pixel are

then obtained by adding the values for the particles which cross this pixel. A visibility determination can be omitted here. On the other hand, for the representation of grass and trees, where the above light source model is not applicable, a visibility determination is required. Here shading must be done explicitly, but greatly simplified procedures must usually be employed because of the large number of particles.

4.5 ANIMATION

In the previous section the representation of time varying processes (explosions, grass in the wind, flows) was touched on briefly. We shall now discuss this topic, so-called animation, in more detail.

4.5.1 Basic Techniques

Animation of static pictures brings time into play as a fourth dimension. This results in a time dynamics for

- the position of the objects (movement),
- the properties of the objects (shape, color, changes in texture), and
- the properties of the surroundings (number and strength of light sources, position of the observer).

With the possibility of realistic computer animation, which clearly goes beyond the early animated applications (e.g., the first flight simulators), the cards for computer graphics have been reshuffled. While the focus of effort was formerly on photorealism, i.e., on the creation of color pictures of the highest possible quality (and, typically, on the honing of ray tracing procedures), attention has now been shifted to (realistic) films, visualization of processes in time, and real-time applications and, thereby, to rapid and efficient representation techniques. In addition to the classical flight simulators, the major areas of application have now shifted to the entertainment industry (video games), the film industry (e.g., the movie "Jurassic Park" together with its sequels, "Terminator II", "Casper," and "Toy Story" with its sequel, in order to list a few milestones), education (tutorials), and scientific research (numerical simulation).

The difficulties associated with animation are evident: since sequences of pictures now must be produced, the requirements for memory and computational time are generally clearly higher than for single pictures. Some refined data compression techniques can offer some

relief here (e.g., the JPEG and MPEG standards[2]), and as many steps as possible should run with hardware support. Some new effects turn up as a result of the time dimension, for example, temporal aliasing. This aliasing effect can be seen in the following example: let the motion of a spoked wheel be too fast for the framing speed (24 frames/s in film or 25–30 frames/s for video). Then the wheel may appear to stand still or turn backwards (see Figure 4.23). Finally, flickering of the screen is another major problem in the display of animation on monitors. The impression of flickering arises from the constant erasure, recalculation, and loading of the screen content. Here some relief is provided by double buffering, in which two screen memories are used (frame buffers; see Section 1.6.) with the picture from the first buffer being shown while the newly calculated picture is made available in the second.

Picture 1 Picture 2 Picture 3

FIGURE 4.23 Temporal aliasing: the observer gains the impression of a motion-less wheel.

The earliest animation procedures were strongly oriented toward the operations of animated cartoon studios: here a film sequence is a sequence of individual pictures generated on the computer [HaMa68, Catm78b, Layb79]. This procedure for creating animation sequences is still widespread today (see Color Plate 42). One advance is automatic inbetweening, in which only the first and last pictures of a sequence are created explicitly. The desired intermediate steps are obtained by temporal interpolation. In many cases linear interpolation does a good service; however, it often yields unrealistic image sequences. An example of this is the motion of a pendulum, for which linear interpolation yields a constant absolute value of the velocity and, thereby, infinite acceleration at the turning points. This is not correct physically nor does it look realistic. If suitable intermediate steps of the pendulum motion are explicitly specified in advance, this leads to an unsteady velocity which is

[2] The standard drawn up by the Joint Photographic Experts Group (JPEG) provides for (lossy) compression of individual pictures. A procedure built upon this for compression of sequences of pictures is known as motion-JPEG. The alternative to this is a variety of standards developed by the Motion Picture Experts Group (MPEG) which take the time behavior of sequences of pictures into account [PeMi93].

oticeable in the film as an unrealistic effect (see Figure 4.24). Higher order interpolation schemes, such as splines, can help here.

Figure 4.24. Linear interpolation for a pendulum without (left) and with prespecified intermediate steps (right).

The motion of complicated objects such as living creatures is often modeled using so-called skeletons [BuWe76, HsLe94]. Thus, for example, a leg may be described in the two-dimensional case as a chain of polygons, for which auxiliary parameters (e.g., for the width) permit the representation of the entire leg. Each coarse pace in walking is now defined in terms of new positions of the joints in the chain of polygons and by reevaluation of the parameters (see Figure 4.25). In between, interpolation is again used.

FIGURE 4.25 Schematic illustration of coarse steps in a skeleton model of the leg of a running man.

As a rule three-dimensional objects are modeled explicitly in animations. For movements in three-dimensional space there is the additional difficulty that changes can occur in orientation (a spinning tennis or ping

pong ball turns in the air), as well as in path, velocity, acceleration, etc. Thus, the interpolation problem is substantially more complicated.

Often the desired animation effects can be realized using significantly simpler means. For example, under certain conditions the entries in a color table (see Section 1.6.2) can be cyclically permuted (color table rotation) [Shou79]. The color i, where $0 \leq i \leq 2^q - 1$, is then replaced by color $(i+1)\mod(2^q)$, where q is the depth of the frame buffer. In this way, for example, an impression of directed flow can be created (see Figure 4.26).

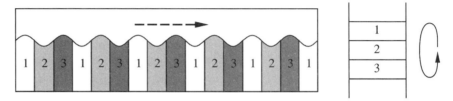

FIGURE 4.26 Creating the impression of flowing water by color table rotation without explicit modeling of the wave motion.

Another example of simple animation techniques is the so-called sprites. A sprite is a small rectangular memory region which, as a piece of the screen, partially hides the screen content or is mixed with it. The actual position of the sprite is kept in a register, so that a change in the register entry leads to movement of the sprite (see Figure 4.27). Sprites are widely used in video games and they are often used as a mouse pointer.

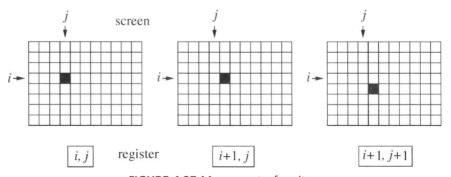

FIGURE 4.27 Movement of sprites.

Widely different concepts are used for programming of animation sequences. Thus, use is made of linear lists [Catm72], in which each

event, i.e., every movement or any other change in the picture, corresponds to an entry in a list which describes the corresponding event completely. Of course, standard programming languages (procedure or object oriented) are extensively used [Reyn82, MaTh85] and, finally, special graphics languages exist which are tailored to the special requirements of graphics and animation and are intended for better readability of the programs (which often function as film scripts) [Baec69, FSB82, Symb85].

4.5.2 Control

The question of the control mechanisms for animation is largely independent of the language used. The following procedures are to be distinguished:

- Explicit control [Ster83] (forward kinematics): Here each individual change is explicitly specified. As an almost classical example let us consider the model of a robot arm or the skeleton of a human arm. The start and end points of the grip or the hand are specified in advance. The forward kinematics explicitly specifies the required motion of each component (e.g., various rods and articulations), beginning with the "root" of the model (in the sense of a hierarchical model). Evidently very precise control is possible, but the whole thing can be very costly (especially for complicated models). In addition intuition falls short: who can say right from the start how all the joints of the arm have to move in order to bring the hand to a given location?
- Backward kinematics (inverse kinematics): The goal-driven inverse kinematics is more intuitive than forward kinetics. Here only the desired change in position of the grip or hand is specified; the movements of all the individual components required for this will be automatically determined and carried out. It is natural to assume that the model is able to rapidly identify the components affected by a movement and that the combined required motions can also then be calculated efficiently. In this way, inverse kinematics shifts the effort from the user to the system.
- Procedural control [ReBl85]: Explicit control is impossible with intense interactions or with the movement of many objects (cf. the modeling of prairie grass in the wind in the preceding section). In this case control is via procedures which, for example, calculate the new positions of the blades of grass from the behavior of the wind.

- Control via rules [Suth63, Born79]: correct adherence to physical laws is ensured by establishing rules such as "the ball rolls downwards" or "the ball bounces back from the wall" in order to control the course of the motion.
- Tracing played scenes (tracking) [GiMa83, BlIs94]: Actors play the scenes live. The movements are either traced on the screen or captured by light emitting diodes or motion sensors on the actors and objects (cf. Section 4.7).

We would not like to end this brief excursion into animation without pointing out three basic rules for the creation of realistic animation that are of the greatest importance [Layb79, Lass87]:

1. It is very important to take into account such material properties as elasticity (e.g., during the distortion of a rubber ball colliding with a wall), since they let the observer recognize the object and the material of which it is made and thereby contribute to the realism. For this reason spring-mass models[3] are often used for modeling sequences of motion.
2. Movements, either of the observer or of the objects in the scene, must never be jerky. In fact, movements that appear to be abrupt actually do require short startup and termination phases (cf. the situation with oscillations, as in spring-mass models) in order not to seem artificial to the observer.
3. The observer position is always chosen so that that which is essential can be seen. If there are multiple centers of action at the same time, these must be clearly separated.

4.6 VISUALIZATION

The advancing capabilities of computer graphics have resulted in the fact that the most widely diverse scientific disciplines are using its potential to an ever greater degree. This can show up in completely different ways.

[3]Spring-mass models consist of bodies with different masses joined by springs under different tensions. They are employed for the greatest possible realism in the simulation of natural sequences of motion (for example, the elastic deformation of a dinosaur's belly in the movie "Jurassic Park").

In medicine, for example, data from ultrasound or tomographic scans are prepared by image processing techniques and displayed graphically. This gives the doctor records that can be interpreted better. In chemistry graphical displays of complex macromolecules yield information on structure, stability, and reactivity. Interactive graphics systems provide efficient and intuitive design processes. Television weather forecasts-nowadays show animations of the predicted cloud cover. An almost classical example of this is the "flight of the clouds" introduced in 1995 bythe ARD network. The extensive data provided by measurement satellites is processed into images in manifold ways (relief maps, area maps, motion detection, etc.). In precision measurement technology (measurement of surface flatness, measurement of vibrations, etc.) graphical displays are used in order to make the measurement results clearer. Even "computer-free" disciplines such as architecture or art history use computer graphics in order to give future homeowners an impression of their house even before construction begins or to show the results of a planned restoration attempt and, thereby, advertise the project (e.g., the rebuilding of the Frauenkirche in Dresden or the Berlin City Castle; cf. Section 4.7). Finally, in mathematics, the fascinating images of Julia-Fatou and Mandelbrot sets [PeRi86] have brought unexpected popularity to fractal structures (cf. Section 4.4.1).

The methods of computer graphics have acquired special significance in scientific computing. Their graphical displays and animations allow the interpretation and visualization of the results of numerical simulations of processes from the standpoint of technology and the sciences. Two and three-dimensional flow phenomena (see, e.g., [GDN95] as well as Color Plates 43, 44, and 48), changes in the weather, optimum control of flight paths and the movement of robots, melting processes and crystal growth, contacts among modern components in semiconductor technology, interactions in fluid structures (see Figure 4.28), or the behavior of systems ranging from switching circuits to production lines: all of these can be simulated numerically (more or less satisfactorily) these days and the resulting data are regularly processed and presented graphically. Validating the results or comparing them with measurement data, or understanding the process better, is almost unthinkable without computer graphics. On the other hand, numerical simulations are often carried out for the purpose of obtaining certain graphical effects (e.g., molecular dynamics simulations to represent folds in cloth) (see Color Plate 47).

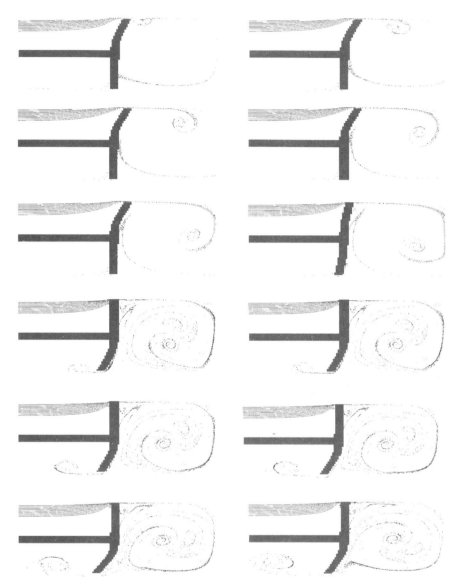

FIGURE 4.28 Twelve frames from a numerical simulation of the interactions of fluid structures in a micropump. The pump membrane lies on the right, and the intake and outlet are at the upper left and lower left, respectively. The top six pictures show the intake phase and the lower six, the discharge phase.

The type of graphical processing and display of data described above is commonly referred to as visualization [KeKe93, NHM97, ScMü99]. One central task of visualization is always the choice of the correct type of display. For example, a two-dimensional flow profile can be well represented by a field of velocity vectors, yet this technique yields utterly unclear images in the three-dimensional case. In animations, this

kind of "arrow picture" is also useless. Here particle tracing (cf. Section 4.4.3 and Figure 4.22) turns out to be very clear. Thus, it is typical for visualization that knowledge about computer graphics, about the corresponding application disciplines (say, fluid mechanics), and about optical perception and the operation of (animated) images is required in order to produce meaningful and effective pictures and animation. Here we shall not go so far by any means, but, rather, concentrate on the technical aspect of image production. Depending on the particular problem at hand, entirely different methods are required:

- Image processing and volume rendering[4] techniques are particularly required for visualization of medical data sets of the sort obtained from image generating procedures such as ultrasound, computer, or nuclear spin tomography.
- The efficient generation of contour surfaces, relief contours, cross sections, or lines of strike (see below) plays an outstanding role in visualizing spatially resolved simulation data sets and, thus, for example, the velocity field and temperature distribution of a flow. (These include some of the classical tasks of volume rendering.)
- Frequently, the fundamental techniques of computer graphics, such as geometric modeling of three-dimensional scenes, illumination models, or visibility determinations are of importance. Examples include simulations of the dynamics of the movement of a car on a test track or simulated movements of an industrial robot.
- Finally, virtual reality techniques show up, as, for example, when an architectural model has to be visualized in order to allow a virtual stroll through the building or with synthetic terrain models for flight simulators, etc.

In the following we shall be concerned briefly with the first two topics. The last section of this chapter is devoted to virtual reality.

4.6.1 Image Processing Techniques

Visualization touches on image production procedures in which measurement values (radar scans by the Satellites ERS-1 and ERS-2, computer tomograms, scanning electron microscope photographs, etc.) are converted to pictures in the ordinary sense. A picture is taken to mean a discrete set of data, more precisely a two or (also in a generalized sense)

[4] Volume rendering is the process of representing three-dimensional scalar fields. Volume rendering is used for graphical display of the properties of the interior of a volume. Standard examples include temperature distributions or density fields from tomographic procedures.

three-dimensional field of gray tones or color values. As opposed to visualization of simulation data, in which images are created from artificially computed data, here we are dealing rather with an optical reconstruction. Here image processing techniques are used extensively.

In a crude subdivision, five categories of image processing operations can be distinguished: geometric, point-to-point, local, comparative, or global processing operations.

Geometric processing operations change the form of a picture or part thereof. The effect of such geometric operations on the color value in a pixel depends on the position of the pixel, but not on the color value in the pixel or in the points adjacent to it. Some examples include enlargement and reduction, rotation, and distortion.

Point-to-point processing involves the modification of a picture through simple local variations in the pixel values. In general, the effect of such point operations on the color value in a pixel depends on the local color value, but not on its position or on the surrounding values. Examples include constant addition (modification of all pixel values by a constant), contrast enhancement (padding the brightness values to the entire region being represented), false color display (different ranges of gray are assigned different colors with each color running through the entire intensity range; large differences in the pixel values show up as distinctions in color and small differences, as before, as distinctions in intensity), and exponential transformation (realistic reproduction of intensities).

In local processing (local-to-point processing) the surrounding gray tone values flow into the new local color values. Examples of these operations include local weighted averaging operators (evaluation of a local environment, weighted averaging by convolution or a generalized smoothing operation), local ranking operators (evaluation of a local environment, sorting of the resulting values, selection in terms of the median or other quantities), segmenting (assignment to classes via threshold values followed by filtering), flank or edge detection (pixel values in smooth regions are reduced or remain unchanged; differences are accentuated for contouring), and extraction of characteristics (localization of certain characteristics such as threshold crossing, edges, oscillations, patterns, textures, etc.).

There is often interest in comparing multiple pictures. The corresponding ensemble processing (comparative processing) operators call up multiple photographs of the same detail in order to derive new images from them. Examples include motion detection (recognition of changes or movements by comparing two pictures taken at different times; applications in medicine and satellite photography) and difference images. (The latter are used, again, in medicine (visualization of blood circulation from

a comparison of scans before and after injection of a contrast medium, since blood, blood vessels, and the surrounding tissue have almost the same x-ray absorption properties and, thus, can be difficult to distinguish optically in a single picture) and in satellite photography (photographs from the Landsat satellites as a combination of the response in four wavelength bands to reveal vegetation or detect mineral resources).

Finally, global information from the entire picture can enter into a new pixel value; hence, we speak of domain processing (global processing). Here complicated pixel value modifications are carried out on the basis of local and global information (Fourier and related transformations). These procedures involve the most time consuming and powerful techniques and can be applied in many areas, e.g., image sharpening, edge emphasis, contrast enhancement, restoration of details, and compression. Examples of compression include cosine transformations (the basis of the JPEG standard for compression of digital image data) and wavelet transformations (used with the Fourier transform, but with space/time and frequency localized basis function (wavelets); high compression, efficient algorithms).

X-ray photography is the beginning of (medical) image production procedures. These are summation images, which frequently prevent recognition of details because of mutual overlap. Tomography can be used to form sharp images of morphological details at an arbitrary layer depth. The layers above and below that depth are blurred out. Thus, three-dimensional views can be generated from single tomographic scans. There is a distinction between transmission tomography, in which rays pass through the objects to be imaged, and emission tomography, in which radiation emitted by incorporated radionuclei are detected. Examples of the former include classical x-ray Computed Tomography (CT), Nuclear Magnetic Resonance Tomography (NMR, MRI), and Confocal Laser Scanning Microscopy (CLSM). Examples of emission tomography include Positron Emission Tomography (PET) and Single Photon Emission Computed Tomography (SPECT).

Nowadays combinations of transmission and emission tomography are coming into operation, e.g., as a superposition of nuclear magnetic resonance tomography with SPECT. These hybrid procedures have the advantage that they make both structural and metabolic information visible and can be used in connection with each other. The CT principle can also be employed generally, as for visualization of the inner structure of the earth using the propagation of mechanical (seismic) waves.

4.6.2 Visualization of Spatially and Temporally Resolved Simulation Data

Let the result (in the form of a large set of numbers) of a numerical simulation, that is, in general a scalar or vector valued function $f: \mathbb{R}^d \supset \Omega \to \mathbb{R}^m$, where $m \in \mathbb{N}$, be given over a d-dimensional field. In the following we shall briefly discuss some techniques or possibilities for optical representation of data sets of this type. These of primary interest is $d=3$ or, with time resolution, $d=4$.

4.6.2.1 Dimension Reduction Techniques

The direct visualization of functions specified in three- or more dimensional space is difficult. Thus, one often turns to the display or emphasis of two- or one-dimensional partial regions (dimension reduction). The most popular possibilities for this kind of display are:

Slices (planes of intersection; see Figure 4.29): Here the quantities of interest are considered only in the intersection of a plane E with the main region Ω, rather than in all of Ω. Two-dimensional techniques can then be applied on the plane of intersection.

FIGURE 4.29 Example of a plane of intersection or slice.

Isosurfaces (see Figure 4.30): The hypersurface on which one of the scalar ($m=1$) functions to be calculated, f, takes a prespecified value, $I(c) := \{\mathbf{x} \in \Omega : f(\mathbf{x}) = c\}$, is displayed. If it is desired to generate the isosurfaces interactively and shift them (change the constant c), then one needs either efficient algorithms for the rapid determination of the isosurfaces (e.g., the well-known marching cubes algorithm) or sufficiently powerful graphics hardware. (In a typical example of a simulation of flow and transport in a complicated obstacle geometry (resolution 512^3 cells), an isosurface can easily be made up of several million polygons.) Two-dimensional techniques can be used

for visualizing other quantities on the isosurface. The analog of isosurfaces in the two-dimensional case is contours or isolines.

FIGURE 4.30 Example of an isosurface.

Streamlines: Streamlines are used to visualize vector fields ($m>1$), i.e., vector valued data. They are defined as the curves in Ω with their tangents parallel to the corresponding position vector at each point. The choice of streamline follows from the choice of the starting point.

Particle tracing: Particle tracing is used for visualization of time dependent vector fields. A virtual particle is introduced at a starting point in the region Ω and then follows the corresponding position vector of the vector field. The path of the particle (theoretically a continuous curve, but in practice a sequence of discrete positions at discrete times) defines the track.

Streaklines: Streaklines are also used for visualizing time dependent vector fields. Beginning at a starting time, particles are injected at a starting point (theoretically continuously, but at fixed intervals in practice) and all of them move forward, following the current position vector of the field. The line which is generated up to a given time is referred to as a streakline. Particle tracing, therefore, reproduces the motion of a single particle over a time interval, while streaklines indicate the positions at a fixed time of many particles which have set out from the same starting point. In the case of a stationary field (no variation with time) streaklines and particle tracks overlap. Streakbands are commonly used, as well as streaklines. Here the particles are injected along a line rather than from a single point. In this way wide bands, rather than curves, develop over time. The advantages of streakbands include the possibility of displaying more information through them as well as the ability to make rotations visible. Streak tubes are also used to improve the impression of three dimensions.

4.6.2.2 Other Techniques

Besides the above possibilities for dimension reduction, there is a series of other techniques for visualizing spatially resolved simulation data or to support its visualization. These will now be discussed below, if only briefly.

The intensity (magnitude) of a (scalar) quantity can be indicated by hue or by color intensity (depth). In this way, the visualization should support intuition. (For instance, in the case of temperature, blue is used for cold and red for hot, rather than the opposite, and for the concentration of a substance, weak intensities correspond to low values, etc.) Otherwise, different colors can be used for different quantities (red hues for the temperature, blue hues for concentration). Here, of course, the human ability to perceive imposes limits: with more than five colors, the parallel processing capacity diminishes. A suitable choice of scale is important in every case: if this covers too wide a range, small differences in the data will disappear, while if the displayed range is too small, marginal differences will appear big.

Increases in dimension are often used. A quantity specified over a two-dimensional region can, for example, be plotted in a three-dimensional image as a function over the region of interest (function plot). Of course, such surface plots make sense only in two dimensions.

Display primitives are also in particularly widespread use. Display primitives are especially appropriate as an extension of dimension reducing procedures. An example of this is arrows in a three-dimensional velocity field which are to be transferred to a selected partial region (a slice, isosurface, or path) and which can carry additional information via size and color. Spheres or balls are widely used as primitives. They are mostly used in particle tracing or streaklines and are supposed to symbolize individual virtual particles. If they are introduced into the scene at fixed time intervals, then the distances between them are also a measure of the absolute velocity in the fluid.

Texturing is also used. Isosurfaces and surfaces or bands of intersection can impart additional information via texture, i.e., by imposing a pattern on the surface. This can be a specified fixed pattern for identifying the surface or a pattern that is determined by a certain quantity of interest. In this way, an isosurface for the concentration of a substance can be textured by a color scale for the norm or the absolute magnitude of the velocity or by a vector field projection on the surface (comparable to iron filings in a magnetic field) for a vector field. The texture can also visualize the properties of the basic region [seepage of oil in soil: the characterstics of the ground (sand, clay, gravel, etc.) may be displayed on an isosurface of the oil concentration].

Labels and legends are essential, not only for spatially and temporally resolved simulation data, but naturally for understanding and correct interpretation of visualizations of any kind. Descriptions in a picture can be helpful but can also divert the observers eye from the essential information and are, therefore, to be introduced with caution.

4.6.2.3 Representation of Data

The visualization of spatially and temporally resolved simulation data relies on the discrete data resulting from a run of the simulation. It thereby naturally inherits the discrete geometry upon which the simulation is based and, therefore, the grid (structured or unstructured, regularly or adaptively refined). If the visualization algorithm can handle inherited geometry directly, then the calculations and graphical display can be carried out on the same grid structure. Otherwise, the calculated simulation data have first to be mapped (i.e., interpolated) onto a suitable visualization lattice.

Modern visualization systems, such as AVS/Express, use a hierarchy of components to describe data records (see Figure 4.31).

FIGURE 4.31 The hierarchy of components in AVS.

Field: The field is the highest ranking component in the hierarchy and represents the aggregate information (in its full generality). It consists of a mesh component and a data component.

Mesh: The mesh component provides the geometric description of the basic domain[5] (specific and factual dimensionality of the domain, the type of mesh: unstructured, structured, rectangular, uniform; cf. Figure 4.32) and determines where and how the data are

[5]An isosurface is actually a two-dimensional form that, in fact, exists in a three-dimensional space.

organized. The corresponding information is retained using a grid component and a cell component.

FIGURE 4.32 Mesh and grid types for AVS: unstructured (leftmost) and structured (conformal, rectangular, uniform, from left to right). In the unstructured case all the grid points and the information on their relationships are stored explicitly. In the conformal case, the positions of the points suffice, in the rectangular case, the mesh width vectors suffice, and for uniform grids, the constant mesh widths suffice.

Grid: The grid component contains the positions of the grid points. Here also there is a distinction between unstructured and structured grids. The more structure a mesh or grid has, the smaller the amount of information that has to be explicitly retained. In the uniform case, for example, the positions and proximity relationships are implicit.
Cell sets: A set of points with corresponding values is still not sufficient for creation of an image (say, an isosurface). The question of proximity or connectivity must be answered. This is provided by the cell components. The cells are general geometric units and can be points, edges, surfaces (triangles, quadrangles), or volumes (tetrahedra, hexahedra). With structured grids, the topological relationships (who borders on whom) are derived automatically from the information in the grid points, while they must be stored separately for unstructured grids.
Data: The data component represents the data in the grid (and thereby the calculated or stored or displayed functions).
Node data: Node data are the data which are assigned to the nodes (grid points) in the grid.
Cell data: Cell data are the data which are assigned to the cells. In fluid mechanics, for example, staggered grids are often used, in which pressure values are assigned to the intermediate points and velocity values, to the midpoints of the sides of the rectangular cells.

The different assignment of the respective quantities to points or cells is of definite importance for visualization: in the first case, only the point has a corresponding value or a corresponding color, and interpolation is done in between. If large cells are assigned, then the entire cells will be colored constantly corresponding to the value (which is, naturally, undesirable from an aesthetic standpoint, as it leads to sharp transitions).

Another central point is the difficulty of interfaces between simulation and visualization data noted at the beginning of this section. Modern discretization procedures reduce the data costs in the calculations fairly substantially (hierarchical structures, adaptive refinement), while visualization systems often are set up with essentially simple and regular structures and thereby sacrifice a lot in terms of efficiency. For example, it is more than annoying if the data in an adaptive grid must first be interpolated to a regular grid for purposes of visualization, or if the type of description must be altered. Purpose built interfaces help here in avoiding loss by friction.

Finally it should be pointed out that techniques from image processing can be helpful in the visualization of spatially and temporally resolved simulation data discussed in this section, for example, the extraction of characteristics for ferreting out certain details (vortex structures in flow visualizations).

4.6.3 From Picture to Film

In time dependent simulation data, a single image is still not entirely satisfactory, because only an isolated time point can ever be observed. Sequences of single images do increase the power of a presentation, but the goal for time dependent problems must, nevertheless, be a film. "I could even imagine that someone might set these pictures in motion since many pictures were hung together anyway," (quotation from a mathematician, February 1999). In fact, it works that way in reality (as we have already seen in Section 4.5), at a rate of 25 or 30 images per second (video frame rate), while an even lower rate is often adequate. Of course, certain other things have to be taken into account in visualization. The sequence of single pictures must naturally be chosen so that neither jerky transitions nor too-slow advance interfere with the perception. Jerky motion of this sort can also occur when different colors encounter each other in two individual images that follow one another. Since adopting the scale of the first picture for all the following pictures likewise involves some risk (if the differences during the run of the film become smaller, they will not be recognized later, but if they grow larger, then ever more values lie outside the region that can be displayed), global minima and maxima must be determined in advance for all the pictures in order to ensure consistent and informative coloration.

In principle, all the single image visualization techniques which describe the properties at a fixed time point are suitable for film. Which display modes will reproduce the dynamics best depends on the particular problem.

What is to be done if the creation of such a large number of single images is too costly? The computation time for a single time step in a three-dimensional flow simulation can easily take hours. This implies a not insignificant computational effort for a one minute film with 1,800 images. Since the time step size in the simulation is subject to numerical constraints (stability conditions), a certain number of individual images (frames) is necessary anyhow. Under some conditions one can dispense with the shrinking of the step size imposed by the visualization process and instead generate other images (frames) by interpolation (inbetween-ing; cf. Section 4.5.1). But it should be kept in mind that this is no longer a visualization of simulation data in the narrow sense (cf. the comments on animation in Section 4.5, as well as rule 6 in the following section).

4.6.4 Above All, Colorful Little Pictures

We have now found that visualization is important; indeed, for disciplines such as numerical simulation it is essential. A bit of skepticism won't hurt, however.

One important aspect is that, first of all, visualization cannot be "better" than the underlying data. An ever so costly and well thought out and shaped visualization says nothing, per se, about the quality of the model that was used, since falsifications are possible from time to time. Moreover, the slowest numerical algorithm imaginable (so it is, therefore, correct) leads to the right result and, thus, to the desired visualization, regardless of how much computational time has been squandered that way.

A second difficulty is optical artifacts: does what I am seeing actually reflect reality or is it just an optical illusion?

Third, the problem of erroneous interpretation must be considered. Am I interpreting the figures correctly (a ubiquitous problem in early work on computer tomography, since tumors were often just overlooked); are we dealing with an actual property of the data in the interpreted phenomenon or might it merely be based on a choice of parameters (color scale, intensity, contrast, etc.)? Despite all the suggestive power of good visualizations, one should have at least some idea of what's going on, based on the discipline or the phenomena to be visualized, before proceeding to an interpretation.

Finally, the possibilities for manipulation in visualization are almost unlimited. In this regard, we should note the report *13 Ways to Say Nothing with Scientific Visualization* [GlRa92] which offers the following advice to the budding visualizer:

1. *Never include a color legend!*
 The optics is the main thing; legends just distract the observer.
2. *Avoid annotation!*
 Explanations merely undermine the visual confusion.
3. *Never mention error characteristics!*
 If a picture looks good, it just has to be right, too.
4. *When in doubt, smooth!*
 Always smooth out the disturbing peaks: beauty and speedy publication are certainly more important than accuracy.
5. *Avoid providing performance data!* Only the small of spirit worry themselves about how much time the visualization requires.
6. *Quietly use stop-frame video techniques!* Why produce a lot of unnecessary frames for an animation when individual frames can be repeated or be interpolated between frames?
7. *Never learn anything about the data or scientific discipline!* Someone who doesn't know what to expect in the picture shouldn't set out to look for mistakes. Long live the lack of bias!
8. *Never compare your results with other visualization techniques!* Others' pictures might look better.
9. *Avoid visualization systems!*
 Why use other people's crap (cf. rule 8) when you can find nice things on your own?
10. *Never cite references for the data!*
 That would only be an invitation to a reexamination and fault-finding.
11. *Claim generality, but show results from a single data set!* What is "wlog" for?
12. *Use viewing angle to hide blemishes!*
 Why not use "Hidden Surface Removal" for "Disturbing Detail Removal?"
13. *"This is easily extended to 3D!"*
 See rule 11.

After this not entirely serious advice on visualization, we now turn to the last topic of this chapter, virtual reality.

4.7 VIRTUAL REALITY

In recent years the concept of virtual reality has moved from research and industry to become a catchword through the groups directly involved in working on it. The huge fascination arising from artificially created and

virtually experienced worlds has led to an astonishing preoccupation with the concept of virtual reality by the mass media. At the same time, the term, first deliberately coined in 1989 to gather related projects under a generic terminology, but circulating under widely differing names since the 1960s, is rather confusing because of the contradictory notions of virtual and reality.

Science fiction authors dealt with the topic quite early. Thus, Aldous Huxley had a "feelie movie" with "perfume organ accompaniment," "pneumatic chairs," and "super stereo sound" in his 1932 novel, *Brave New World*. A good fifty years later, W. Gibson in his 1984 novel *Neuromancer* coined the term cyberspace, often used today as a synonym for virtual reality, in which people could navigate through virtual data worlds, while their nervous systems were directly connected to a world-spanning network.

Since computer graphics plays a decisive role in virtual reality, in the last section of this chapter we would like to discuss this topic briefly. For a detailed discussion we refer the reader to [Hels91, Borm94, Kala94].

To define the concept of virtual reality in a few words, two of its aspects have to be taken into account. First, there are the artificial worlds designed by people and created on computers, where an individual can act with the aid of special in- and output devices, as well as through computers and networks. In the narrow sense, this means the three-dimensional scenarios produced by the methods of graphical data processing, and in the broader sense, it includes the communications possibilities opened up by the world wide web. In addition, virtual reality signifies the techniques and procedures by which people can interact with the artificial worlds.

A virtual reality system consists essentially of three groups of components: input devices through which the user communicates his actions to the system, graphical and control computers, which compute the effect of these actions on the scene or on a detail in a picture and undertake the control of the individual components, and output devices, which then make the modified scene or the reaction of the scene available to the user.

Conventional input devices, such as the keyboard, mouse, or joy stick, are unsuitable for virtual reality systems because they do not support three-dimensionality adequately. Thus, new ways of man-machine interaction must be explored:

- Data gloves allow the user to grasp, move, or otherwise manipulate virtual objects. Here a graphical image of the hand in the virtual world simultaneously follows the movements of the natural hand. Numerous sensors for orientation, bending, or strain sense the position of the hand, as well as the positions of the fingers relative to one

another. The absolute position of the hand is determined using a position sensor (see below). Under certain conditions special contact actuators are installed at the fingertips for touch feedback.

- Data suits go a step further. Here the sensors are installed on a whole body suit and more than fifty degrees of freedom of movement can be taken into account. In the early models only blinking light emitting diodes were installed instead of sensors. Cameras recorded the light signals and the position and posture were calculated from them. This technique, referred to as tracking, is still applied to computer animation today (see Section 4.5). The natural movements of living creatures are thus converted into computer generated objects or their wire grid models. For example, many of the animation sequences in the movie "Jurassic Park" were made in this way.

- Position sensors (tracking systems) are installed on data gloves, data suits, or head mounted displays and make it possible to determine the current spatial position of the observer. Important quality characteristics of tracking systems include the accuracy of the determined position, the resolution (smallest detectable position change), the frequency with which the position is determined, and the time delay (the time between a change in position and the feedback). Electromagnetic, mechanical, acoustic, and optical tracking systems can be distinguished (see [Borm94]).

- The so-called poolball is, aside from a possible cable connection, a hollow sphere that can move freely in space and contains a position sensor. The poolball is a "three-dimensional mouse" with which the user can act in a three-dimensional scene.

- Eye tracking systems make it possible to take in the line of sight of the eyes, which can, again, serve as an input for the graphics computer (viewer's perspective).

- Speech recognition systems permit spoken input and, thereby, replace the keyboard.

The control and graphics computers constitute the heart of every virtual reality system. The demands on hardware and software are, therefore, extremely high and the graphics is typically the bottleneck. Besides special graphics hardware, here real-time capable rendering techniques (cf. Section 4.1), such as Gouraud shading (cf. Section 3.4), radiosity procedures (cf. Sections 3.6.3.4 and 3.8), and texture mapping (cf. Section 4.2.1), come into use (see Figure 4.33).

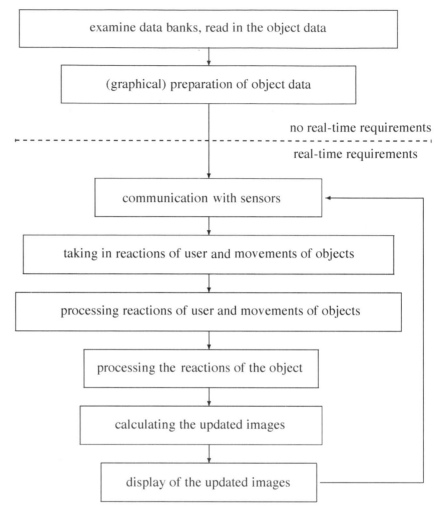

FIGURE 4.33 Schematic representation of the time sequence in virtual reality systems.

Output devices in the sense of virtual reality systems include all devices which directly stimulate the human senses and thereby make the virtual world perceptible to humans. At present, visual systems (head mounted displays) predominate, but auditory systems and systems which rely on touch or orientation also exist.[6] In today's head mounted displays a small screen is mounted in front of both eyes. Both conventional cathode ray tubes (high resolution, good image quality, but large, heavy, and bright), as well as increasingly flat and lightweight LCD picture screens are in use.

[6]Thus far, on the other hand, the human chemical senses (smell and taste) play no role in virtual reality systems.

We conclude with a brief look at the most important applications of virtual reality. Although we limit ourselves to civilian applications here, it should not go unmentioned that military institutions have strongly supported development in the area of virtual reality from the beginning and are today among its chief users. Many of the technologies listed below are just in the beginning stages and their potential remains to be seen.

- *Applications in air and space travel*:
 Here flight simulators are the classical application for VR methods. In the simple systems from the entertainment industry, only a screen and a loudspeaker are used for the output. The more costly systems from airplane manufacturers and airline companies, on the other hand, also simulate such effects as motion and acceleration. In flight control systems so-called synthetically generated vision must also allow for precision flight under the most adverse natural sight conditions (especially takeoff and landing) (see Color Plates 45 and 46). Telerobotics makes it possible to repair satellites in outer space by means of robots controlled from the earth.

- *Applications in medicine*:
 Virtual realities are also of increasing importance in medicine. Surgical interventions can be practiced beforehand in virtual operations on virtual patients and specialists in different locations can carry out an operation on a patient together using remote surgery. In the meantime, minimally invasive surgery, in which tiny teleoperators (robots) move along the circulatory system or the digestive tract to the place where they will be used, is firmly established. Surgical treatment is thus possible without a serious operation and the associated risks. Finally, VR techniques can ease communication with the surrounding world and the operation of equipment by those afflicted with many kinds of physical disability.

- *Further applications in science and technology*:
 Here there is a wide spectrum of applications in the areas of simulation and visualization (cf. Section 4.6). For example, flow simulations are visualized (simulations of the circulation inside motor vehicles for optimizing the design of ventilation systems or climate control) ever more frequently in VR environments (CAVE, computer aided virtual environment or Holobench).

- *Applications in architecture and design*:
 In these fields, as well, there is considerable potential for applications of artificial worlds. For example, architects can take virtual

walks with their clients through their new houses even before the first cut with a shovel. In large town planning projects such as that of the 1990s in Berlin, the observer can stroll across virtual squares and thereby gain an impression of the planned structures. Stores and specialized distributors can offer distant customers trial use of many different kinds of equipment without having to assemble it. Finally, in automobile manufacturing, poor accessibility of a switch or a high noise level in the interior of a vehicle can be recognized prior to production and the designers and engineers can make interactive changes.

- *Applications in the entertainment industry*:
 VR applications are omnipresent in entertainment, as well. These include virtual reality simulators in recreational parks and interactive television or (entirely or partially) synthetically produced movies, as well as the important area of computer games.

Of course, the social and political problems involving virtual reality should not be forgotten, although they cannot be discussed in detail at this point.

For the sake of completeness we should note that virtual and actual reality (thus, for example, synthetically generated pictures and photographs) are being more and more frequently combined as, for example, when an architect wanted to demonstrate the effect of "his" design for the rebuilding of Ground Zero on the skyline of Manhattan. One then refers to augmented reality.

INTERFACES AND STANDARDS

In Figure 1.1 of Chapter 1 we illustrated the general sequence of work in computer graphics from the actual scene or from the production of an artificial scene in a computer to an image on an output device. Each intermediate step along this path operates with special data. First the data are submitted as user data in a more or less formal description (e.g., the distribution of the turnover of a small enterprise over different areas of the business). Then an appropriate representation scheme (see Chapter 2) and a graphics editor are used to generate, say, a pie chart from these user data. Now the data are at hand as geometric data in an abstract geometric description. In the next step the data are tied together into a graphical context (colors, perspective, etc.). The resulting image data now describe the virtual image independently of any device. Then device-driven raster data are generated, after which the device driver finally converts these into device-specific device data, which can then be used to display a picture (and, thus, the pie chart) on the device. A process of this type is often described in information science by a hierarchical layer model and, in fact, models of this sort have also become widespread in graphical data processing (see Figure A.1).

Wherever layer models and interfaces are involved, the question of standards immediately arises. This is especially true of computer graphics, in which standards have quite a long tradition. Without going into details here, we should briefly mention a few important standards.

A series of standards at the level of abstract geometrical description (see Figure A.1) have been developed since the middle of the 1970s. Examples include the 3D Core Graphics System (Core, 1977/1979) [GSPC77, GSPC79], the Graphical Kernel System GKS (1985) [ANSI85] and GKS-3D (1988) [ISO88], or the Programmer's Hierarchical Interactive Graphics System (PHIGS, 1988) [ANSI88], as well as PHIGS+ (1988) [PHIG88].

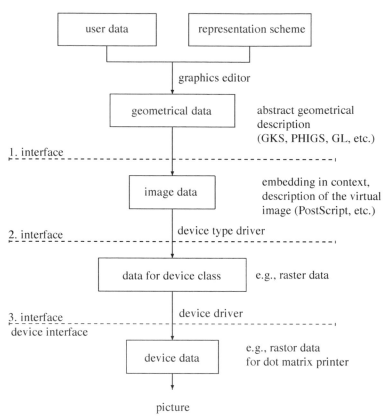

FIGURE A.1 An example of a layer model in graphical data processing.

Besides this, there is a series of producer specific solutions, of which, for example, the Graphics Library (GL) of Silicon Graphics, a collection of C-library functions, has acquired great importance. In particular, OpenGL [NDW93], which originated from it and, in the meantime, become available for almost all computer platforms, has evolved into a quasi-standard. We shall introduce and briefly discuss OpenGL in Section B.1 of the following Appendix B.

At the level of (virtual) image data the PostScript printer [Adob85a, Adob85b] has come into widespread use and can be regarded as a quasi-standard today. The picture formats TIFF, GIF, JPEG, BMP, PPM, TGA, and RLE are especially important for image processing [Holt94].

B GRAPHICS SOFTWARE

Anyone who is concerned with the practical application of graphical data processing will find hardware that is specially tailored to the requirements of computer graphics, as well as a very extensive supply of software. The spectrum ranges from simple drawing programs using modelers and ray tracers to extensive visualization systems with wide ranging application capabilities. It is not the purpose of this appendix to attempt a complete overview of the available graphics software. Such an attempt would undoubtedly be fated to run aground because of the ever increasing set of relevant programs and program systems. Rather, the reader should be acquainted with a sample of programs and libraries with various functions and objectives, so as to get an idea of what is currently available for solving problems in computer graphics, especially in computer work station environments. Since some of these programs are available as public domain (PD) software or are delivered as part of work station computers, the interested reader is in a position to gain some practical experience with the topics of this book without great expense.

B.1 GRAPHICS LIBRARIES, OPEN GL

The graphics libraries available for the most common higher programming languages contain procedures which make it possible to use basic graphical functions in programs via subprogram calls. This extends from simple routines for graphical primitives to functions required for the production of animations. The various programs are generally very closely tied to hardware, which leads to a high efficiency of the sort essential for real-time capabilities. Programming in a higher language affords the greatest possible flexibility; nevertheless, a basic understanding of graphical programs is necessary.

The following are examples of graphics libraries:

- Starbase (for HP systems, forms part of HP-UX, programmable in C or FORTRAN; ray tracing, radiosity; substantially displaced by OpenGL)
- DirectX (a standard introduced by Microsoft in 1995, available for various systems in Windows)
- GL (for SGI systems, forms part of IRIX; programmable in C or FORTRAN; essentially supplanted by OpenGL)
- OpenGL (a standard developed from GL forms part of IRIX; available for various systems such as SGI, DEC, SUN, HP, Intel).

A freely available collection of algorithms named *Graphics Gems* [Glas90, Arvo91, Kirk92, Heck94], which is independent of any particular programming language, contains many of the basic algorithms described in this book, as well as some very task specific functions. The latter, of course, have to be adapted to the corresponding programming language.

Given the paramount importance in computer graphics that OpenGL has gained over the last few years, both generally and for graphic programming, we shall discuss it in somewhat more detail below.

B.1.1 Basics of OpenGL

OpenGL has gained widespread acceptance as a standard for graphical API (Application Programming Interfaces). Thus, it is, first of all, an interface between graphics software and graphics capable hardware. The core of OpenGL consists of roughly 120 different commands, all of which are completely independent of the particular hardware and only perform rudimentary functions. Commands involving a window system, user input, or the modeling of complicated objects, are additionally available.

So that not everything is left to the user, there is a series of associated libraries:

- The *OpenGL Utility Library* (GLU) contains a series of routines which provide more complex functions based on the simple OpenGL program. The GLU is a constituent of an OpenGL implementation.
- The *OpenGL Extension to the X Window System* (GLX) provides a link between the OpenGL basis routines and the X window system. GLX is likewise a constituent of an OpenGL implementation.

- The *OpenGL Utility Toolkit* (GLUT) offers the possibility of simple transfer to an arbitrary window system, as well as simple access to different input devices. GLUT is also a constituent of an OpenGL implementation.
- *Open Inventor* is an object oriented program collection which provides objects and methods for extensive interactive 3D graphics applications. Open Inventor is distributed by SGI as an independent product.

With extension libraries the spectrum of applications for OpenGL includes 3D modeling and CAD, real time 3D animation, rendering, texture mapping, special effects, visualization functions, and much more. Numerous application programs build, in the meantime, on OpenGL; thus, for example: Maya from Alias|Wavefront, the CATIA CAD/CAM system from Dassault, and I-DEAS from SDRC, or the AVS/Express visualization package. OpenGL is extensively supported in industry and is often and substantially independent of manufacturer, as well as persistently and upwardly compatible, so that the applications are transferable. In the meantime, OpenGL is available for almost the entire palette of architectures, from laptops to supercomputers (e.g., UNIX, Windows 95 and successors, Mac OS, Linux, OS/2, etc.). It is highly user friendly and can be used in many programming languages (e.g., FORTRAN, C, C++, Java, etc.) and has also been documented at length.

Some of the capabilities of OpenGL are listed here with no claim of completeness:

Accumulation Buffer: multiple calculated frames can be overlapped or combined to achieve certain effects [blurred image, lack of depth definition, motion blur (trailing)].

Alpha Blending: the possibility of realizing continuous transparency (see Section 3.5.1) via a parameter $\alpha \in [0,1]$, which specifies the transparency of a surface or object (through a so-called extended RGB or RGBA value).

Antialiasing: local smoothing operator (see Sections 1.5.3 and 4.6.1).

Double Buffering: a second frame buffer is installed to eliminate the flickering that develops during animation owing to the constant erasing, recalculation, and loading of the screen content, by storing successive images in different screen memories (see Section 4.51).

Gouraud Shading: see Section 3.4.2.1.

Material Properties: these can be involved in the calculation of the light or color intensity values for surfaces.

Texture Mapping: see Section 4.2.1.

Affine Transformations: the capability of explicitly carrying out transformations (reflections, rotations, elongations, change of view) through specification of transformation matrices.

z-Buffering: see Section 3.2.3.

3D Textures: part of hardware-accelerated volume rendering.

Control of Level of Detail: textures exist in different resolutions (mipmap textures) which are adjusted in accordance with the distance of the object to be textured from the observer.

B.1.2 Viewing in OpenGL

With regard to OpenGL, viewing is taken to mean the task of assigning (three-dimensional) spatial models (in the world) to a scene, examining these from a certain position, and creating a two-dimensional image on the output device from the result.[1] Since this is all to be programmed explicitly in OpenGL, we shall go into this in somewhat more detail from here on, although the procedure is already known in principle from Chapter 1. The following things must also be done:

1. arranging and aligning models of objects in space with the aid of appropriate transformations (modeling transformations),
2. selecting and aligning the observation point in space using similar transformations (viewing transformations; by default the observer is at the origin and looks in the direction of the negative z axis),
3. determining the segment of the world to be viewed (viewing volume) using the six clipping planes and projecting them onto two dimensions (projection transformations), and
4. imaging the result onto the prescribed region in the output device (viewport transformation).

The individual steps can be illustrated quite simply using the example of photography: the people and objects to be photographed are suitably arranged (1.), the camera is positioned and adjusted on a tripod (2.), the picture detail is established using zooming or selecting the lens (3.), and finally it is decided in what format the photo is to be printed (4.).

Each transformation images a given coordinate system onto a new one. With homogeneous coordinates $((x,y,z,w)$ with $w=1$ in 3D and $z=0$ in 2D)[2] both affine transformations (displacement, extension, rota-

[1] This is the way things are seen in OpenGL: viewing in the narrow sense starts with a scene already modeled which then has to be imaged.

[2] The z coordinate is included in order to provide depth information at each time for the visibility determination (cf. Section 3.1).

tion, reflection, shear) and central (up to perspective division) and parallel projections can be represented as a multiplication of the corresponding coordinate vectors by a 4 x 4 matrix. As a four-dimensional vector an object point is also subject to numerous matrix vector multiplications before it returns as a pixel on the screen. How this looks in OpenGL is illustrated in Figure B.1.

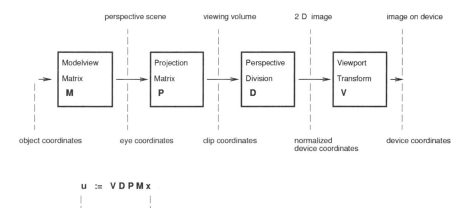

FIGURE B.1 Viewing in OpenGL: individual transformation steps, the associated matrices, and the corresponding coordinate systems are indicated.

The so-called modelview matrix in Figure B.1 is the product of several matrices for execution of all the viewing and modeling transformations. This unified treatment is also sensible, since the two are closely interwoven: moving the camera from the scene in the sense of a viewing transformation is evidently the equivalent of moving the scene from the camera in the sense of a modeling transformation. OpenGL then always applies the matrix of a further transformation automatically to the one already accumulated by product formation or multiplies it by this accumulation. If a new object is to be transformed (a second wheel, for example, is to be mounted on a car), then the identity must always be loaded first in order to initialize the memory. Since the matrix for a sequential transformation is always multiplied on the right of the current modelview matrix, the last written transformation will de facto be applied to the coordinate vector first:

$$M_4, \ M_3, \ M_2, \ M_1 \quad \text{corresponds to} \quad M_4{\cdot}M_3{\cdot}M_2{\cdot}M_1{\cdot}x. \tag{B.1}$$

Since in OpenGL the scene is first constructed and the camera is positioned afterwards, the viewing transformations in OpenGL must always appear in front of the modeling transformations in code.

The standard affine mappings are available as modeling transformations: translation, rotation and scaling with the special cases of zoom (extension) and mirroring. Because of the above-mentioned symmetry, viewing transformations can be realized through modeling transformations, but special, more comfortable commands do exist.

The projection transformation fixes the region to be imaged (the viewing volume), defines the clipping by that means (nothing outside the viewing volume will be drawn), and carries out the projection of this three-dimensional region onto a two-dimensional plane. By default, the direction of projection is always the z axis and the center of perspective (the observer) for a central projection is at the origin. The result in each case is a region that is to be displayed which is bounded by six clipping planes, i.e., a cuboid or parallelepiped for parallel projection or a truncated pyramid for central projection (cf. Figure. 3.9 and 3.10 in Section 3.2.1). The plane of projection is parallel to the front and back clipping planes and is usually taken to lie between the two.

We still have to discuss the viewport transformation. The preparation of a window for the output is one of the tasks of the window manager. The viewport, i.e., the region in the output device onto which the image is to be output, has the entire window size as a default, but appropriate segments of it can be specified. In order to avoid distortions, the aspect ratio of the viewport must be consistent with that of the viewing volume or of the clipping rectangle. During the viewport transformation the z value will be normalized to the interval $[0,1]$ and stored. In that way, as before, the depth information for a visibility determination is still available.

Finally, yet another OpenGL specialty, the matrix stack, should be pointed out. As noted above, the matrices in the mapping (B.1) are, in turn, generalized products of numerous transformation matrices. This is especially true of the modelview matrix. Imagine a three-dimensional scene with a table and four chairs. The object chair and the object table are available as models, with each, for example, being positioned at the origin (object coordinates) and oriented in a preferential direction. The scene and image can be constructed in the following way:

- leave the table at its position and draw it;
- store the current position, rotate the object chair, carry out a translation to the location of the first chair, and draw the chair;
- return to the starting point, take note of this, rotate the object chair, carry out a translation to the location of the second chair, draw this chair;
- etc.

A stack is a natural structure for the administration of such runs. With each new transformation the expanded modelview matrix is stacked with a further factor (push operation); after the drawing of an object is completed, the transformations applied up to that time are again cancelled by removal of the corresponding matrices from the stack (pop operations), and one again lands automatically at the starting point of the last operation to get a new object. In this way hierarchical objects (the scene consists of table and chairs, table and chairs consist of legs and boards, etc.) can be elegantly positioned and drawn. Since the stack is usually used many times and often during construction of the modelview matrix, a nesting depth of 32 is customarily provided for. The stack is initialized with the identity matrix.

As opposed to this, with the projection matrix the stack consists generally of only two matrices, the projection matrix and the identity on initialization. Beyond this, there are also cases which require a greater depth, e.g., when a help window (certainly not in perspective to the projection) with text has to be blended into a three-dimensional scene projected with perspective. Here a parallel projection can be turned on temporarily.

B.2 RAY TRACERS

As opposed to the graphics libraries, in which real-time applications are in the foreground, ray tracers involve programs which aim at the production of photorealistic single frames. A three-dimensional model is constructed directly through specification of the geometry or by using a CSG-like modeler (see Section B.3). After the observer position and the light sources, etc., are set, the two-dimensional picture is generated using the ray tracing described in Section 3.7. Depending on the magnitude and quality of the picture, this process may require up to several hours of computational time.

Examples of ray tracers include POV-Ray (Persistence of Vision Ray Tracer; freeware), rayshade (PD), and RenderMan from Pixar.

B.3 3D MODELERS

3D modelers are programs for modeling three-dimensional bodies in the sense discussed in Chapter 2 of this book. For example, they provide possibilities for drawing solids of rotation, constructing compound objects from elementary solids in accordance with the CGS scheme, or for definition of free form surfaces. To that extent, 3D modelers can also be regarded as CAD systems. What sets the modelers used in computer

graphics apart from conventional engineering CAD systems is their very well-honed animation capabilities. (For example, see the Maya system which is briefly described in Appendix C).

An example of a simple 3D modeler is i3dm. It also shows up as a demonstration program on SGI systems. Usually, these modelers, like the ray tracers, form a part of a larger graphics animation system. Examples of these include SoftImage|XSI, imagine, Maya, LightWave3D, and Caligari trueSpace.

B.4 PAINTING AND DRAWING PROGRAMS

Painting and drawing programs are classical forms of graphic editors. These essentially provide for the creation, shifting, and rotation of two-dimensional elementary objects (lines, circles, polygons, letters, etc.). Line types and character sets can be chosen, polygons can be filled with different patterns, and, finally, individual objects can be colored differently or transformed. This kind of programming is used, for example, to create textures. Examples of painting and drawing programs include xpaint (pixel oriented, PD), The GIMP (pixel oriented, Freeware), xfig (vector oriented, freeware), and idraw (vector oriented, Freeware, in the framework of Interviews[3]).

Separate programs are often used for finishing and data format conversion. Examples of simple image processing programs include ImageMagick (Freeware), xv (Shareware), and, again, The GIMP (Freeware).

B.5 FUNCTION PLOTTERS

Function plotters have been developed especially for representing mathematical functions. Thus, they often appear in a mathematical environment, for example, in computer algebra systems (e.g., Maple, Mathematica) or MATLAB (a program for numerical computation and visualization). Hence, the input is usually only in the form of a mathematical function or entry of the coordinates of individual points, which are then interpolated. A prominent example of a function plotter is gnuplot (PD; available for almost all the current computer types and drivers; different output formats). Of course, the visualization systems described in Section B.6, such as AVS (graph viewer) or Khoros (xprism), include function plotters.

[3]A C++ graphics library as an extension of the X11 window system.

The public domain program, xfractint (available for all the current computer types) for creation of fractal images, is also a program for graphical representation of very special functions. The fern in Figure 4.18 was created using this program.

B.6 VISUALIZATION SYSTEMS

Here there is a distinction between specialized and general systems. The former have been developed for special applications or are tailored to a limited set of tasks and are usually easy to use, but can only be modified or extended to a limited degree.

Examples of special visualization systems include DataVisualizer (regular and irregular grids, planes of intersection, particle paths, volume rendering, color table editor, etc; available for current workstations), IDL (Interactive Data Language; raster images, isosurfaces, filter functions, signal processing, statistic, etc.; programmable), PV-Wave (comparable to DataVisualizer; programmable through IDL), and Grape (SFB 256 "nonlinear partial differential equations" at the University of Bonn; Shareware; major applications include differential geometry and continuum mechanics).

The general systems are represented by application builders, the most advanced kind of data visualization. These systems are graphically programmable through linking of individual modules to a data flow chart. Modules are provided for, among others, data input, conversion, and output, as well as for graphical display and processing of images or signals. Animations can be created by successive generation of frame sequences, as well as by recording the user's actions or constant variation of individual parameters in the data flow chart. Graphical program assistance is often available for creating new modules in a higher programming language. Examples of general visualization systems include AVS/Express (Advanced Visual Systems; rendering, shading, etc.), IRIS Explorer (previously delivered with SGI systems, now distributed as an independent product), and Khoros (conceived primarily for image processing).

C PROBLEMS

W e conclude by offering a few problems. They have been taken from the laboratory manual "Applications of Computer Graphics" introduced by the first author in 1999 at the Technical University of Munich. The purpose of this manual is to learn to deal with computer graphics libraries and software and thereby, on one hand, to prepare for a typical work situation and, on the other, to obtain attractive and valuable results as quickly as possible. For the sake of completeness, however, it should be pointed out that the range of the problems and the effort required to get into the chosen software do considerably exceed the capacities of an exercise designed to accompany a series of lectures.

The first set of topics (modeling, rendering, and animation) is based on the program Maya from Alias|Wavefront, one of the most powerful program packages of this type and is one of the most widely used in the motion picture industry. The second topic (graphics programming) is, as expected, handled with the aid of OpenGL. The AVS/Express program system is used for the problems on visualization. Some solutions handed in by students are shown starting with Color Plate 48. For further information on this laboratory manual, the topics dealt within it, and the problems to be worked out, see http://www5.in.tum.de/lehre/praktika/. Some of the material presented here can be downloaded from that site if necessary.

C.1 PROBLEMS ON MODELING, RENDERING, AND ANIMATION

In order to become familiar with the program Maya from Alias|Wavefront, we begin with problems devoted to the production of simple objects, and these are built upon in the subsequent exercises. Modeling with polygons is in the forefront here and Maya has an abundance of tools for this purpose. Afterwards, the first steps toward animation techniques can be practiced, under the keyword *Keyframe*, through

which the objects can be subjected, for example, to rotation or displacement with the passage of time. Free form surfaces (NURBS) come into action for more advanced modeling. These provide for far more manipulation capabilities, so that there are almost no limits to fantasy in modeling. The specific problem statements can vary according to taste: one can imagine a room with a door, windows, and various pieces of furniture (Subproblems 1.1 and 1.2) or the creation of LEGO™ blocks (Subproblem 2.1) from which a complex model will later be assembled according to a building plan and supplied with functionality (Subproblem 2.2). Finally, a complete car is created using the LEGO™ model, primarily from free form surfaces (Subproblem 2.3).

Next, the objects are provided with a realistic external appearance by allocating material properties and textures. Maya provides different illumination models or different mapping procedures for this. One or more material properties and textures are created and assigned to complete objects in this work step. Experiments can then be done with the different mapping techniques which may have a strong effect on the appearance of realism. Likewise, the choice of proper illumination plays a major role, since not every type of light source is appropriate to every scene, e.g., a directed light source "simulates" sunlight but is less suited to ceiling light. Now a few adjustments must be settled on, such as camera position and line of sight, shadowing by/on objects, quality of antialiasing, image size in pixels, etc., before rendering can be started. The problem definitions are chosen in accordance with these items. Both the room and the car are provided with material properties (Subproblems 1.3 and 2.4), one or more light sources are installed in the scene (Subproblems 1.4 and 2.5), and, finally, images are computed from various perspectives (Subproblems 1.5 and 2.5).

The last part of the problem involves making the synthetic environment of the calculated pictures natural by means of appropriate effects and creating a complete animation. For this Maya provides atmospheric effects and particle systems, for example, so that things like fog, dust, or fire can be simulated. The scene is now so well-prepared that animation can be attempted, for example, in the form of traveling with a camera through the scene. Then comes the part that is most wearisome by far, namely waiting until all the pictures are finished computing. Suitable software now makes it easy to create a film in one of the current formats (e.g., MPEG or AVI). Subproblems 1.6 and 2.6, as well as 1.7 and 2.7, provide some practice in this.

Problem 1 (A room):

Subproblem 1.1: Create a scene with the following specifications:

- The basis is a room with walls, at least two windows, plus a door.
- Several stationary objects are in the room (table, chairs, cabinet), of which some have a hierarchical relation to one another. (For example, a table with a flower vase on it: when the table is moved, the vase moves automatically with it, but the opposite is not true!)
- There are frames for some decoration on the walls or on the floor, for example, a picture frame, space for curtains at the sides of the windows, or a pad for a rug.
- At least one object must be assembled from faithfully detailed models of many individual parts (e.g., a sink, a record player, a bowl of fruit on the table, a decorated Christmas tree, etc.).
- At least one object must be modeled in space using free form surfaces (NURBS) (a sofa, a bed, sofa pillows, a curved armchair).

Subproblem 1.2: Bring some life into your scene, by enhancing it as follows:

- At least one object should be animated in place, i.e., it must move but remain stationary. This might be a rotating globe, a pendulum clock, or something similar.
- Finally, we would also like to see some real dynamics: let at least one object move "right across" the room and change its position (a ball thrown through a window, a mouse running through the room, a faucet dripping).

Subproblem 1.3: Provide the objects in Subproblem 1.1 with different surface properties:
- Apply various materials with different properties [referring to colors and reflection (see Subproblem 1.4), etc.].
- Texturize some objects using different kinds of texture. A texture map can fill a picture frame or cover a sofa pillow, a bump map can make a smooth surface appear uneven (e.g., an unironed tablecloth), and simple reflection effects can be modeled using environment mapping. Here, again, use textures that you yourself have scanned or photographed with a digital camera.

Subproblem 1.4: Bring light into your scene:

- Multiple light sources of various types must be constructed, that is, point light sources (radiating in all directions or, as with spotlights, into a limited region) or infinitely distant sources (uniform light from a certain direction), e.g., for sunlight.
- Set different illumination models for the objects in your scene (Lambert, Blinn, Phong, dependent on material properties). For the simple shading procedures used thus far (automatically) in the editor panel of Maya, these properties are still insignificant, but they may be important later for ray tracing.

Subproblem 1.5: Use the ray tracer to create realistic pictures including multiple reflections and shadows. Use different frames from your animation in Subproblem 1.2 as a basis. Go for full resolution (maximum 1280 x 1024).

Subproblem 1.6: In themselves, with extensive modeling, scenes of this sort typically appear synthetic and, thus, unrealistic. The fault lies, on one hand, in the unsatisfying solution provided for the global illumination problem, and therefore, in the integration of ambient and directed light, and, on the other, in the fact that we seem to be in a "germ free" world. We would like to change this situation now. Enhance the natural effect of your scene

- by embedding atmospheric effects (fog, dust, etc.) and
- by using particle systems (smoke, dripping water).

Subproblem 1.7: And now the crowning glory: ray trace your entire animation and generate a short film from that. In considering the number of frames, certainly some modesty in the resolution is indicated—it shouldn't exceed about 320 x 240.

Problem 2 (LEGO™ blocks and a car):

Subproblem 2.1: First generate a few simple LEGO™ components, e.g., blocks, axles, cogwheels, etc., in the course of which you apply, for example, boolean operations (union, intersection, and difference) to various Maya primitives. Appropriate patterns for your designs should be made available. Additional objects, such as tires, pins, and special parts, will be made available to you and you are to assemble a complex LEGO™ model from them. Plans for different LEGO™ models will, likewise, be made available.

Subproblem 2.2: In order to ensure a certain functionality in your LEGO™ model, some of the structural components from Subproblem 2.1 have to be animated or restricted in their degrees of freedom. This restriction might mean, for example, that the front wheels of your model only turn about an axis and, here, only by a specified amount. Furthermore, this turning is not controlled by the wheels themselves, but by the steering wheel. Thus, the corresponding objects (steering wheel, tie rod, rack, wheels, etc.) must be set in a hierarchical relationship and linked in Maya through so-called expressions.

Subproblem 2.3: In this problem, the focus is on construction of an entire car. It must consist of a chassis, a passenger compartment, an engine with drive train, and a body. The individual parts should be equipped with an abundance of details but functionality must also be kept in mind. Make the model to the greatest extent possible using free form surfaces (NURBS), as most of the parts have to have curved outer surfaces. The minimum requirements for your car are, therefore, the following:

- Chassis: vehicle frame, at least two axles, one shock absorber per wheel, one brake per wheel, at least four wheels with rims, and a shaft with a universal joint.
- Passenger compartment: at least two seats, a back seat, a dashboard with a steering wheel and control levers, a hand brake lever, a gear shift lever, and three pedals.
- Engine with drive train: engine block, at least four cylinders with connecting rod and cylinder heads, at least two valves per cylinder, a camshaft, a drive train, and an exhaust system.
- Body: at least two doors, a hood, trunk lid, two interior and two exterior mirrors, windshield wipers, front and back lights, a license plate.
- Then apply an appropriate animation; e.g., open the doors or the hood and sweep by or through your car. (Hint: for this problem it is suggested that two or three students form in groups and that roughly three groups model a complete car).

Subproblem 2.4: Provide the object from Subproblem 2.3 with various surface properties:

- Apply various materials with different properties (referring to color, reflection (see Subproblem 2.5), etc.).

- Texturize a few objects using various types of texture. A texture map can fill the dashboard or cover a front or back seat, with a bump map a smooth surface can be made to appear rough (e.g., seats with leather covers), and environment mapping can be used for simple reflection effects. Use textures that you have scanned yourself or photographed with a digital camera, as well here.

Subproblem 2.5: Use the ray tracer to create realistic pictures including multiple reflections and shadows. As a basis use different frames from your animation in Subproblem 2.3. Go for full resolution (maximum 1280 x 1024).

Subproblem 2.6: In themselves, with extensive modeling, scenes of this sort typically appear synthetic and, thus, unrealistic. The fault lies, on one hand, in the unsatisfying solution provided for the global illumination problem, and therefore, in the integration of ambient and directed light, and, on the other, in the fact that we seem to be in a "germ free" world. We would like to change this situation now. Enhance the natural effect of your scene

- by embedding atmospheric effects (fog, dust, etc.) and
- by using particle systems (smoke, dripping water).

Subproblem 2.7: And now the crowning glory: ray trace your entire animation and generate a short film from that. Considering the number of frames, certainly some modesty in the resolution is indicated—it shouldn't exceed more than about 320 x 240.

The results of several runs of the lab exercises are shown in Color Plates 49–53.

C.2 PROBLEMS ON GRAPHICAL PROGRAMMING

After this excursion into the creation of photorealistic pictures, we now examine hardware related graphical programming. This both enables graphical output in real time and can be employed in very many ways, for example, for the visualization of data or in computer games. The two freely available current libraries OpenGL and GLUT are used as a basis for this. In particular, the OpenGL Utility Toolkit makes functions available to the programmer for simple interaction with the scene, e.g., via a keyboard or mouse.

Similarly to the procedure with Maya, the first steps involve creating all the required models for a scene. All the relevant data must be explic-itly specified for each surface to be drawn, i.e., the coordinates of the

individual vertices as well as the corresponding polygon type. If the surface is to be shadowed later using Gouraud shading, then the normal vector corresponding to each vertex also has to be specified. For very complex objects or very many vertices, it is recommended that all the data be stored in a display list, since these can operate faster. Then there is the specification of material properties, where the number of possibilities is substantially more limited than with Maya. Many effects, such as glow (self illumination), are too computationally demanding to be implemented in OpenGL without loss of real-time capability.

Before the first pictures show up on the screen, some further settings have to be dealt with. These include, among others, the projection from the model world onto the plane of projection, the position and line of sight of the camera, the position and type of light sources, as well as the interrogation of the desired input devices. For this reason, a typical OpenGL program can be subdivided into individual segments, each of which handles one or more of the tasks listed above. Based on a rudimentary programming framework, a primitive flight simulator is now to be developed which fulfills the following requirements. A routine is to be implemented that reads in a gray halftone picture. The gray tones are treated as altitude data for the terrain to be drawn, during which an adequate coloration for the terrain is likewise to be provided. In addition, various flight control indicators are to be superimposed, the airplane must be steerable with a mouse, and at least one, arbitrary object must move across the terrain.

Problem 3 (Graphics Programming):

Subproblem 3.1: Write down a function for reading in data based on the function read_pic() provided to you for interpreting color channels as altitudes. The data that are read in must be appropriately converted in a meaningful way so that rapid access is provided as the terrain is being drawn.

Subproblem 3.2: Write down a function for drawing the terrain. This should involve coloring the terrain as well as the surface normals necessary for the illumination settings.

Subproblem 3.3: Write down a suitable mouse control [the functions mouse_button() and mouse_motion()] which permits a low level flight over the terrain as well as loop-the-loop flight.

Subproblem 3.4: Arrange for an object (e.g., a car) to move over the terrain. In the simplest case this could be a cube. Make sure that the cube

does not float over the surface or sink too far into it. (Tip: set the cube on one of its corners.)

Subproblem 3.5: Write down a function which superimposes a flight control indicator. The simplest way of realizing a flight control indicator would be, for example, to set a crosshair in the middle of the window. More complicated variants might implement an artificial horizon as is found in the head up display of modern flight systems.

Some results for these problems are given in Color Plates 54 and 55.

C.3 Problems on Visualization

The third problem area is concerned with the visualization of large data sets, for which a commercial software product is used. Because of the power of its visualizations, the modular structure of applications, and the power of its programming interface, the AVS/Express program package from Advanced Visual Systems will be employed here. Besides the common visualization procedures such as isosurfaces and isovolumes, more costly methods such as streamlines or particle tracking can be brought to bear.

Some entirely new, in-house modules can be developed by combining various modules already prepared in the Network Editor or by using the different capabilities for manipulating the data that have been read in. Depending on the application, the core information from the corresponding data set can be accentuated. For this problem we make available a 3D data set from a flow simulation in which a stationary fluid is first heated and the resulting heat is removed by the flow that is generated after some time. This data set contains the velocity components in the x, y, and z directions, the pressure, and the temperature, as well as geometrical information (obstacle or fluid cells). The individual scalar quantities are to be displayed graphically with the aid of the modules provided by AVS/Express (Subproblem 4.1). In connection with this, the flow speed is to be calculated and, likewise, displayed graphically (Subproblem 4.2).

Since a color display alone is not very informative, the quantities to be visualized are supplied with corresponding legends and labels. Thus, now and then it is helpful if the specific value of a quantity can be obtained as, for example, when the particular value is superimposed on the display by clicking on the desired point. Subproblem 4.3 is concerned with these annotations and interactions. Depending on the complexity of the data set to be read in, an interaction may not always occur in real time. In some cases it can last quite long, even until the next image is drawn.

In order to avoid such situations, it is advisable that the images be stored and a film be made out of them. Here another point has to be kept in mind which can always come up with time resolved data sets. A change in the extreme values of the individual data sets can lead to a falsification of the result as, for example, the color palette gets shifted. In order to prevent such mistakes, the extrema of the data set must be established at the start. This difficulty will be dealt with in Subproblem 4.4, before the individual frames are stored and then processed into a film.

Problem 4 (Visualization):

Subproblem 4.1:

- Visualize at least two scalar quantities from the data that are provided using different techniques (e.g., geometry by means of isosurfaces, temperature by means of color surfaces).
- Combine the scalar velocity components into a vector quantity and visualize it using at least two techniques for vector data (e.g., streamlines, vector fields, particle tracking).
- Choose suitable colors for the background and objects. (For example, a color range from blue (cold) to red (hot) is appropriate for the temperature.)

Subproblem 4.2: An important parameter for the analysis of flows is the flow speed (magnitude of the velocity) of the fluid. This, of course, is not available in the data set, but it can be calculated from the other data available there.

- Calculate the additional component "flow speed."
- Assemble this together with the other components into a data set, so that all of the data are passed on to the next module.

Subproblem 4.3:

- Provide your visualization with labels and legends.
- Make it possible to interrogate the values at different points in an intersecting plane and mark the chosen position with a geometry-object.
- The simulated flow does not remove the heat optimally. Explain this difficulty and its causes using the visualization.

Subproblem 4.4: The data provided here come from a numerical simulation of a nonstationary flow with time lapse. Thus, an animation requires the successive display of sequences of data sets. The required

functionality is provided by the Read Field module. Of course, the extreme values of the different data sets change, so it is necessary to set these right at the beginning, since otherwise the coloration can create a false impression. An animation can be generated from single images of the data set.

- Determine the extreme values for the data set and set these.
- Convert the output data of the viewer into a picture and put these into a file.
- Generate a movie out of the individual frames.

Some results for these problems are given in Color Plates 56 and 57.

C.4 FURTHER PROBLEMS

After the various topics in computer graphics have been dealt with, some further study in one of the three preceding areas should now be undertaken. Thus, the laboratory manual contains a number of projects in which the subjects that have been learned are to be applied. These further problems are concentrated in a single topic area, but they can range over two topic areas, for example, the creation and export of models in Maya and their further application in an OpenGL program (e.g., models for a computer game).

Here is a short list of various projects (including an indication of the area of emphasis) which have been set in a number of laboratory manuals and can now serve readers as a starting point for their own further problem sets:

- creation of a cartoon for a study and presentation video (C.1)
- creation of a computer game with network capability (C.2)
- augmented virtual reality (C.1 and C.3)
- implementation of the Line Integral Convolution visualization technique (C.2 and C.3; see also [CaLe93]).
- creation of a function plotter for 2D and 3D data (C.2).

Some results for these problems are given in Color Plates 48 and 58–61.

COLOR PLATE CAPTIONS

COLOR PLATES FROM CHAPTER 1

Color Plate 1: Line model of a scene (without antialiasing).
Color Plate 2: Line model of a scene (with antialiasing).
Color Plates 3 and 4: Magnified detail (left, without antialiasing; right, with antialiasing).
Color Plate 5: A picture in 24-bit color.
Color Plate 6: Display with 256 gray shades.
Color Plate 7: Display with 4 gray shades.
Color Plate 8: Black and white display with dithering (Floyd-Steinberg algorithm).
Color Plate 9: RGB or CMY color model (view to black).
Color Plate 10: RGB or CMY color model (view to white).
Color Plate 11: HSV color model.
Color Plate 12: A section of the CIE cone with the colors that can be displayed on a typical color monitor.
Color Plate 13: Additive color mixing.
Color Plate 14: Subtractive color mixing.

COLOR PLATES FROM CHAPTER 2

Color Plate 15: Model of a three-dimensional object.
Color Plate 16: Representation in a cell decomposition scheme.
Color Plate 17: Approximate representation in a standard cell enumeration scheme.
Color Plate 18: The sphere as a CSG primitive.
Color Plate 19: The cube as a CSG primitive.
Color Plate 20: Sphere \cup cube.
Color Plate 21: Sphere \cap cube.
Color Plate 22: Sphere \ cube.
Color Plate 23: Cube \ sphere.
Color Plate 24: Wire model of a scene (central projection).
Color Plate 25: Representation with a rear clipping plane.
Color Plate 26: Representation with depth cueing.
Color Plate 27: Wire model of a scene (central projection).
Color Plate 28: Wire model after removal of the back side.
Color Plate 29: Difference in visualization with the z-Buffer procedure.

Color Plates From Chapter 3

Color Plate 30: Illumination with ambient light alone.

Color Plate 31: An illumination model with ambient light and a single point light source.

Color Plate 32: Illumination with ambient light and two point sources (diffuse and specular reflection according to Phong).

Color Plate 33: Constant shading (no specular reflection).

Color Plate 34: Phong shading (no specular reflection).

Color Plate 35: Phong shading (specular reflection according to Phong, with a specular reflection exponent $k=40$).

Color Plates 36 and 37: A room with a view (with and without point light sources in the space) represented using the radiosity procedure. The poorly defined contours of the shadows compared to ray tracing can be recognized readily. The floor was modeled near the two legs of the table closer to the window using much smaller surface segments than for the rest of the floor. Then the contrast between direct illumination and shadows is especially strong here. With small surface segments the shadow correction can be processed more precisely than, say, with the legs of the chair in the foreground. For that reason the two chairs seem to be suspended, while the table creates the impression of standing firmly on the floor. In all, 4,680 surface segments were used, of which 32 (above) and 200 (below) were emitters. (Pictures from M. Geppert and M. Alefeld, Chair of Higher Mathematics and Numerical Mathematics (Prof. R. Bulirsch), Technical University of Munich [Gepp95]).

Color Plate 38: Texture mapping. The cloudy structure is applied to a transparent sphere which surrounds the globe which is made available, in turn, by texture mapping. In this way shadows can be realized under the clouds.

Color Plate 39: Bump mapping.

Color Plates From Chapter 4

Color Plates 40 and 41: These plates show different possibilities for the visualization of a turbulent flow in a pipe. The clear representation of complex flow effects is often difficult and time consuming, since turbulent phenomena are, among other things, three-dimensional, so they yield very large sets of data. In the two pictures shown here the impression of a three-dimensional image is achieved by using anaglyphs, i.e., by overlapping two slightly displaced images (red/green or red/cyan). The observer wears special glasses for this. There are several approaches for realizing anaglyphs. Color Plate 40 shows the result with a so-called stereographic window projection. In Color Plate 41 the three-dimensional effect is achieved using an on-axis projection. Both pictures are from [Mess94].

Color Plate 42: Realization of an animation sequence through the production of sequences of individual pictures.

Color Plates 43 and 44: Color Plate 43 shows the flow in an open plan office with three desks, separator walls, and two doors into which fresh air is fed in through a square opening in the middle of the ceiling. The air can flow out through the left door and two exhaust shafts on

the left and right walls. The furniture and separators are shown as transparent isosurfaces. The flow is indicated by vector arrows in the direction of flow whose bases are all fixed in one plane and whose thicknesses and color reflect the strength and velocity of the flow. In addition, a red track and a blue track can be seen. These indicate the path of two particles streaming in with the fresh air through the ceiling opening. Color Plate 44 shows the air stream around Jan Mayen Island in the North Atlantic, with the wind blowing from the left. The island itself is again shown as an isosurface (enlarged vertically), whose coloring corresponds to height. The green tracks indicate the air turbulence that develops behind the island. In addition, the flow velocity is indicated by color scaling in two cross section planes. Some of the velocity ranges are masked out for clarity. Both pictures are taken from [GDN95].

Color Plate 45: Flying with computer generated synthetic vision: low level flying in the Altmühtal. The flight channel integrated into the terrain view indicates the nominal flight path.

Color Plate 46: Flight test with synthetic vision: test pilot with a head mounted display. Two miniature cathode ray tubes are used to present a computer generated synthetic image of the landscape to the pilot. (The pictures are from Prof. G. Sachs, Chair of Flight Mechanics and Flight Control, Technical University, Munich.)

Color Plate 47: Interactive simulation of folds in cloth, especially clothing, is one of the major challenges for computer graphics. One very promising approach for this is particle methods. Here the cloth is discretized into a large number of particles, which each interact with their neighbors in three dimensions through potential functions corresponding to attractive and repulsive forces between the particles. The dynamics are then described numerically by the Newtonian equations of motion and calculated numerically by molecular dynamics procedures. As an example we consider a cloth discretized into 50 x 50 particles. At the beginning the particles lie at the bottom of the three-dimensional simulation region. Then the particles at points (35,25) and (50,50) are moved upward at a constant velocity. The pictures show the result at different times in the simulation.

Color Plate 48: Especially informative visualizations of vector fields are provided by the line integral convolution algorithm. Here a texture (e.g., a white noise), whose resolution (number of texels) must correspond to the resolution of the vector field (number of cells), is folded along the streamlines of this vector field. That is, for each texel of the texture a certain segment over the corresponding neighboring texel is scanned with the aid of the local direction of the stream lines of the vector field. In this way the gray half tones of the scanned texel are added with a weighted sum to the gray half tone of the starting texel, before the newly calculated value in the resulting image is stored. The length of the so-called fold-kernel (this corresponds precisely to the number of steps, which often must be taken from a texel to one of its neighbors) thus determines how strongly or weakly the resulting image is "smeared out." Pictures (a)–(d) are visualizations of the simulation of a driven cavity flow at different times and with fold-kernels of different lengths. Plates (a) and (c) correspond to time t_1 with fold-kernel lengths of 20 and 50, respectively, and (b) and (d), to another time t_2, again with fold-kernel lengths of 20 and 50. For further information see [CaLe93].

COLOR PLATES FROM APPENDIX B

Color Plate 49: Wire mesh model of a living room with animation potential (casement, ball; a solution to Subproblems 1.1 and 1.2 in Appendix C).

Color Plate 50: The preceding wire mesh model provided with material properties and textures (a solution to Subproblems 1.3-1.5 in Appendix C).

Color Plate 51: A detailed segment from another modeled and textured room; the glow effect can be recognized clearly (self lighting, glows; a solution to Subproblems 1.3-1.5 in Appendix C).

Color Plate 52: Wire mesh model of a LEGO™ fork lift assembled from individual LEGO™ blocks (a solution to Subproblems 2.1 and 2.2 in Appendix C).

Color Plate 53: A LEGO™ model of the fork lift, now provided with material properties and textures, as well as illumination (a solution to Subproblems 2.1 and 2.2 in Appendix C).

Color Plate 54: Snapshot from a simple flight simulator with flight control indicators (a solution to Problem 3 in Appendix C).

Color Plate 55: Snapshot from an alternative solution to Problem 3 in Appendix C, this time with an extensively textured landscape.

Color Plate 56: A visualization of flow and heat transfer: the leftmost block is initially heated, after which the heating is turned off and the cold fluid flowing from back to front removes the heat (plane of intersection, colored according to temperature, and arrows, with colors and lengths according to speed (magnitude of the velocity); a solution to Problem 4 in Appendix C).

Color Plate 57: The same scenario, visualized here using two orthogonal planes of intersection (colors: temperature) and colored streamlines instead of arrows.

Color Plate 58: A racing car crashes through the wall of a movie theater: snapshot from a computer animation for a production in the framework of the VideoMath series from Springer Verlag (a lab project on modeling and simulation).

Color Plate 59: Snapshot from another animation for the preceding project, this time with robots and lightning strokes obtained using particle systems (another example of a lab project on modeling and animation).

Color Plate 60: A Maya model of the new building for the Technical University of Munich Computer Science Department (TUM-Informatik) in Garching (internal partitions, the colors represent floors); generated from 2D CAD data embedded in VR environments (Holobench), information on parts of the building obtainable with a mouse click (a lab project and final thesis on virtual reality and augmented reality).

Color Plate 61: Parts of the new building in a semitransparent display.

REVIEWS AND OTHER REFERENCES

TEXTBOOKS AND REVIEWS

[BuGi89] P. Burger and D. Gillies, *Interactive Computer Graphics: Functional, Procedural, and Device-Level Methods,* Addison-Wesley Publishing Company, Reading, MA, 1989.

[Cunn92] S. Cunningham et al., eds., *Computer Graphics Using Object-Oriented Programming,* John Wiley, New York, 1992.

[ESK95] J. Encarnaçao, W. Strasser, and R. Klein, *Graphische Datenverarbeitung 1,* R. Oldenbourg Verlag, München, 1995.

[ESK97] ——-, *Graphische Datenverarbeitung 2,* R. Oldenbourg Verlag, München, 1997.

[FDFH97] J. D. Foley, A. van Dam, S. K. Feiner, and J. F. Hughes, *Computer Graphics: Principles and Practice,* Addison-Wesley Publishing Company, Reading, MA, 2nd ed., 1997.

[FDFHP94] J. D. Foley, A. van Dam, S. K. Feiner, J. F. Hughes, and R. L. Phillips, *Introduction to Computer Graphics,* Addison-Wesley Publishing Company, Reading, MA, 1994.

[Fell92] W. D. Fellner, *Computergrafik,* BI Wissenschaftsverlag, Mannheim, 2nd ed., 1992.

[Grie92] I. Grieger, *Graphische Datenverarbeitung,* Springer-Verlag, Berlin, 2nd ed., 1992.

[Harr87] S. Harrington, *Computer Graphics – A Programming Approach,* McGraw-Hill, New York, 1987.

[Kopp89] H. Kopp, *Graphische Datenverarbeitung,* Hanser, München, 1989.

[Meie86] A. Meier, *Methoden der grafischen und geometrischen Datenverarbeitung,* Teubner, Stuttgart, 1986.

[NeSp84] W. Newman and R. Sproull, *Principles of Interactive Computer Graphics,* McGraw-Hill, New York, 4th ed., 1984.

[NHM97] G. M. Nielsen, H. Hagen, and H. Müller, ed., *Scientific Visualization: Overviews, Methodologies, and Techniques,* IEEE Computer Society Press, Los Alamitos, 1997.

[Purg85] W. Purgathofer, *Graphische Datenverarbeitung,* Springer-Verlag, Wien, 1985.

[Raub93] T. Rauber, *Algorithmen in der Computergraphik,* Teubner, Stuttgart, 1993.

[ScMü99] H. Schumann and W. Müller, *3D Visualisierung: Grundlagen und allgemeine Methoden,* Springer-Verlag, Berlin, 1999.

[Watt99] A. Watt, *3D Computer Graphics,* Addison-Wesley Publishing Company, Reading, MA, 3rd ed., 1999.

[ZaKo95] R. Zavodnik and H. Kopp, *Graphische Datenverarbeitung – Grundzüge und Anwendungen,* Hanser, München 1995.

OTHER REFERENCES

[AbMü91] S. Abramowski and H. Müller, *Geometrisches Modellieren,* BI Wissenschafts-verlag, Mannheim, 1991.

[Adob85a] Adobe Systems, Inc., *PostScript Language Reference Manual,* Addison-Wesley Publishing Company, Reading, MA, 1985.

[Adob85b] —-, *PostScript Language Tutorial and Cookbook,* Addison-Wesley Publishing Company, Reading, MA, 1985.

[ANSI85] ANSI (American National Standards Institute), *American National Standard for Information Processing Systems – Computer Graphics – Graphical Kernel System (GKS) Functional Description,* ANSI X3.124 – 1985, ANSI, New York, 1985.

[ANSI88] —-, *American National Standard for Information Processing Systems – Programmer's Hierarchical Interactive Graphics System (PHIGS) Functional Description, Archive File Format,* Clear-Text Encoding of Archive File, ANSI X3.144 –1988, ANSI, New York, 1988.

[Appe68] A. Appel, *Some Techniques for Shading Machine Renderings of Solids,* in: Proceedings of the Spring Joint Computer Conference, 1968, pp. 37–45.

[Arvo86] J. R. Arvo, *Backward Ray Tracing,* in: *Developments in Ray Tracing*, A. H. Barr, ed., Course Notes 12 for ACM SIGGRAPH '86, 1986.

[Arvo91] J. R. Arvo, ed., *Graphics Gems II,* Academic Press Professional, Boston 1991.

[Baec69] R. M. Baecker, *Picture Driven Animations,* in: *Proceedings of the Spring Joint Computer Conference,* AFIPS Press, Montvale, NJ, 1969, pp. 273–288.

[BaRi74] R. E. Barnhill and R. F. Riesenfeld, *Computer Aided Geometric Design,* Academic Press, New York, 1974.

[Baum72] B. G. Baumgart, *Winged-Edge Polyhedron Representation,* Technical Report STAN-CS-72-320, Computer Science Department, Stanford University, Palo Alto, CA, 1972.

[Baum74] —-, *Geometric Modeling for Computer Vision,* Report AIM-249, STAN-CS-74-463, *Dissertation, Computer Science Department,* Stanford University, Palo Alto, CA, 1974.

[Baum75] —-, *A Polyhedron Representation for Computer Vision,* in: *Proceedings of the National Computer Conference 75,* 1975, pp. 589–596.

[BaWö84] F. L. Bauer and H. Wössner, *Algorithmische Sprache und Programmentwicklung,* Springer-Verlag, Berlin, 2nd ed., 1984.

[BBB87] R. Bartels, J. Beatty, and B. Barsky, *An Introduction to Splines for Use in Computer Graphics and Geometric Modeling,* Morgan Kaufmann, Los Altos, CA, 1987.

[BBK82] T. Berk, L. Brownston and A. Kaufman, *A New Color-Naming System for Graphics Languages,* IEEE Computer Graphics and Applications, 2(3) (1982), pp. 37–44.

[BEH79] A. Baer, C. Eastman, and M. Henrion, *Geometric Modeling: A Survey*, Computer Aided Design, 11(5) (1979), pp. 253–272.

[BeSp63] P. Beckmann and A. Spizzichino, *The Scattering of Electromagnetic Waves from Rough Surfaces*, Macmillan, New York, 1963.

[Bezi70] P. Bézier, *Emploi des Machines Commande Numérique*, Masson et Cie., Paris, 1970.

[Bezi74] —–, *Mathematical and Practical Possibilities of UNISURF*, in Computer Aided Geometric Design, R. Barnhill and R. Riesenfeld, ed., Academic Press, New York, 1974.

[BHS78] I. C. Braid, R. C. Hillyard, and I. A. Stroud, *Stepwise Construction of Polyhedra in Geometric Modeling*, CAD Group Document No. 100, Cambridge University, Cambridge, England, 1978.

[Blin77] J. F. Blinn, *Models of Light Reflection for Computer Synthesized Pictures*, in: *Proceedings of SIGGRAPH '77*, Computer Graphics, 11(2), ACM SIGGRAPH, New York, 1977, pp. 192–198.

[Blin78] —–, *Simulation of Wrinkled Surfaces*, in: *Proceedings of SIGGRAPH '78*, Computer Graphics, 12(3), ACM SIGGRAPH, New York, 1978, pp. 286–292.

[Blin91] —–, *A Trip Down the Graphics Pipeline: Line Clipping*, IEEE Computer Graphics and Applications, 11 (1991), pp. 98–105.

[BlIs94] A. Blake and M. Isard, *3D Position, Attitude and Shape Input Using Video Tracking of Hands and Lips*, in: *Proceedings of SIGGRAPH '94*, ACM SIGGRAPH, New York, 1994, pp. 185–192.

[BlNe76] J. F. Blinn and M. E. Newell, *Texture and Reflection in Computer Generated Images*, Communications of the ACM, 19(10) (1976), pp. 542–547.

[BoKe70] W. J. Bouknight and K. C. Kelly, *An Algorithm for Producing Half-Tone Computer Graphics Presentations with Shadows and Movable Light Sources*, in: *Proceedings of the Spring Joint Computer Conference*, AFIPS Press, Montvale, NJ, 1970, pp. 1–10.

[Borm94] S. Bormann, *Virtuelle Realitt*, Addison-Wesley Publishing Company, Reading, MA, 1994.

[Born79] A. Borning, *Thinglab – A Constraint-Oriented Simulation Laboratory*, Technical Report SSI-79-3, Xerox Palo Alto Research Center, Palo Alto, CA, 1979.

[Bouk70] W. J. Bouknight, *A Procedure for Generation of Three-Dimensional Half-Toned Computer Graphics Presentations*, Communications of the ACM, 13(9) (1970), pp. 527–536.

[Bres65] J. E. Bresenham, *Algorithm for Computer Control of a Digital Plotter*, IBM Systems Journal, 4(1) (1965), pp. 25–30.

[Bres77] —–, *A Linear Algorithm for Incremental Digital Display of Circular Arcs*, Communications of the ACM, 20(2) (1977), pp. 100–106.

[Bron74] R. Brons, *Linguistic Methods for the Description of a Straight Line on a Grid*, Computer Graphics and Image Processing, 3 (1974), pp. 48–62.

[Bron85] —–, *Theoretical and Linguistic Methods for Describing Straight Lines*, in Fundamental Algorithms for Computer Graphics, R. A. Earnshaw, ed., Springer-Verlag, Berlin 1985, pp. 19–57.

[BuWe76] N. Burtnyk and M. Wein, *Interactive Skeleton Techniques for Enhancing Motion Dynamics in Key Frame Animation,* Communications of the ACM, 19(10) (1976), pp. 564–569.

[CaLe93] B. Cabral and L. Leedom, *Imaging Vector Fields Using Line Integral Convolution,* in: *Proceedings of SIGGRAPH '93,* Computer Graphics, 27, ACM SIGGRAPH, New York, 1993, pp. 263–272.

[Carp84] L. Carpenter, *The A-Buffer, an Antialiased Hidden Surface Method,* in: *Proceedings of SIGGRAPH '84,* Computer Graphics, 18(3), ACM SIGGRAPH, New York, 1984, pp. 103–108.

[Catm72] E. Catmull, *A System for Computer Generated Movies,* in: *Proceedings of the ACM Annual Conference,* ACM, New York, 1972, pp. 422–431.

[Catm74] —–, *A Subdivision Algorithm for Computer Display of Curved Surfaces,* Report UTEC-CSc-74-133, Dissertation, Computer Science Department, University of Utah, Salt Lake City, UT, 1974.

[Catm78a] —–, *A Hidden-Surface Algorithm with Anti-Aliasing,* in: *Proceedings of SIGGRAPH '78,* Computer Graphics, 12(3), ACM SIGGRAPH, New York, 1978, pp. 6–11.

[Catm78b] —–, *The Problems of Computer-Assisted Animation,* in: *Proceedings of SIGGRAPH '78,* Computer Graphics, 12(3), ACM SIGGRAPH, New York, 1978, pp. 348–353.

[CCWG88] M. F. Cohen, S. E. Chen, J. R. Wallace, and D. P. Greenberg, *A Progressive Refinement Approach to Fast Radiosity Image Generation,* in: *Proceedings of SIGGRAPH '88,* Computer Graphics, 22(4), ACM SIGGRAPH, New York, 1988, pp. 75–84.

[CGIB86] M. F. Cohen, D. P. Greenberg, D. S. Immel, and P. J. Brock, *An Efficient Radiosity Approach for Realistic Image Synthesis,* IEEE Computer Graphics and Applications, 6(3) (1986), pp. 26–35.

[CoGr85] M. F. Cohen and D. P. Greenberg, *The Hemi-Cube: A Radiosity Solution for Complex Environments,* in: *Proceedings of SIGGRAPH '85,* Computer Graphics, 19(3), ACM SIGGRAPH, New York, 1985, pp. 31–40.

[Coon67] S. A. Coons, *Surfaces for Computer Aided Design of Space Forms,* MIT Project Mac TR-41, Massachusetts Institute of Technology, Cambridge, MA, 1967.

[CoTo82] R. Cook and K. Torrance, *A Reflectance Model for Computer Graphics,* ACM Transactions on Graphics, 1(1) (1982), pp. 7–24.

[CoWa93] M. F. Cohen and J. R. Wallace, ed., *Radiosity and Realistic Image Synthesis,* Academic Press, San Diego, 1993.

[CyBe78] M. Cyrus and J. Beck, *Generalized Two- and Three-Dimensional Clipping,* Computers and Graphics, 3(1) (1978), pp. 23–28.

[Dahm89] W. Dahmen et al., ed., *Computation of Curves and Surfaces,* Kluwer Academic Publishers, Dordrecht 1989.

[deBo78] C. de Boor, *A Practical Guide to Splines,* Applied Mathematical Science Series, Bd. 27, Springer-Verlag, New York 1978.

[Dier95] P. Dierckx, *Curve and Surface Fitting with Splines,* Clarendon Press, Oxford, 1995.

[DoTo81] L. Doctor and J. Torborg, *Display Techniques for Octree-Encoded Objects,* IEEE Computer Graphics and Applications, 1(3) (1981), pp. 29–38.

[Fari87] G. Farin, ed., *Geometric Modeling: Algorithms and New Trends,* SIAM, Philadelphia, 1987.

[Fari90] G. Farin, *Curves and Surfaces for Computer Aided Geometric Design,* Academic Press, San Diego, 2nd ed., 1990.

[Fari94] G. Farin, *Kurven und Flächen im Computer Aided Geometric Design: Eine praktische Einführung,* Vieweg, Braunschweig, 1994.

[FlSt75] R. Floyd and L. Steinberg, *An Adaptive Algorithm for Spatial Gray Scale,* Society for Information Display, 1975 Symposium, Digest of Technical Papers, (1975), p. 36.

[Forr80] A. R. Forrest, *The Twisted Cubic Curve: A Computer Aided Geometric Design Approach,* Computer Aided Design, 12(4) (1980), pp. 165–172.

[FSB82] S. Feiner, D. Salesin, and T. Banchoff, *DIAL: A Diagrammatic Animation Language,* IEEE Computer Graphics and Applications, 2(7) (1982), pp. 43–54.

[GDN95] M. Griebel, T. Dornseifer, and T. Neunhoeffer, *Numerische Simulation in der Strömungsmechanik - Eine praxisorientierte Einführung,* Vieweg, Braunschweig 1995.

[Gepp95] M. Geppert, *Ein globales Beleuchtungsmodell für die diffuse Reflexion,* Diplomarbeit, Mathematisches Institut, TU München, 1995.

[GiMa83] C. M. Ginsberg and D. Maxwell, *Graphical Marionette,* in: *Proceedings of the SIGGRAPH/SIGART Interdisciplinary Workshop on Motion: Representation and Perception,* Toronto, 1983, pp. 172–179.

[Glas89] A. S. Glassner, ed., *An Introduction to Ray Tracing,* Academic Press, London, 1989.

[Glas90] A. S. Glassner, ed., *Graphics Gems I,* Academic Press Professional, Boston 1990.

[GlRa92] A. Globus and E. Raible, *13 Ways to Say Nothing with Scientific Visualization,* Report RNR-92-006, NASA Ames Research Center, Moffett Field, CA, 1992.

[GoNa71] R. A. Goldstein and R. Nagel, *3D Visual Simulation,* Simulation, 16(1) (1971), pp. 25–31.

[Gord83] W. Gordon, *An Operator Calculus for Surface and Volume Modeling,* Computer Graphics, 18(10) (1983), pp. 18–22.

[Gour71] H. Gouraud, *Continuous Shading of Curved Surfaces,* IEEE Transactions on Computers, C-20(6) (1971), pp. 623–629.

[Gree86] N. Greene, *Environment Mapping and Other Applications of World Projections,* IEEE Computer Graphics and Applications, 6(11) (1986), pp. 21–29.

[Grie84] M. Griebel, *Die Beschreibung von starren Körpern durch ihre Oberflächen,* Diplomarbeit, Institut für Informatik, TU München, 1984.

[GSCH93] S. J. Gortler, P. Schröder, M. F. Cohen, and P. Hanrahan, *Wavelet Radiosity,* in: *Proceedings of SIGGRAPH '93,* ACM SIGGRAPH, New York, 1993, pp. 221–230.

[GSPC77] Graphics Standards Planning Committee, *Status Report of the Graphics Standards Planning Committee of ACM SIGGRAPH,* Computer Graphics, 11(3) (1977).

[GSPC79] ——, *Status Report of the Graphics Standards Planning Committee of ACM SIGGRAPH,* Computer Graphics, 13(3) (1979).

[GTGB84] C. M. Goral, K. E. Torrance, D. P. Greenberg, and B. Battaile, *Modeling the Interaction of Light Between Diffuse Surfaces,* in: Proceedings of SIGGRAPH '84, Computer Graphics, 18(3), ACM SIGGRAPH, New York, 1984, pp. 213–222.

[GuSp81] S. Gupta and R. E. Sproull, *Filtering Edges for Gray-Scale Displays,* in: *Proceedings of SIGGRAPH '81,* Computer Graphics, 15(3), ACM SIGGRAPH, New York, 1981, pp. 1–5.

[GWW86] I. Gargantini, T. Walsh, and O. Wu, *Viewing Transformations of Voxel-Based Objects via Linear Octrees,* IEEE Computer Graphics and Applications, 6(10) (1986), pp. 12–21.

[Haen96] T. Haenselmann, *Raytracing: Grundlagen, Implementierung, Praxis,* Addison-Wesley Publishing Company, Bonn 1996.

[Hage91] H. Hagen, *Geometric Modeling: Methods and Applications,* Springer-Verlag, Berlin 1991.

[HaGr83] R. A. Hall and D. P. Greenberg, *A Testbed for Realistic Image Synthesis,* IEEE Computer Graphics and Applications, 3(8) (1983), pp. 10–20.

[Hall86] R. Hall, *Hybrid Techniques for Rapid Image Synthesis,* in: *Image Rendering Tricks, Course Notes 16 for SIGGRAPH '86,* T. Whitted and R. Cook, eds., Dallas, TX, 1986.

[HaMa68] J. Halas and R. Manvell, *The Technique of Film Animation*, Hastings House, New York, 1968.

[Hanr93] P. Hanrahan, *Rendering Concepts,* in: *Radiosity and Realistic Image Synthesis*, M. F. Cohen and J. R. Wallace, ed., Academic Press, San Diego, 1993.

[Haus19] F. Hausdorff, *Dimension and usseres Mass,* Mathematische Annalen 79, (1919), pp. 157–179.

[Heck94] P. S. Heckbert, ed., *Graphics Gems IV,* Academic Press Professional, Boston 1994.

[Hels91] S. K. Helsel, *Virtual Reality: Theory, Practice, and Promise,* Mechler, Westport 1991.

[Hodg92] L. F. Hodges, *Time-Multiplexed Stereoscopic Computer Graphics,* IEEE Computer Graphics and Applications, (1992), pp. 20–30.

[Holl80] T. M. Holladay, *An Optimum Algorithm for Halftone Generation for Displays and Hard Copies,* in: *Proceedings of the Society for Information Display*, 21(2), 1980, pp. 185–192.

[Holt94] K. Holtorf, *Das Handbuch der Graphikformate,* Franzis' Verlag, Poing, 1994.

[HoMA93] L. F. Hodges and D. F. McAllister, *Computing Stereoscopic Views,* in: *Stereo: Computer Graphics and Other True 3D Technologies*, D. F. McAllister, ed., Princeton University Press, Princeton, NJ, 1993, pp. 71–89.

[HoRo95] C. Hoffmann and J. Rossignac, eds., *Proceedings of the 3rd Symposium on Solid Modeling and Applications,* Salt Lake City, 1995, ACM, New York, 1995.

[HsLe94] S. C. Hsu and I. H. H. Lee, *Drawing and Animation Using Skeletal Strokes,* in: *Proceedings of SIGGRAPH '94,* ACM SIGGRAPH, New York, 1994, pp. 109–118.

[ICG86] D. S. Immel, M. F. Cohen, and D. P. Greenberg, *A Radiosity Method for Non-Diffuse Environments,* in: *Proceedings of SIGGRAPH '86,* Computer Graphics, 20(4), ACM SIGGRAPH, New York, 1986, pp. 133–142.

[ISO88] International Standards Organization (ISO), *International Standard Information Processing Systems – Computer Graphics – Graphical Kernel System for Three Dimensions (GKS-3D) Functional Description,* ISO Document Number 8805:1988(E), American National Standards Institute, New York, 1988.

[Jens96] H. W. Jensen, *Global Illumination Using Photon Maps,* in: *Rendering Techniques '96,* Springer-Verlag, Wien, (1996), pp. 21–30.

[Kahl99] A. Kahler, *Monte Carlo Ray Tracing Using Photon Maps,* Diplomarbeit (Thesis), Institut für Informatik, TU München, 1999.

[Kaji86] J. Kajiya, *The Rendering Equation,* in: *Proceedings of SIGGRAPH '86,* Computer Graphics, 20(4), ACM SIGGRAPH, New York, 1986, pp. 143–150.

[KaKa86] T. L. Kay and J. T. Kajiya, *Ray Tracing Complex Scenes,* in: *Proceedings of SIGGRAPH '86,* Computer Graphics, 20(4), ACM SIGGRAPH, New York, 1986, pp. 269–278.

[Kala94] R. S. Kalawsky, *The Science of Virtual Reality and Virtual Environments,* Addison-Wesley Publishing Company, Reading, MA, 1994.

[KaSm93] W. Kaufmann and L. Smarr, *Simulierte Welten,* Spektrum Akademischer Verlag, Heidelberg, 1993.

[KeKe93] P. Keller and M. Keller, *Visual Cues: Practical Data Visualization,* IEEE Computer Society Press, Hong Kong, 1993.

[Kirk92] D. Kirk, ed., *Graphics Gems III,* Academic Press Professional, Boston 1992.

[Lass87] J. Lasseter, *Principles of Traditional Animation Applied to 3D Computer Animation,* in: *Proceedings of SIGGRAPH '87,* Computer Graphics, 21(4), ACM SIGGRAPH, New York, 1987, pp. 35–44.

[Layb79] K. Laybourne, *The Animation Book,* Crown, New York, 1979.

[LiBa84] Y.-D. Liang and B. Barsky, *A New Concept and Method for Line Clipping,* ACM Transactions on Graphics, 3(1) (1984), pp. 1–22.

[Lind68] A. Lindenmayer, *Mathematical Models for Cellular Interactions in Development, Parts I and II,* J. Theor. Biol., 18 (1968), pp. 280–315.

[Lipt93] L. Lipton, *Composition for Electrostereoscopic Displays,* in: *Stereo Computer Graphics and Other True 3D Technologies,* D. F. McAllister, ed., Princeton University Press, Princeton, NJ, 1993, pp. 11–25.

[Mänt81] M. Mäntyl, *Methodological Background of the Geometric Workbench,* Report HTKK-TK0-B30, Helsinki University of Technology, CAD-Projekt, Laboratory of Information Processing Science, 1981.

[Mänt88] ——, *Introduction to Solid Modeling,* Computer Science Press, Rockville, MD, 1988.

[Mänt89] ——, *Advanced Topics in Solid Modeling,* in: *Advances in Computer Graphics V,* W. Purgathofer und J. Schönhut, ed., Springer-Verlag, Berlin 1989, pp. 49–75.

[MAGI68] Mathematical Applications Group, Inc., *3D Simulated Graphics Offered by Service Bureau,* Datamation, 13(1) (1968), p. 69.

[Mand77] B. Mandelbrot, *Fractals: Form, Chance and Dimension,* W. H. Freeman, San Francisco, CA, 1977.

[Mand87] ——, *Die fraktale Geometrie der Natur,* Birkhuser Verlag, Basel 1987.

[MaTh85] N. Magnenat-Thalmann and D. Thalmann, *Computer Animation: Theory and Practice,* Springer-Verlag, Tokyo 1985.

[McAl93] D. F. McAllister, *Introduction,* in: *Stereo Computer Graphics and Other True 3D Technologies,* D. F. McAllister, ed., Princeton University Press, Princeton, NJ, 1993, pp. 2–10.

[Meag82] D. Meagher, *Geometric Modeling Using Octree Encoding,* Computer Graphics and Image Processing, 19(2) (1982), pp. 129–147.

[Mess94] W. Messner, *Stereographische Visualisierung von dreidimensionalen, turbulenten und instationären Rohrströmungen mit Hilfe von Anaglyphen,* Diplomarbeit (Thesis), Institut für Informatik, TU München, 1994.

[Mort85] M. Mortenson, *Geometric Modeling,* John Wiley, New York, 1985.

[Muck70] H. Mucke, *Anaglyphen - Raumzeichnungen - Eine Anleitung zum Konstruieren von Raumbildern,* B. G. Teubner Verlagsgesellschaft, Leipzig, 1970.

[Musg89] F. K. Musgrave, *Prisms and Rainbows: A Dispersion Model for Computer Graphics,* in: *Proceedings of Graphics Interface '89,* London, Ontario, 1989, pp. 227–234.

[NDW93] J. Neider, T. Davis, and M. Woo, *OpenGL Programming Guide,* Addison-Wesley Publishing Company, Reading, MA, 1993.

[NiNa85] T. Nishita and E. Nakamae, *Continuous Tone Representation of Three-Dimensional Objects Taking Account of Shadows and Interreflection,* in: *Proceedings of SIGGRAPH '85,* Computer Graphics, 19(3), ACM SIGGRAPH, New York, 1985, pp. 124–146.

[NNS72] R. E. Newell, R. G. Newell, and T. L. Sancha, *A Solution to the Hidden Surface Problem,* in: *Proceedings of the ACM National Conference,* 1972, pp. 443–450.

[Nolt88] H. Noltemeier, ed., *Computational Geometry and its Applications, Proceedings of the Int. Workshop CG '88 on Computational Geometry,* Lecture Notes in Computer Science 333, Springer-Verlag, Berlin 1988.

[PeMi93] W. Pennebaker and J. L. Mitchell, *JPEG Still Image Data Compression Standard,* Van Nostrand Reinhold, New York, 1993.

[PeRi86] H.-O. Peitgen and P. H. Richter, *The Beauty of Fractals: Images of Complex Dynamical Systems,* Springer-Verlag, Berlin 1986.

[PeSa88] H.-O. Peitgen and D. Saupe, ed., *The Science of Fractal Images,* Springer-Verlag, New York, 1988.

[PHIG88] PHIGS+ Committee, *PHIGS+ Functional Description Revision 3.0,* Computer Graphics, 22(3) (1988), pp. 125–218.

[Phon75] B.-T. Phong, *Illumination for Computer Generated Pictures,* Communications of the ACM, 18(6) (1975), pp. 311–317.

[PiGr82] M. L. V. Pitteway and A. J. R. Green, *Bresenham's Algorithm with Run Line Coding Shortcut,* Computer Journal, 25 (1982), pp. 114–115.

[PiTi87] L. Piegl and W. Tiller, *Curve and Surface Constructions Using Rational B-Splines,* Computer Aided Design, 19(9) (1987), pp. 485–498.

[Pitt67] M. L. V. Pitteway, *Algorithm for Drawing Ellipses or Hyperbolae with a Digital Plotter,* Computer Journal, 10(3) (1967), pp. 282–289.

[PLH88] P. Prusinkiewicz, A. Lindenmayer, and J. Hanan, *Developmental Models of Herbaceous Plants for Computer Imagery Purposes,* in: *Proceedings of SIGGRAPH '88,* Computer Graphics, 22(4), ACM SIGGRAPH, New York, 1988, pp. 141–150.

[Prit77] D. H. Pritchard, *U.S. Color Television Fundamentals – A Review,* IEEE Transactions on Consumer Electronics, CE-23(4) (1977), pp. 467–478.

[PrSh85] F. P. Preparata and M. I. Shamos, *Computational Geometry: An Introduction,* Springer-Verlag, New York, 1985.

[ReBl85] W. T. Reeves and R. Blau, *Approximate and Probabilistic Algorithms for Shading and Rendering Particle Systems,* in: *Proceedings of SIGGRAPH '85,* Computer Graphics, 19(3), ACM SIGGRAPH, New York, 1985, pp. 313–322.

[Reev83] W. T. Reeves, *Particle Systems - A Technique for Modeling a Class of Fuzzy Objects,* in: *Proceedings of SIGGRAPH '83,* Computer Graphics, 17(3), ACM SIGGRAPH, New York, 1983, pp. 359–376.

[REFJP88] P. de Reffye, C. Edelin, J. Françon, M. Jaeger, and C. Puech, *Plant Models Faithful to Botanical Structure and Development,* in: *Proceedings of SIGGRAPH '88,* Computer Graphics, 22(4), ACM SIGGRAPH, New York, 1988, pp. 151–158.

[Requ77] A. A. G. Requicha, *Mathematical Models of Rigid Solids,* Technical Memo 28, Production Automation Project, University of Rochester, Rochester, NY, 1977.

[Requ80a] ——, *Representation of Rigid Solid Objects,* in: Lecture Notes in Computer Science 89, Springer-Verlag, Berlin, 1980, pp. 2–78.

[Requ80b] ——, *Representations for Rigid Solids: Theory, Methods, and Systems,* ACM Computing Surveys, 12(4) (1980), pp. 437–464.

[Requ88] ——, *Solid Modeling – A 1988 Update,* in: CAD Based Programming for Sensory Robots, R. Bahram, ed., Springer-Verlag, Berlin, 1988.

[ReTi78] A. A. G. Requicha and R. B. Tilove, *Mathematical Foundations of Constructive Solid Geometry: General Topology of Closed Regular Sets,* Technical Memo 27a, Production Automation Project, University of Rochester, Rochester, NY, 1978.

[ReVo82] A. A. G. Requicha and H. B. Voelcker, *Solid Modeling: A Historical Summary and Contemporary Assessment,* IEEE Computer Graphics and Applications, 2(2) (1982), pp. 9–24.

[Reyn82] C. W. Reynolds, *Computer Animation with Script and Actors,* in Computer Graphics, 16(3), ACM SIGGRAPH, New York, 1982, pp. 289–296.

[Rush86] H. E. Rushmeier, *Extending the Radiosity Method to Transmitting and Specularly Reflecting Surfaces,* Master's thesis, Mechanical Engineering Department, Cornell University, Ithaca, NY, 1986.

[Rush93] ——, *From Solution to Image,* SIGGRAPH Course 22, 22(7) (1993), pp. 1–10.

[Same84] H. Samet, *The Quadtree and Related Hierarchical Data Structures,* ACM Computing Surveys, 16(2) (1984), pp. 187–260.

[SCB88] M. Stone, W. Cowan, and J. Beatty, *Color Gamut Mapping and the Printing of Digital Color Images,* ACM Transactions on Graphics, 7(3) (1988), pp. 249–292.

[Scha93] R. Schardt, *Strecken- und Kreisdigitalisierungen in der Pixel- und Hexelebene,* Diplomarbeit (Thesis), Lehrstuhl für angewandte Mathematik insbesondere Informatik, RWTH Aachen, 1993.

[Shou79] R. G. Shoup, *Color Table Animation,* in: *Proceedings of SIGGRAPH '79,* Computer Graphics, 13(2), ACM SIGGRAPH, New York, 1979, pp. 8–13.

[SiPu89] F. Sillion and C. Puech, *A General Two-Pass Method Integrating Specular and Diffuse Reflection,* in: *Proceedings of SIGGRAPH '89,* Computer Graphics, 23(3), ACM SIGGRAPH, New York, 1989, pp. 335–344.

[Smit78] A. R. Smith, *Color Gamut Transform Pairs,* in: *Proceedings of SIGGRAPH '78,* Computer Graphics, 12(3), ACM SIGGRAPH, New York, 1978, pp. 12–19.

[Smit84] ——, *Plants, Fractals and Formal Languages,* in: *Proceedings of SIGGRAPH '84,* Computer Graphics, 18(3), ACM SIGGRAPH, New York, 1984, pp. 1–10.

[Star89] M. Stark, *Spezifikation und Implementierung einer Datenstruktur für dreidimensionale finite Elemente,* Diplomarbeit (Thesis), Institut für Informatik, TU München, 1989.

[Stei86] R. Steinbrüggen, *Line-Drawing on a Discrete Grid,* Report No. TUM-I8610, Institut für Informatik, TU München, 1986.

[Stei88] ——, *Brons Decompositions of the Chain Code of a Straight Line,* unpublished report, Institut für Informatik, TU München, 1988.

[Ster83] G. Stern, *Bbop - A System for 3D Keyframe Figure Animation,* in: *Introduction to Computer Animation, Course Notes 7 for SIGGRAPH '83,* ACM SIGGRAPH, New York, 1983, pp. 240–243.

[Stoe94] J. Stoer, *Numerische Mathematik 1,* Springer-Verlag, Berlin, 7th ed., 1994.

[SuHo74] I. E. Sutherland and G. W. Hodgman, *Reentrant Polygon Clipping,* Communications of the ACM, 17(1) (1974), pp. 32–42.

[Suth63] I. E. Sutherland, *Sketchpad: A Man-Machine Graphical Communication System,* in: *Proceedings of the Spring Joint Computer Conference,* Spartan Books, Baltimore, MD, 1963.

[Symb85] Symbolics Inc., ed., *S-Dynamics,* Symbolics Inc., Cambridge, MA, 1985.

[Thom86] S. W. Thomas, *Dispersive Refraction in Ray Tracing,* The Visual Computer, 2(1) (1986), pp. 3–8.

[ToSp67] K. E. Torrance and E. M. Sparrow, *Theory for Off-Specular Reflection from Roughened Surfaces,* J. Opt. Soc. Am., 57(9) (1967), pp. 1105–1114.

[TrMa93] R. Troutman and N. L. Max, *Radiosity Algorithms Using Higher Order Finite Elements,* in: *Proceedings of SIGGRAPH '93,* ACM SIGGRAPH, New York, 1993, pp. 209–212.

[TrRe75] T. S. Trowbridge and K. P. Reitz, *Average Irregularity Representation of a Rough Surface for Ray Reflection,* J. Opt. Soc. Am., 65(5) (1975), pp. 531–536.

[TSB66] K. E. Torrance, E. M. Sparrow and R. C. Birkebak, *Polarization, Directional Distribution and Off-Specular Peak Phenomena in Light Reflected from Roughened Surfaces,* J. Opt. Soc. Am., 56(7) (1966), pp. 916–925.

[Voss87] R. Voss, Fractals in *Nature: Characterization, Measurement, and Simulation,* Course Notes 15 for SIGGRAPH '87, (1987).

[Warn69] J. Warnock, *A Hidden-Surface Algorithm for Computer Generated Half-Tone Pictures,* Technical Report TR 4-15, NTIS AD-753 671, Computer Science Department, University of Utah, Salt Lake City, UT, 1969.

[Watk70] G. S. Watkins, *A Real Time Visible Surface Algorithm,* Technical Report UTEC-CSc-70-101, NTIS AD-762 004, Dissertation, Computer Science Department, University of Utah, Salt Lake City, UT, 1970.

[WCG87] J. R. Wallace, M. F. Cohen, and D. P. Greenberg, *A Two-Pass Solution to the Rendering Equation: A Synthesis of Ray Tracing and Radiosity Methods,* in: *Proceedings of SIGGRAPH '87,* Computer Graphics, 21(4), ACM SIGGRAPH, New York, 1987, pp. 311–320.

[WeAt77] K. Weiler and P. Atherton, *Hidden Surface Removal Using Polygon Area Sorting,* in: *Proceedings of SIGGRAPH '77,* Computer Graphics, 11(2), ACM SIGGRAPH, New York, 1977, pp. 214–222.

[Whit80] T. Whitted, *An Improved Illumination Model for Shaded Display,* Communications of the ACM, 23(6) (1980), pp. 343–349.

[Will78] L. Williams, *Casting Curved Shadows on Curved Surfaces,* in: *Proceedings of SIGGRAPH '78,* Computer Graphics, 12(3), ACM SIGGRAPH, New York, 1978, pp. 270–274.

[WREE67] C. Wylie, G. W. Romney, D. C. Evans, and A. C. Erdahl, *Halftone Perspektive Drawings by Computer,* in: Proceedings of the Fall Joint Computer Conference, Thompson Books, Washington, DC, 1967, pp. 49–58.

[WySt82] G. Wyszecki and W. Stiles, *Color Science: Concepts and Methods, Quantitative Data and Formulae,* J. Wiley, New York, 2nd ed., 1982.

[Zatz93] H. R. Zatz, *A Higher Order Solution Method for Global Illumination,* in: *Proceedings of SIGGRAPH '93,* ACM SIGGRAPH, New York, 1993, pp. 213–220.

INDEX